T0160694

Patterns, Costumes and Stencils

ISBN: 978-0-86356-679-0

This first edition published by Saqi in 2009

A full CIP record for this book is available from the British Library.
A full CIP record for this book is available from the Library of Congress.

Manufactured in Lebanon by Chemaly & Chemaly

SAQI
26 Westbourne Grove, London W2 5RH
825 Page Street, Suite 203, Berkeley, California 94710
Tabet Building, Mneimneh Street, Hamra, Beirut
www.saqibooks.com

Chant Avedissian

PATTERNS, COSTUMES & STENCILS

SAQI

London San Francisco Beirut

For 'the music, the cats and the décor'

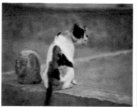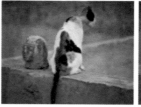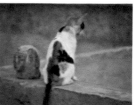

Towards Samarkand

Apart from an equal dialogue, there are other ways to encounter another culture; one can try to learn from the other culture, or one can try to mould the other culture.

In either case, we must meet half way, so as to avoid becoming a copy of the other or to render the other a copy of us. It seems few practised this elementary principle.

We lose our identity if we forget who we are, and become the other. In the second case we also lose, as we might think that what we are teaching is the only truth for humanity, but it is *our* truth, which is an insult to the humanity of the other.

For the past two hundred years the French, then the British, and later the Soviet colonial policymakers employed this second approach to encountering the other; 'Civilizing the Arabs' was the foreground of their expansionist economic interests.

Learning from the other was high on the agenda of the Egyptians. But contrary to imperial mechanisms, the Egyptians' approach to learning from the other had limits, as Egyptians already had an older culture, with a different language and alphabet spread throughout a geographically vaster span. Above all, they also had a knowledge of their own country and its culture, unlike their colonial invaders.

The Egyptians were already part of the culture of encounter and had been for centuries. From Saragossa to Samarkand, teachers and masters were known to each other, and masters and students alike could travel all that distance from west to east and back again, in search of knowledge shared by people of the same language and craft.

Culture cannot be 'imposed' by armed invasions, secret police, or the construction of hospitals, zoological parks, archaeological institutes, football stadiums, cinemas, museums, operas and theatres, or even the partial financing of a dam.

The 'Orient', as it is mystically called within colonial academic circles and whose cultures are still labelled by the French, the British or the Russians – despite their linguistic differences – as 'folklore', is not a uniform generality.

The term 'folklore', which is used even in Arabic, as understood by Orientalist scholars and directors of 'Oriental and ethnographic institutes', is today an institutionalized mantra, with an inferior, 'low' culture connotation as opposed to what is considered 'high European' culture. Since the days of modern colonialism and its nation builders, 'folklore institutes', 'folklore museums' and 'folklore studies' were a planned substitute for the culture of the colonized. The colonizers deliberately and systematically replaced what should have been respected as the civilization of the other with the colonizers' own cultural values, under the auspices of the universality of art.

By diminishing a given civilization to 'folkloric', 'local' or 'ethnic' and under the banner of protecting mainly French, British and Russian 'universal values' and with the backing of much cash, armies and armaments, the 'militarily civilized' cultural elites' values are extended to the remotest corners of the earth.

With the invention of concepts such as 'culture is universal' or 'music is universal', national culture was forcibly replaced during colonial rule by national 'folklore museums' and 'institutes of ethnographic research'. This latter fabrication has become an exotic attraction in the service of these same former colonialists for their ethnographic museums, research expeditions, TV documentaries, and today's exotically chic shops, ethnic restaurants and environmentally correct holidays.

Folklore, as understood by colonial ethnographers, has its pedigrees. Sushi is high on the folklore list, as are French restaurants, Italian opera, Russian ballet and football. But these are not supposed to be labelled folklore; they are 'haute cuisine', 'national patrimony', 'lyric arts', 'dance' and 'sports'.

Our understanding of what we see as art is closely monitored. For example, European classical music has its place, and Afghan music has its rather different place on the 'music is universal' scale. However, to make it politically chic, today the two sometimes meet: the international meets the local.

'Culture is universal' has a patronizing undertone, as it depends who is saying it, and what kind of monopolies are attached to a given 'universal' work of art and therefore a given knowledge.

Artisans have displayed their work in markets for hundreds of years, exchanging their work and knowledge with others without the galleries, copyright laws and international patent laws which protect art and artistic production today. Their knowledge was not protected, but shared.

On the other hand, culture is the work of specific groups at specific times and in specific geographic locations. All might be different but all are equally valid and complementary. A given culture takes ages to develop; one person or one group is no match for a nation and its post-colonial cultural institutions, if it decides voluntarily to classify its own identity in an ethnographic museum as 'national folklore'.

What follows is inspired by the work of myriad people from different places, which I discovered during journeys that always took me back to the same elementary forms, colours and shapes.

This book is about that journey.

The western-oriented 'art and culture' world is mainly confined to galleries, museums and certain spaces under stringent laws and often armed protection.

Fortunately much cultural knowledge is outside these institutions. Knowledge and learning can be found outside the control of specialists and ethnographic academic institutions.

Thousands of master craftsmen and their disciples still work and create anonymously. Thankfully, these craftsmen, along with cats, walls and city streets, have not yet been patented.

It is a fact that what we consider 'art' is confined to different institutions under different names, such as national, local, ethnic, universal or modern, to name a few. Museums too, with their different names, seem to segregate and separate what should have been presented under one roof.

The pretension that European cultural patrimony is universal seems a contradiction in terms when these same 'universal art' and 'art is a universal language' nations have heavily protected borders. Travelling to these nations from the 'Orient' is a human drama, as seen in tragic clandestine border crossings and the resultant deaths of many youth who believe in the 'universal'.

A world without copyright

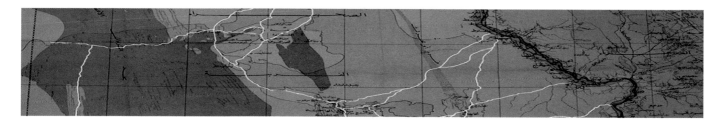

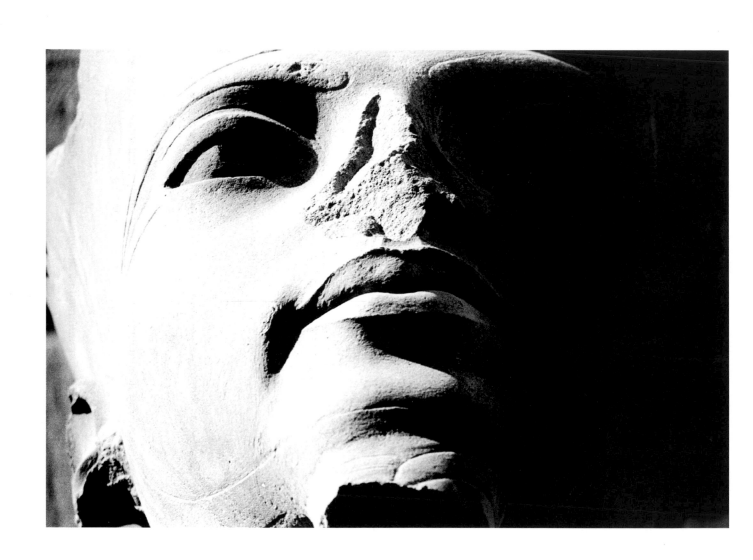

Tutankhamun at the Karnak temples

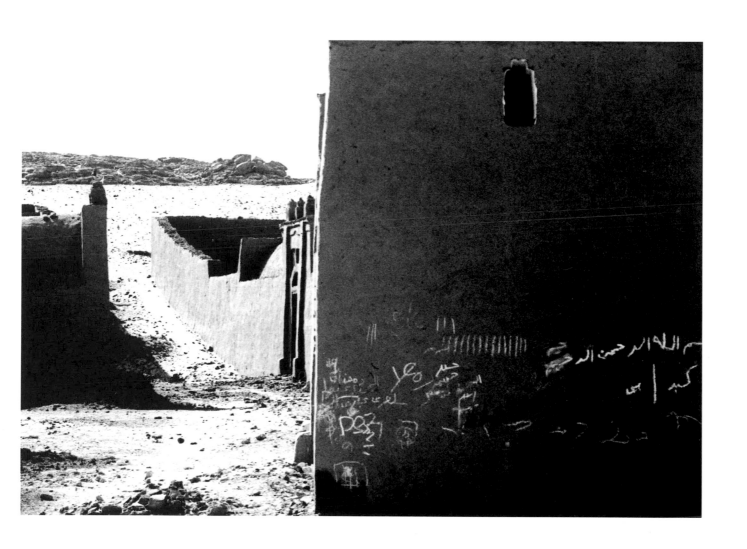

Gharb Aswan

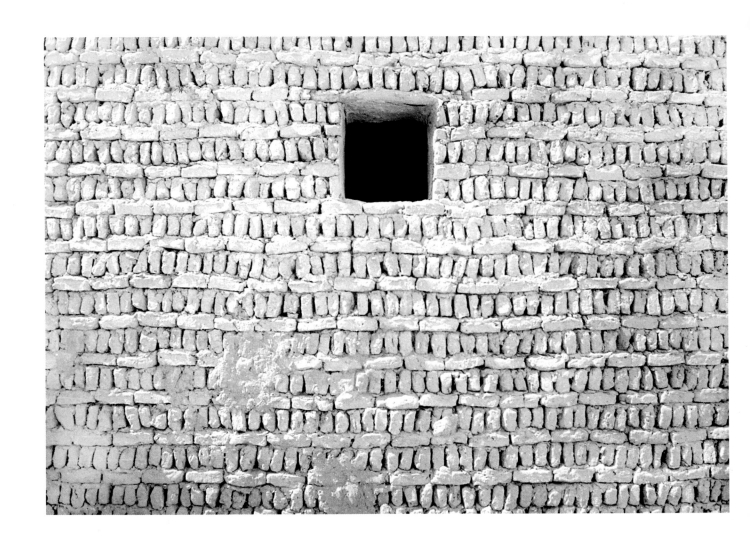

Dakhla Oasis, Al-Qasr

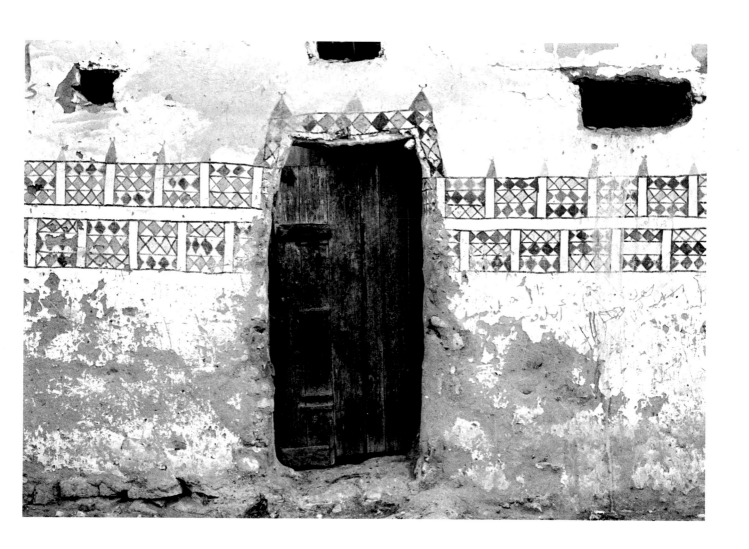

Bahariyya Oasis, Bawiti

A similar pattern of cities with similar cultural heritage such as city gates, markets and buildings can be found from the Atlantic to the Persian plateau, and from the Himalayas to Central Asia.

Like the roots of a language, cities such as Samarkand, Fatihpur Sikri, Jaisalmer, Damascus, Cairo and Fez, among others on the Silk Road, have much in common.

Despite much destruction by wars, court intrigues, Tsarist and European expansionist appetites, and despite the fact that many objects and stones, after being 'discovered' in these cities, are then transferred to Russian and European museums these cities still have much to teach us.

Fortunately, imperial appetites could not remove fortresses, streets, cats, houses or inhabitants along with their customs and manners, as all this was too difficult to hang on museum walls. This appetite was fulfilled in part by amateur missionary and military photographers and can be found in archives of 'institutes for Oriental studies' and 'ethnographic research centres'.

Nevertheless some tried to develop and modernize or annihilate whole cities along with their inhabitants. Some succeeded in annihilating much history in the name of progress. Others in the name of unquestionable national or strategic interests created new countries with artificial borders at the cost of many lives and much destruction.

The artificial creation of 'national' borders, drawn unilaterally by politicians in closed offices in Moscow, London and Paris at the beginning of the twentieth century, still represents a tragic, unresolved legacy of Colonialism. The endless list of border conflicts in Asia, Africa, the Balkans, the Middle East and Transcaucasia, with its human dramas and population displacements caused by reprehensible programmes of 'ethnic selection', is too well known to mention here. The cultural loss is there by deduction.

Walls of glazed brick

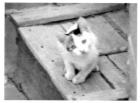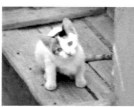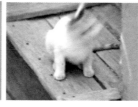

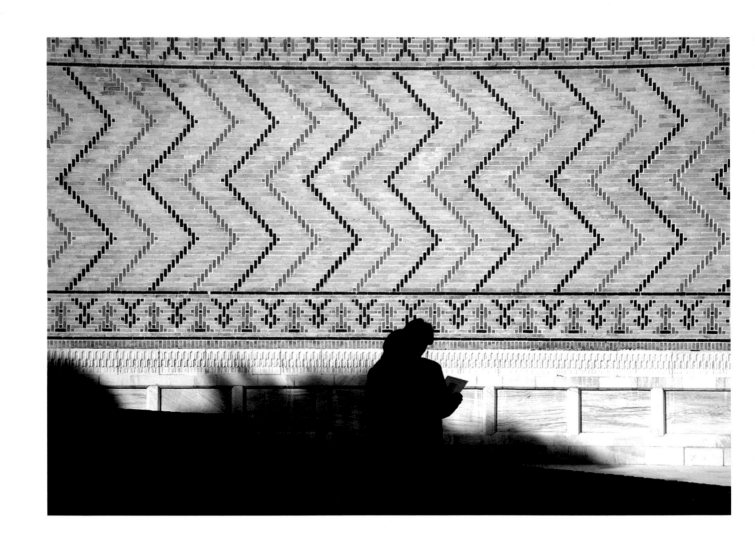

Bibi-Khanym Mosque, Samarkand

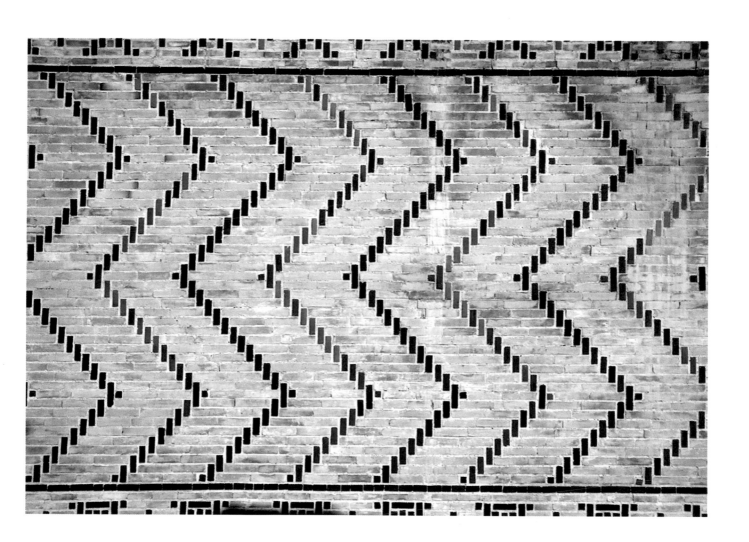

Bibi-Khanym Mosque, Samarkand

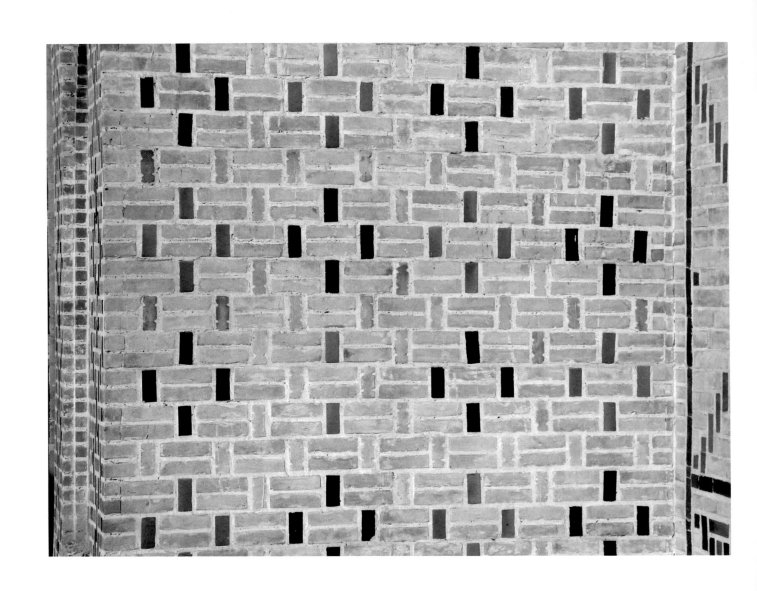

Bibi-Khanym Mosque, Samarkand

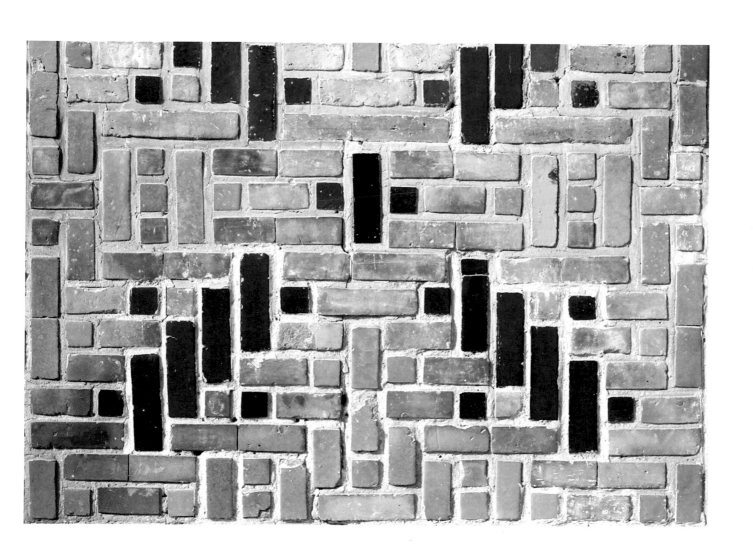

Shahi-Zinda, Samarkand

Using the three basic shapes of the rectangle, square and triangle, one is able to construct panels out of wood, paper, textile or any other material.

It was in western Rajasthan, and particularly in Jaisalmer, that I first came in contact with the world of appliqué textile, which inspired me to make textile panels. Travelling by train through the Thar Desert, one arrives at this ancient city, through which merchants passed as they crossed Iran from Africa along the caravan route to India and China.

The square is divided into rectangles and triangles. These squares placed together form the panels. Several assembled panels form the tent; it's a movable space, easily disassembled, folded and transported.

Formation of squares from rectangles and triangles

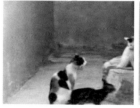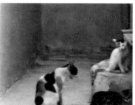

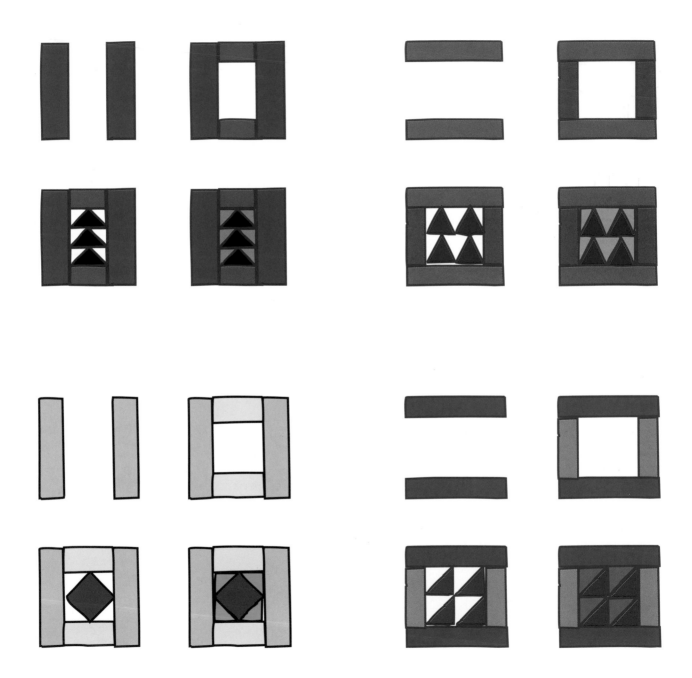

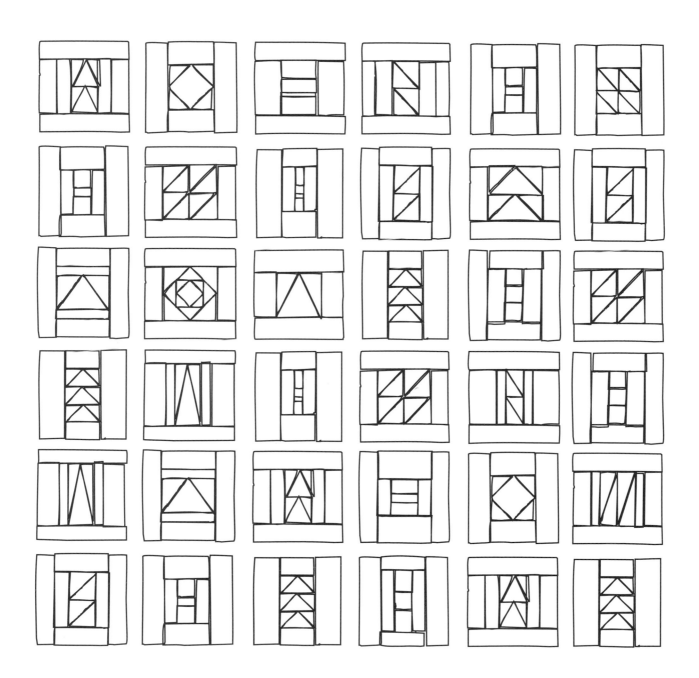

23

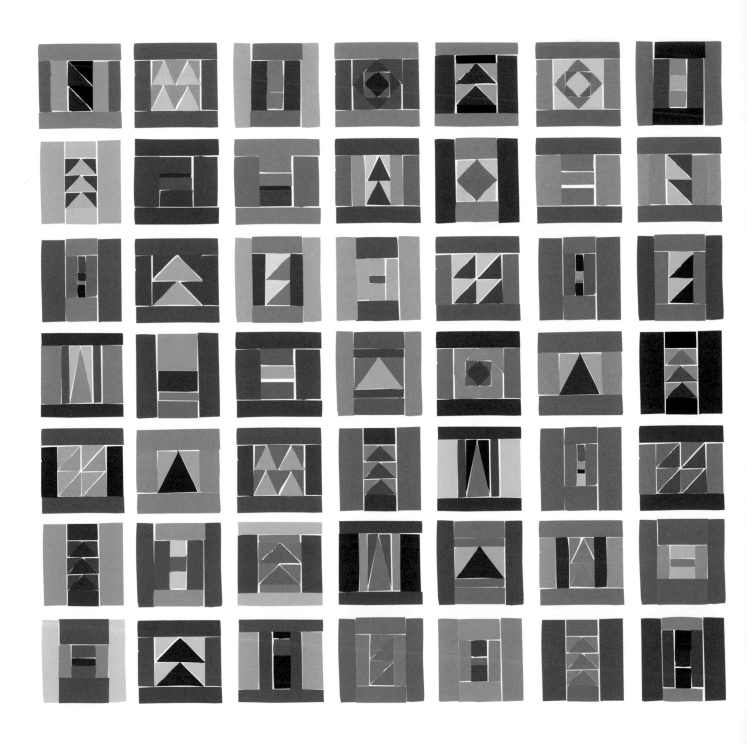

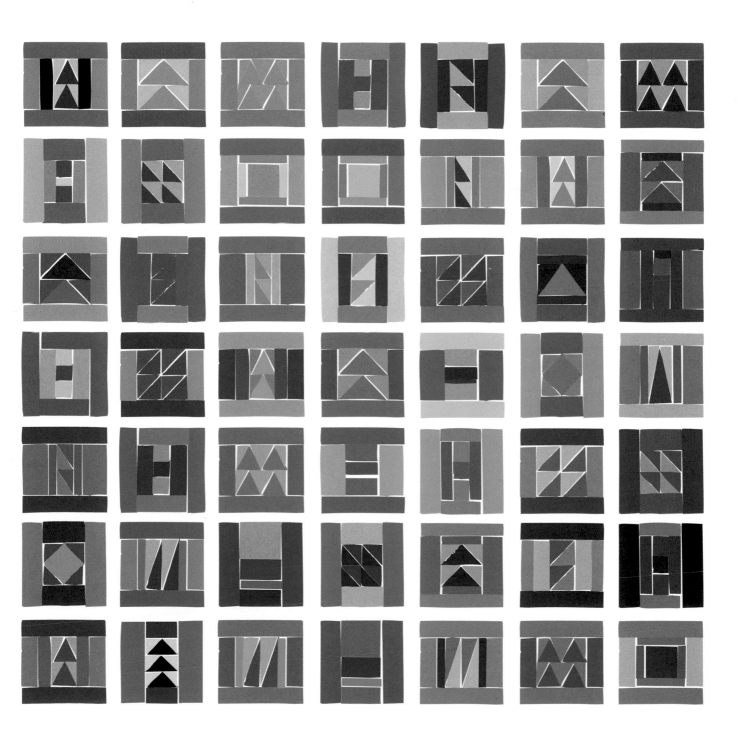

The tent, or mobile shelter, is characteristic of people on the move and is still in use in many parts of the world. The Mongolian *ger* or yurt is one example.

Textile tents are used for special occasions. In Egypt they are mainly used for weddings, funerals, official meetings or festivals. The textile panels are assembled by appliqué technique, using floral and geometric patterns that are found in wood or marble on and in buildings all over the country. Master drawings are transferred to the base which is usually a thick cotton textile; these patterns are multiplied all over the base and reversed as in a mirror. Colour is added by cutting textiles of different colours according to the rhythm of the base pattern. These pieces are then folded at the edges and sewn on to the base by hand.

Modern printed versions are in use today, with designs inspired from traditional tent patterns.

The material that I used to build my textile hangings is *dammour*, a popular and inexpensive Egyptian cotton. This was deliberately chosen primarily to overcome the concept that the more expensive, permanent and rare the materials of an 'artwork' are, the better it is.

I hand-dyed the *dammour* and after cutting it into geometric forms inspired from Pharaonic patterns, Bedouin carpets, Central Asian brick walls or Syrian mother-of-pearl inlaid boxes, I sewed the pieces together by machine.

Textile panels

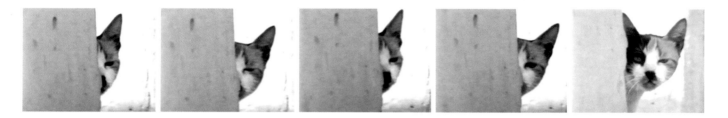

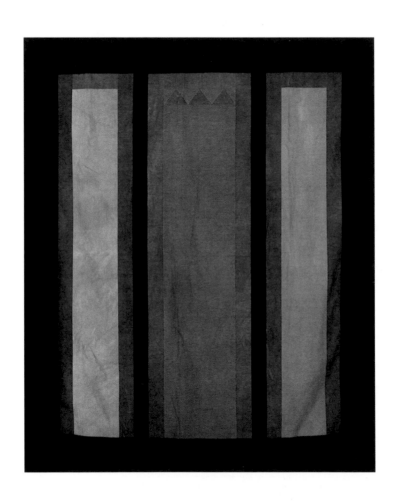

Hand-dyed cotton, 148 x 125 cm

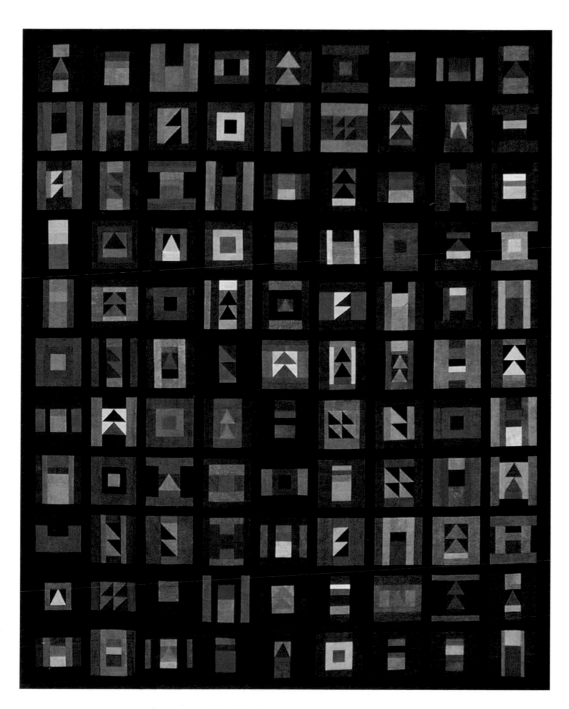

Hand-dyed cotton, 222 x 185 cm

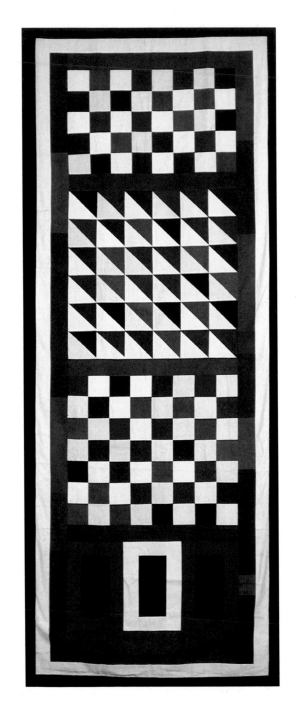

Hand-dyed cotton, 243 x 97 cm

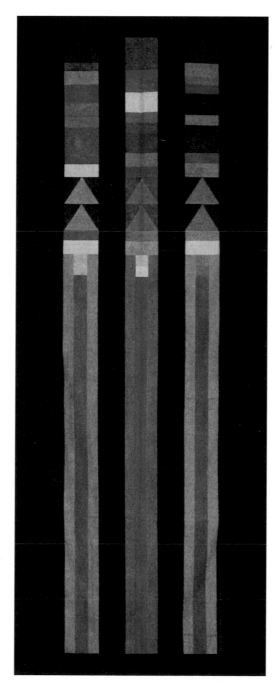

Hand-dyed cotton, 250 x 100 cm

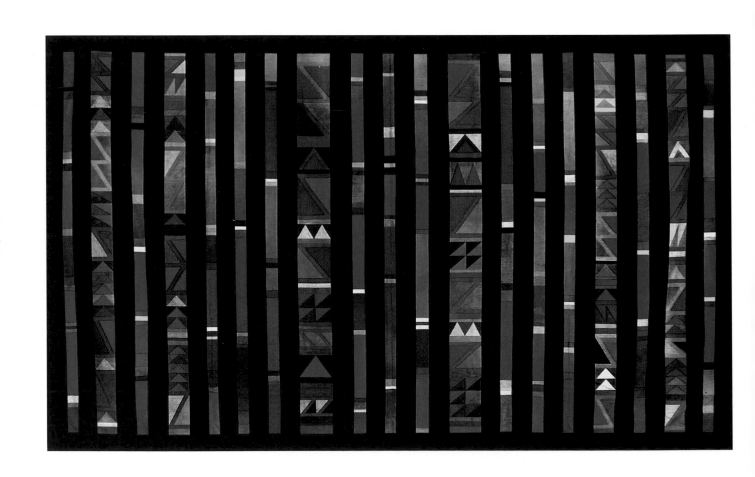

Hand-dyed cotton, 235 x 335 cm

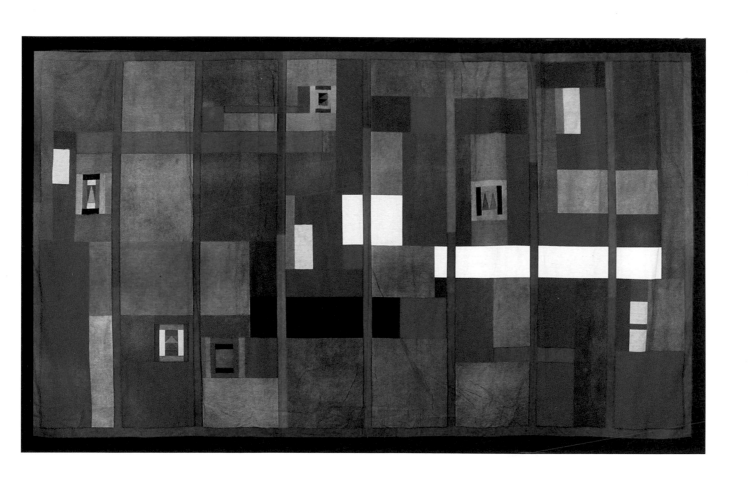

Hand-dyed cotton, 230 x 410 cm

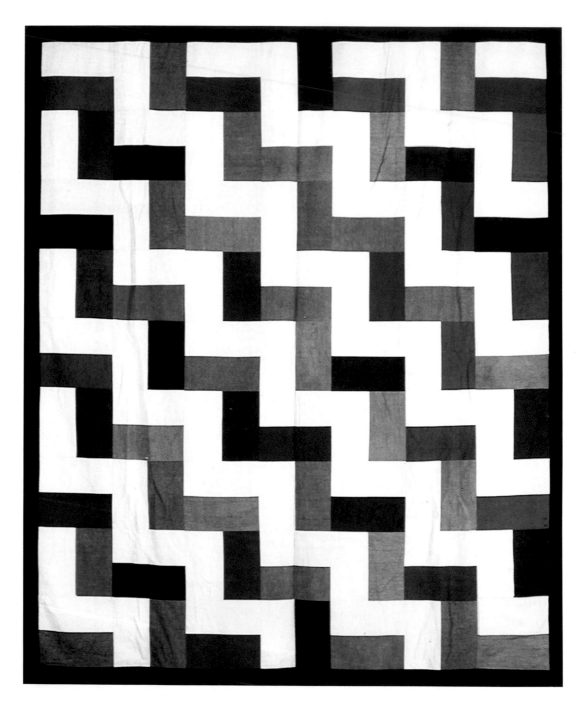

Hand-dyed cotton, 240 x 200 cm

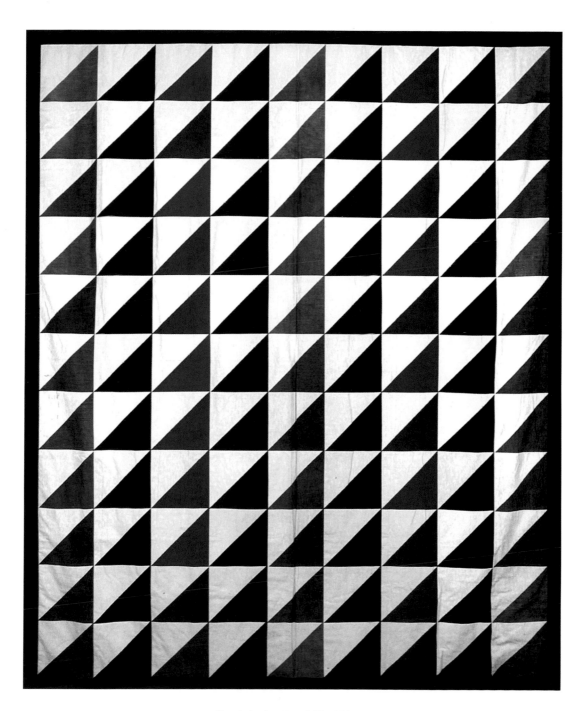

Hand-dyed cotton, 240 x 200 cm

There is not much difference over a huge expanse of geography in the basic cuts of a traditional costume. The measurements comply to the length and width of the woven textile. This is usually divided to form the front, the back and the sleeves.

Much as in Silk Road architecture, similarity is a constant feature of these costumes.

The *haik* of the Atlas resemble the *melaya* of the Nile, which also resemble the *sari* of India. The principle is one piece of unstitched textile.

Similarly, caftans are found from Morocco to Mongolia. They are variations on a theme, and all of almost the same cut.

Material, however, differs. The wealthier the individual and the higher their social status, the more expensive the material, but from the top to the bottom of society the cut is the same. What changes is the quality of the textile and the tailoring.

Men's costumes are sometimes more luxurious than women's, with expensive material, fastidious tailoring, golden threads and ornaments on the front and neckline, and hand-sewn finishing for a very simply cut *gebba*.

Formation of costumes from rectangles and triangles

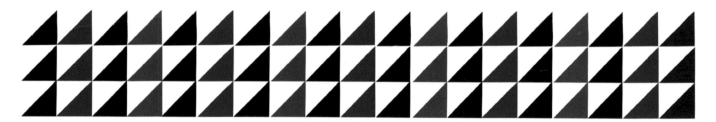

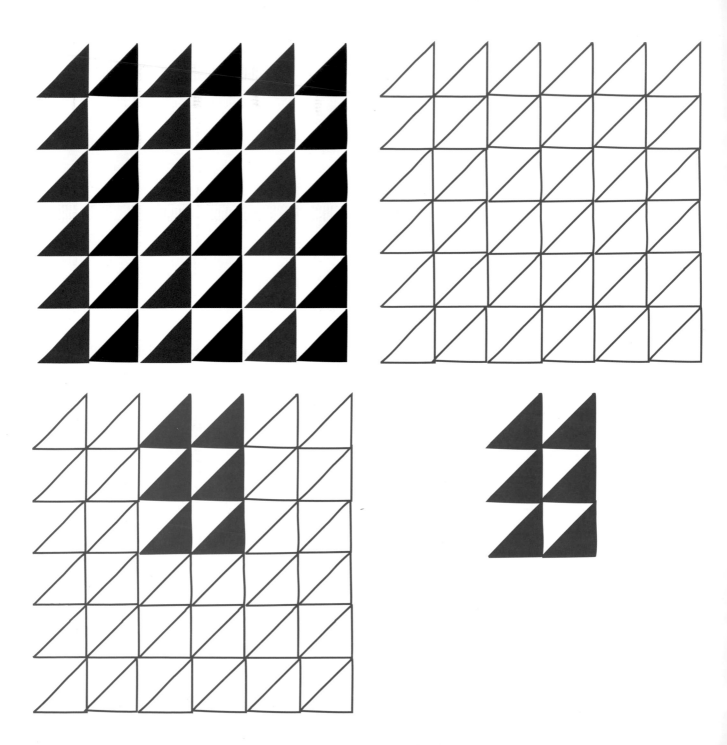

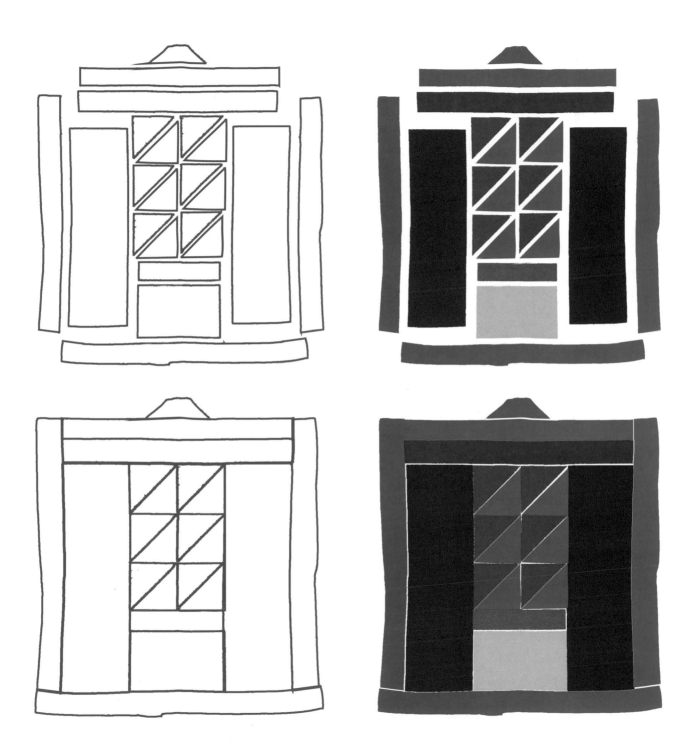

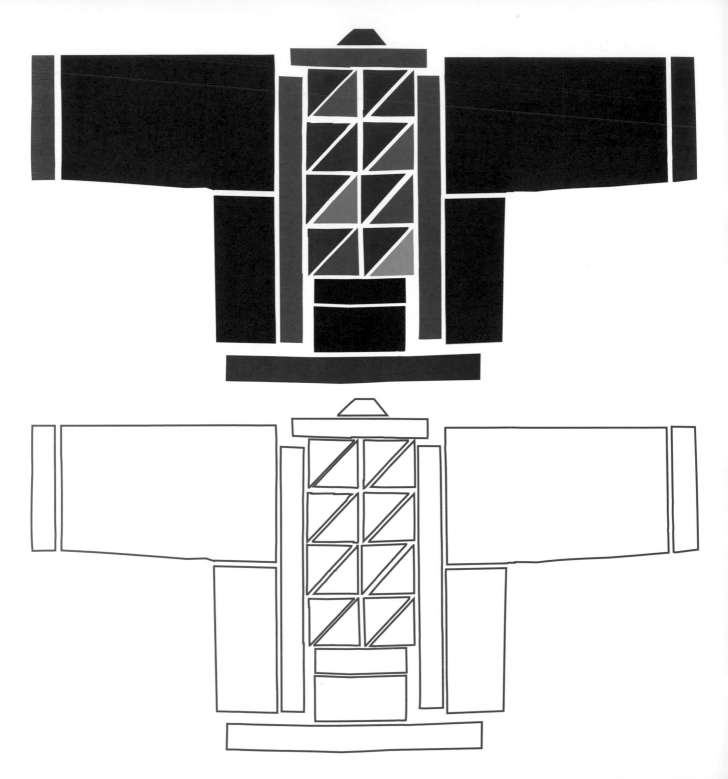

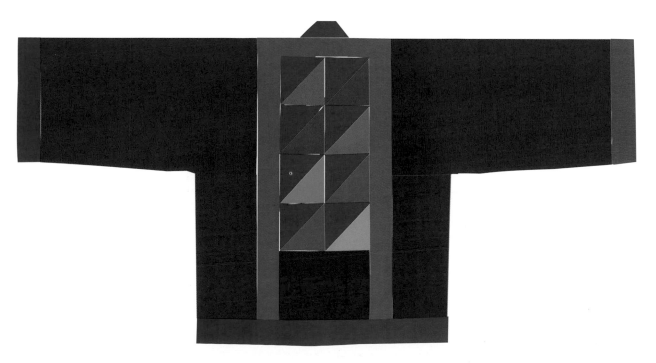

The world of traditional Egyptian costumes – the diversity and the richness of weavers and their textiles, tailors and their cuts, embroiderers and their symbols – is a world whose beauty and richness can still be discovered.

Through costumes, one embraces all aspects of a given geographical area. Costumes, houses, daily utensils, pottery and jewellery all reveal the way of life of a particular society.

While working on these costumes I discovered the intelligence of economy in cutting a textile with minimal wasted material throughout the Arab world and later further east in Central Asia.

The pieces here are all inspired by traditional minimalist cuts, used since times immemorial.

Costumes

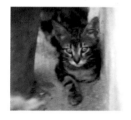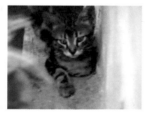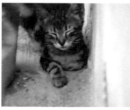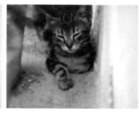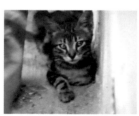

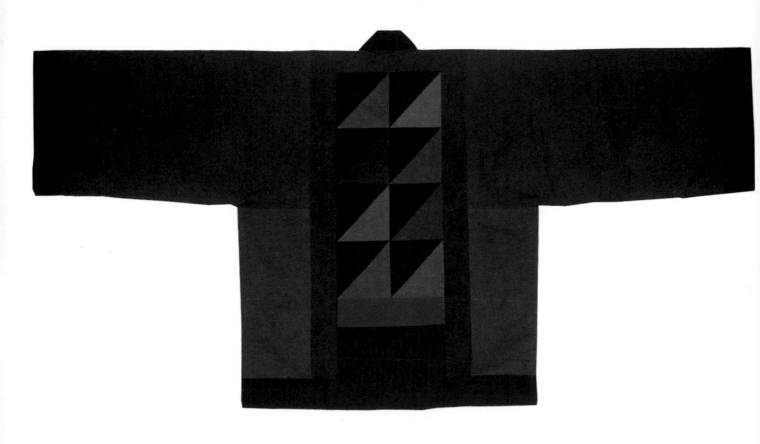

Hand-dyed cotton jacket with blue triangles, 77 x 164 cm, back

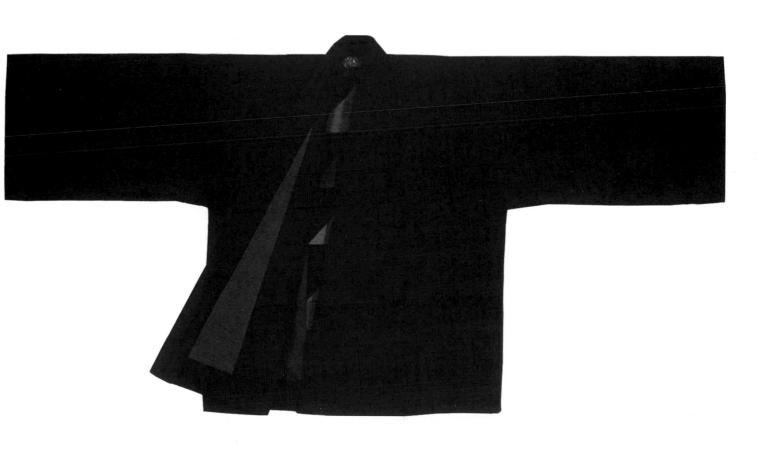

Hand-dyed cotton jacket with blue triangles, 77 x 164 cm, front

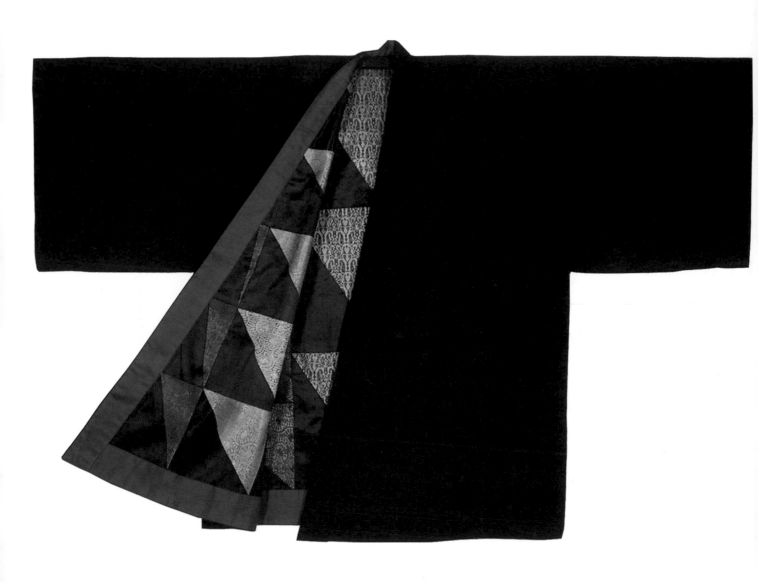

Cotton and brocade coat, 115 x 179 cm

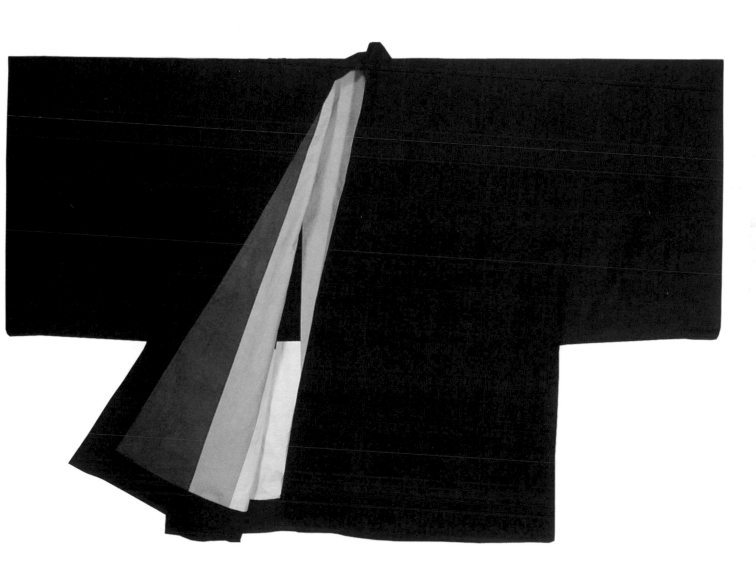

Hand-dyed cotton coat with grey triangle, 115 x 179 cm

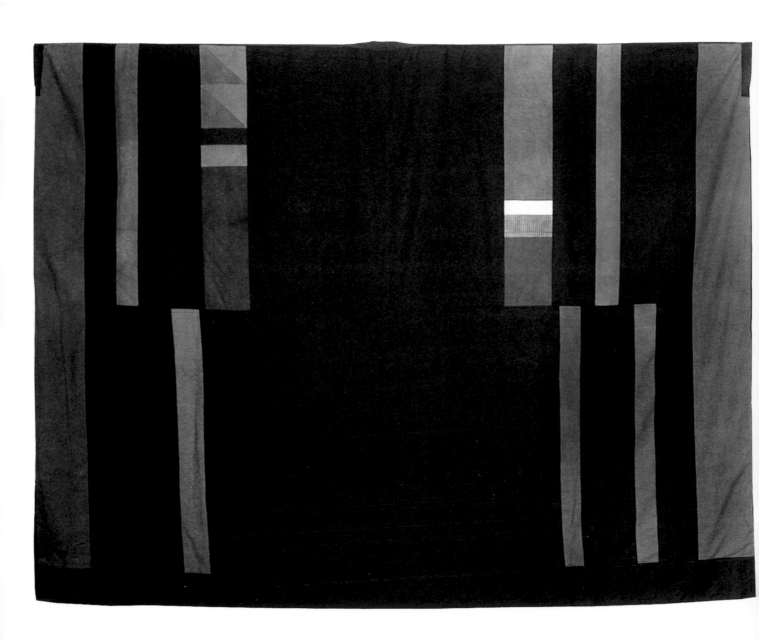

Hand-dyed cotton *gebba*, 160 x 188 cm, back

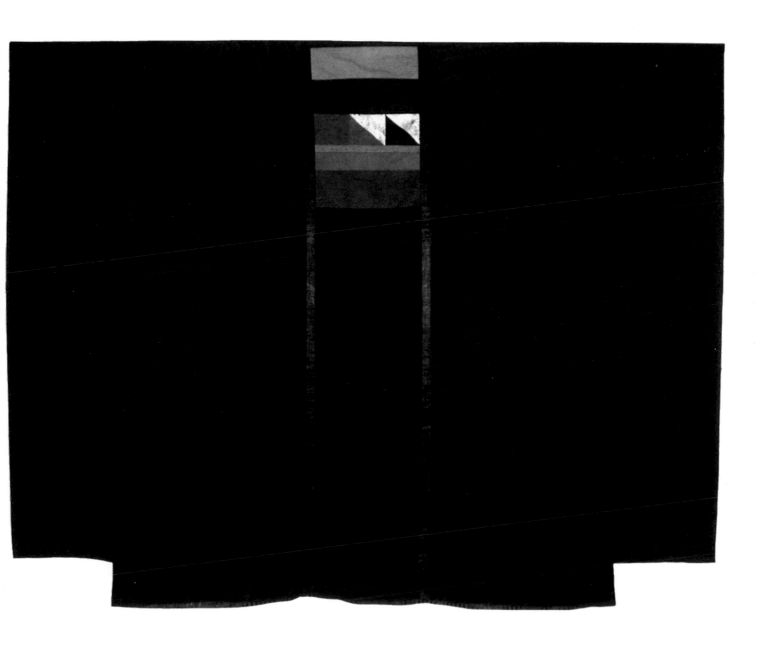

Hand-dyed cotton and brocade dress, 173 x 200 cm

By starting in Cairo, then different towns of Egypt, then further east and north as far as Delhi and Samarkand and still further till Xi'an, and by always keeping the Cairo that I know as the centre, travelling became the rediscovery of almost identical patterns, used in far-apart cities, to give a personalized signature to objects.

Despite the labelling of cultural heritage under different styles and dates, there are similarities between wall decorations in India and Upper Egypt, and wood textile blocks from Uzbekistan could as easily be found in Aleppo.

The different periods in history, according to specialized scholars, are mixed and present in daily life. In Egypt, from Aswan in the south to Alexandria in the north, in real life the styles have no time, no date, no epoch; they are all present, sometimes imperceptibly mixed.

Costume drawings

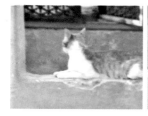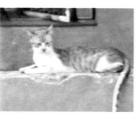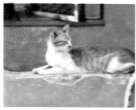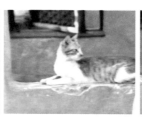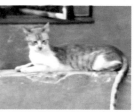

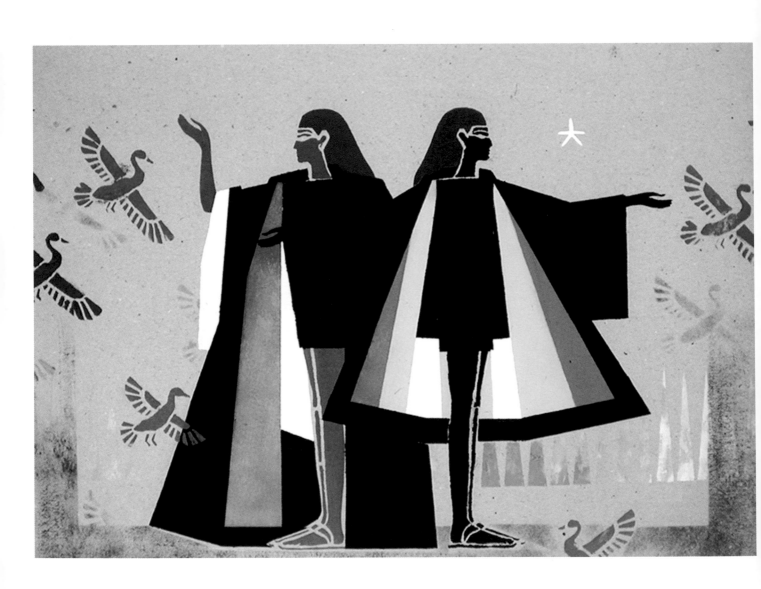

Coats

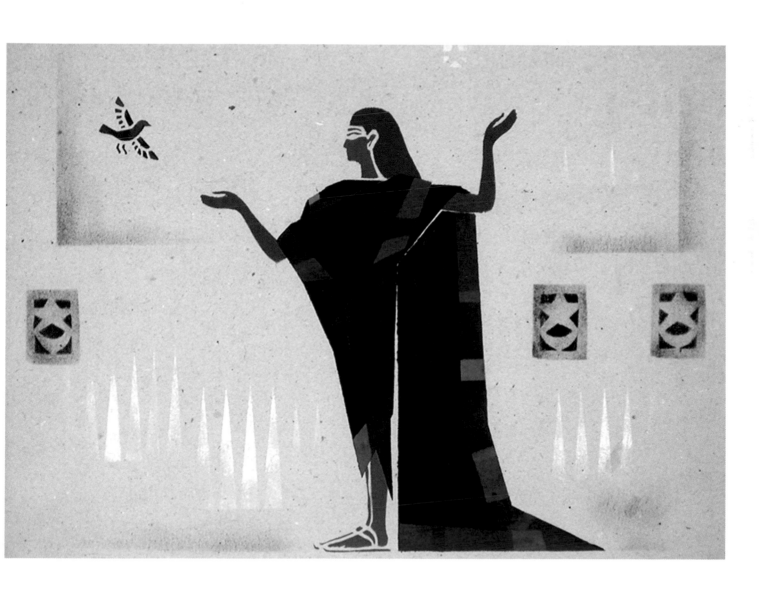

Melaya

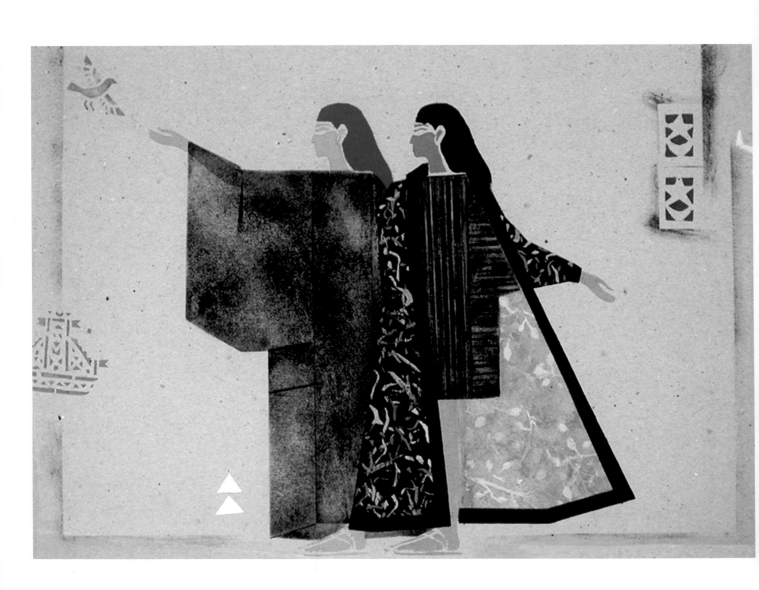

Gergare and coat

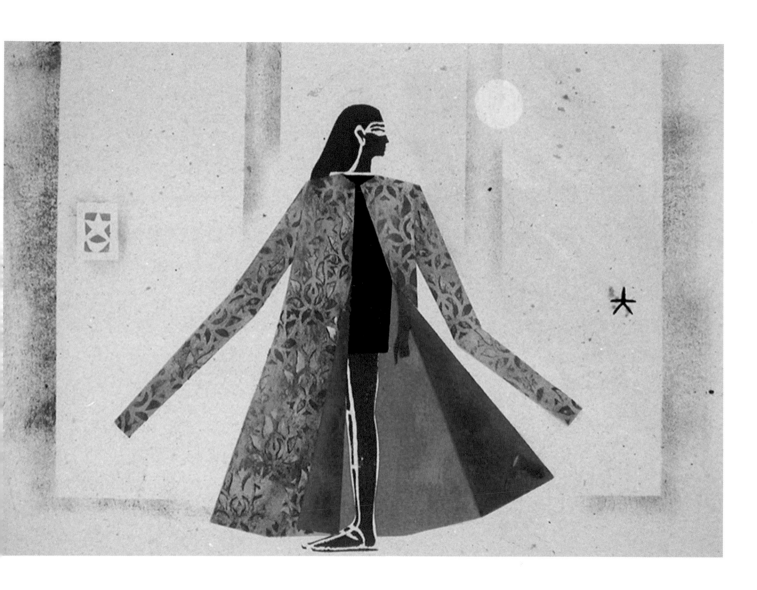

Caftan

The folding, measuring and cutting of an approximately six-metre textile to assemble a costume is a lesson in geometry.

The tailor makes small incisions directly on the edge of the material, of the height of the customer, length of arms and width of shoulders. There are only these three small cuts of a few millimetres each. No rulers or other measurements are required.

Traditional tailors usually cut the material on a table of 70 x 200 cm, 35 cm high; they are seated on the floor. The cutting stage takes a few minutes, and the final result depends on this moment of cutting which requires utmost precision.

The material is folded and cut according to the minute incisions above; diagonals are cut by folding the material and cutting it through the folded line.

There is almost no leftover material.

The separate elements fit together like a puzzle.

Traditional cuts and assembly of costumes

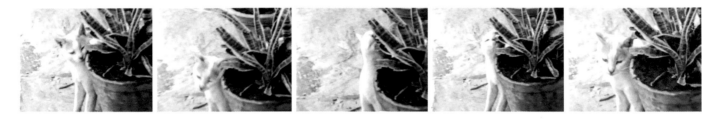

Traditional cut and assembly of a *gebba*

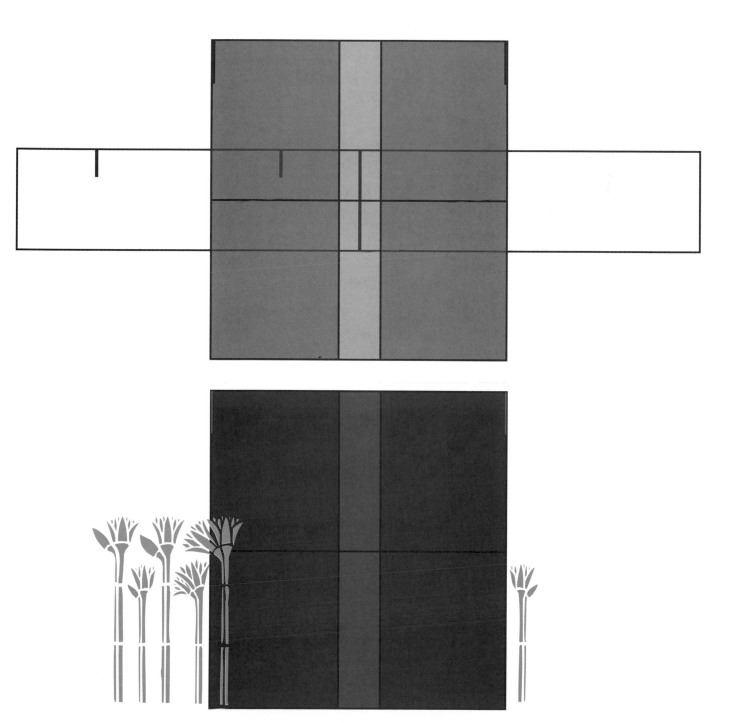

Traditional cut and assembly of a *gebba*

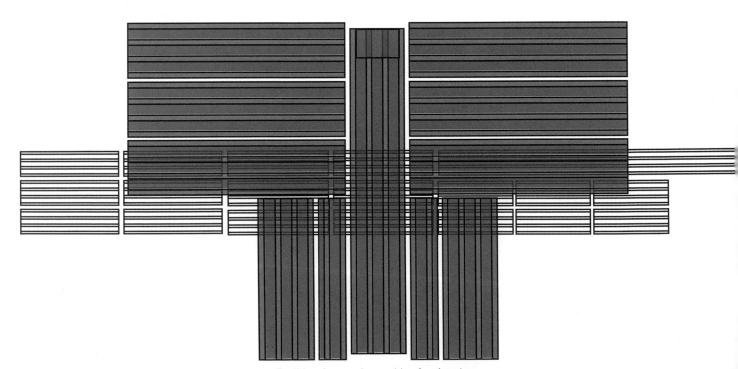

Traditional cut and assembly of a *siwa* dress

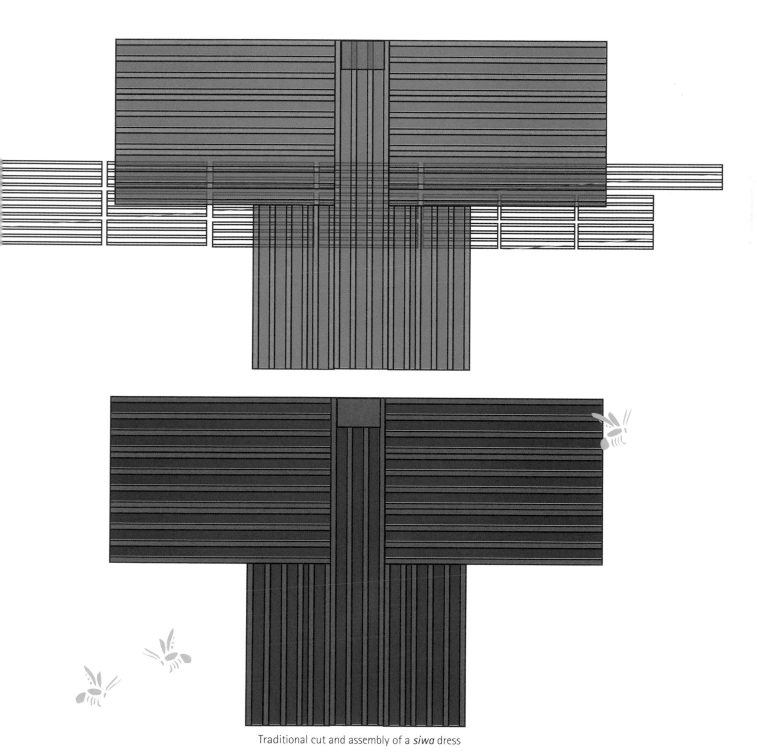

Traditional cut and assembly of a *siwa* dress

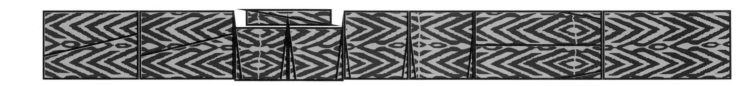

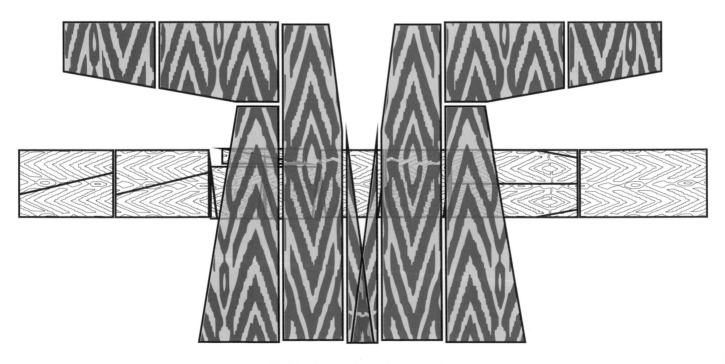

Traditional cut and assembly of a caftan

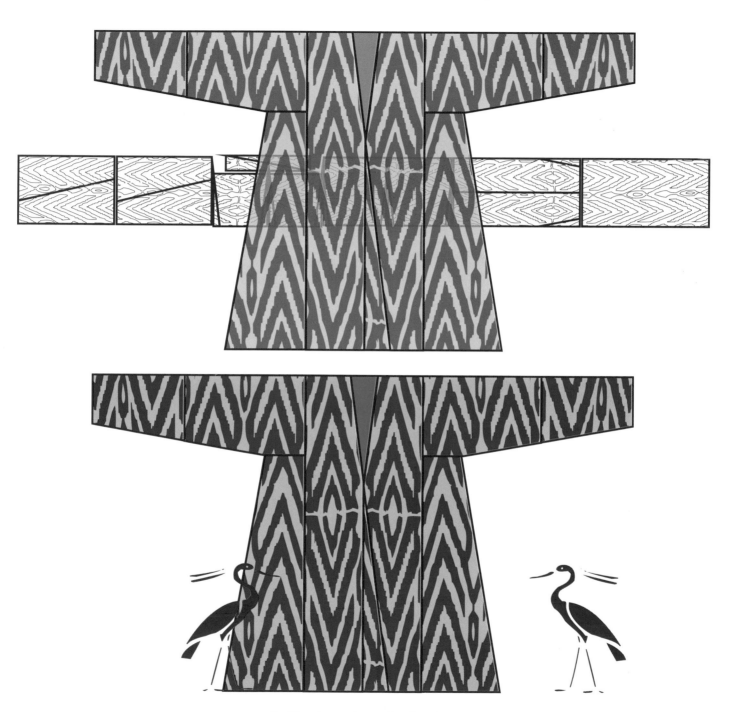

Traditional cut and assembly of a caftan

Contemporary Cairo, like so many cities of the Silk Road with their different histories, still has within its modern present the city built by the sophisticated Caliphates – a commercial and cultural metropolis.

Apart from the majestic Arabic calligraphy, geometrically divided patterns on walls, windows, carved wooden doors and marble courtyards follow the same mode of filling the space by repeating a pattern across a given surface, often according to the shape of a given space and the material used.

From the manuscripts of master calligraphers, to the marbled walls of the Taj Mahal, Moroccan ceramic walls, Syrian mother-of-pearl inlaid boxes, Ottoman embroideries and the marble courtyards of Cairo: all use similar patterns. Almost all comply with geometrical divisions, transmitted by master craftsmen from one generation to the next.

Cairo is full of these geometric patterns, but they can also be found in all cities where Arabs, Persians, Afghans, Indians and Ottomans, to name a few – who used Arabic script and its calligraphy – were patrons of the arts.

Cairo: A city of sophisticated patterns

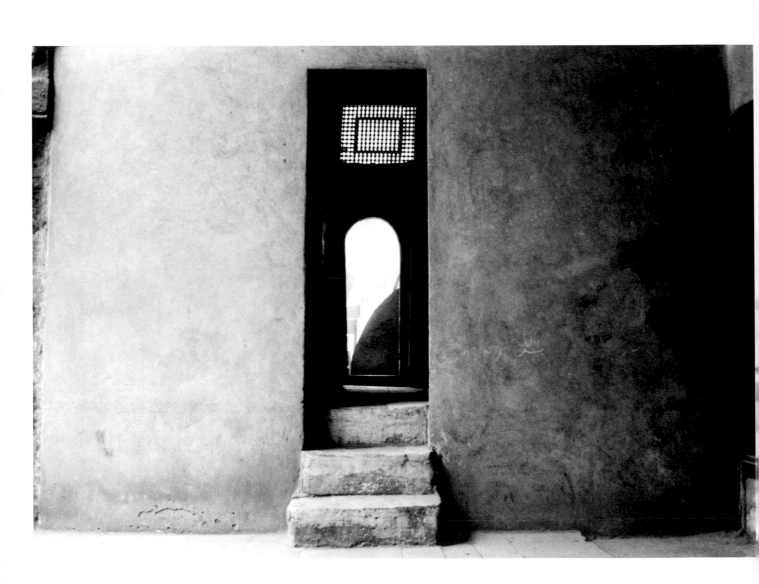

Doorway, house of Jamal ad-Din adh-Dhahabi

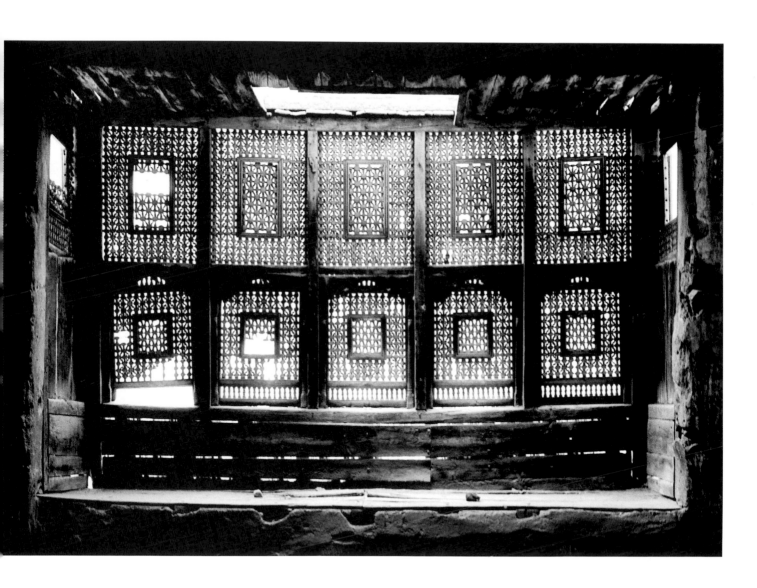

Mashrabiya, house of Ahmad Katkhuda ar-Razzaz

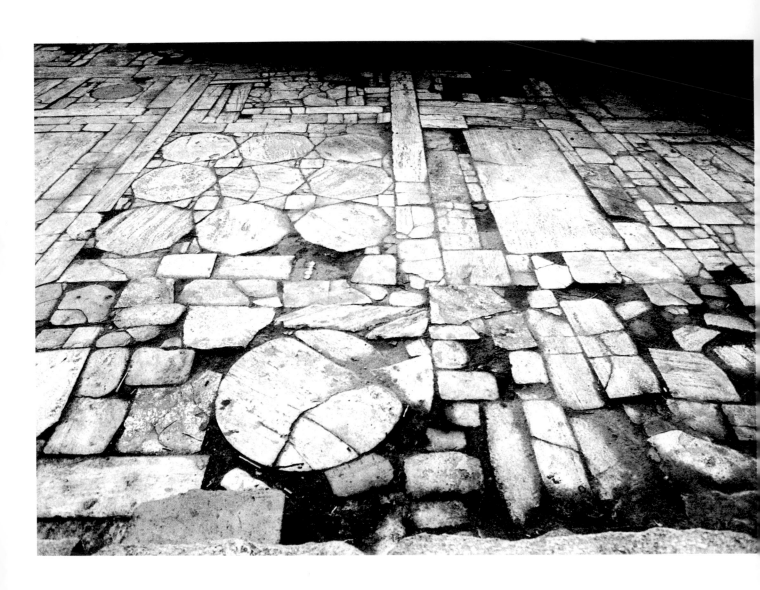

Courtyard, Khanqah Shaykhu

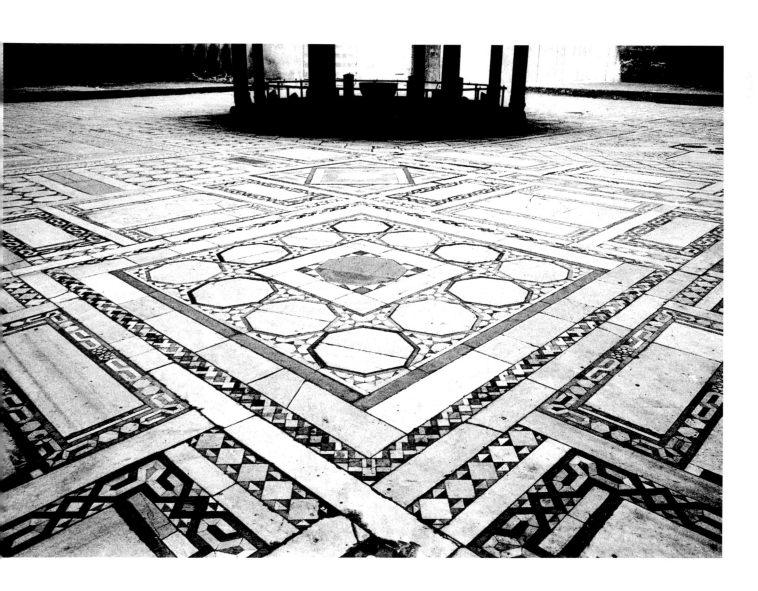

Courtyard, Mosque of Sultan Hassan

Carved wood blocks in a given pattern are used in Aleppo to handprint huge pieces of textile, usually cotton.

Patterns are drawn, then traced and transferred on wood, marble, textile and metal.

The patterns shown here are from glazed bricks on a wall in Khiva, a painted ceiling from Deir el-Bahri temple, an appliqué caftan from Bukhara, and from a magazine ad for Nasr television in the 1960s.

They have in common the repetition of a single element to form a continuous pattern, evenly spaced.

Colour depends on the material itself, whether it be marble, wood or mother of pearl.

The various colours of the external calligraphy and patterns of the Taj Mahal are set into the striking polished white marble background.

A pattern, its repetition and its colouring

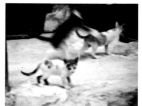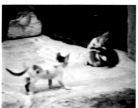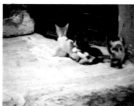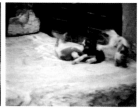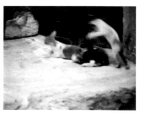

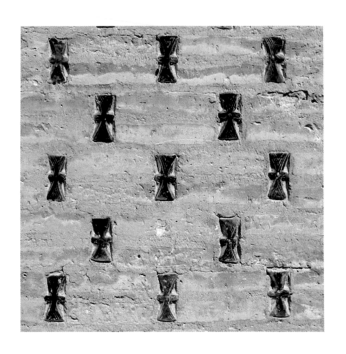

Top left: Maiolica, Khiva

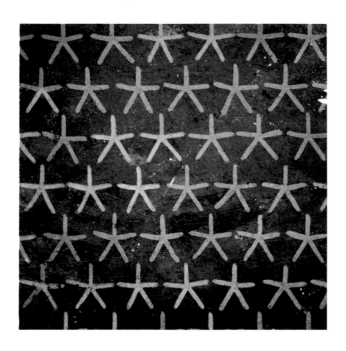

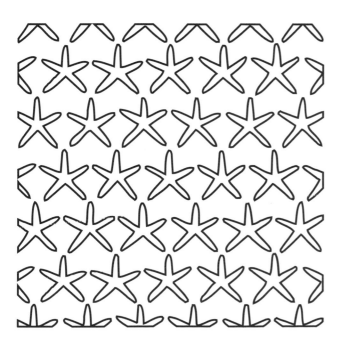

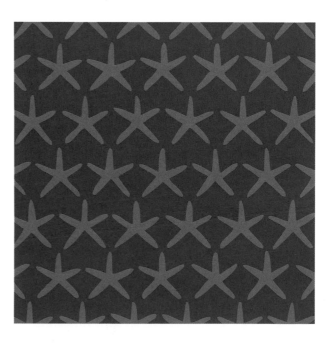

Top left: Ceiling of Anubis shrine, Temple of Queen Hatshepsut at Deir el-Bahri

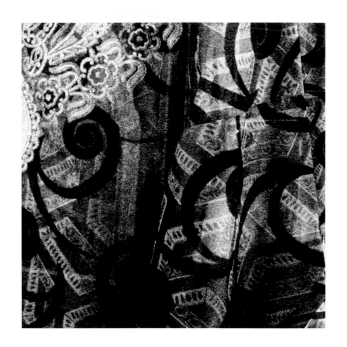

Top left: Bukhara caftan, Tamerlane Museum, Tashkent

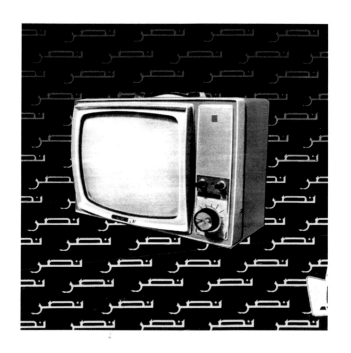

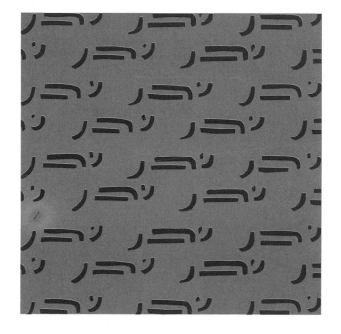

Top left: Nasr television, Egyptian magazine advert, 1960s

With the advent of print and then photography and television, visual reproductions of real events and real people became widely available.

Burning the image of a king or a president in public could result in harsh reprimands.

During nationalistic speeches, some leaders use huge photos of themselves or men often safely dead, such as national heroes, to portray seriousness and continuity of power to their public.

Some even govern by transforming themselves into virtual digital images to appear to their assembled public, replacing the classical 'balcony speech scene' with huge TV screens while they give their speeches from some secret secure location.

Any two-dimensional image seen from the side is nothing more than a few millimetres thick, yet despite not being real, and being merely an illusion, painted, digital or printed images have a very powerful impact.

The three images used here are from three stories in the Egyptian media. The stories are about young girls being trained to become maids, a king adored by his people, and new life thanks to a dam. They are divided into different shapes, thus separated into individual patterns, then reassembled to form a story.

Selective division of images into several
shapes and their reassembling and colouring

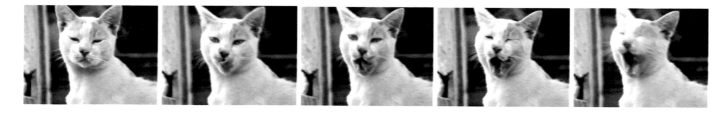

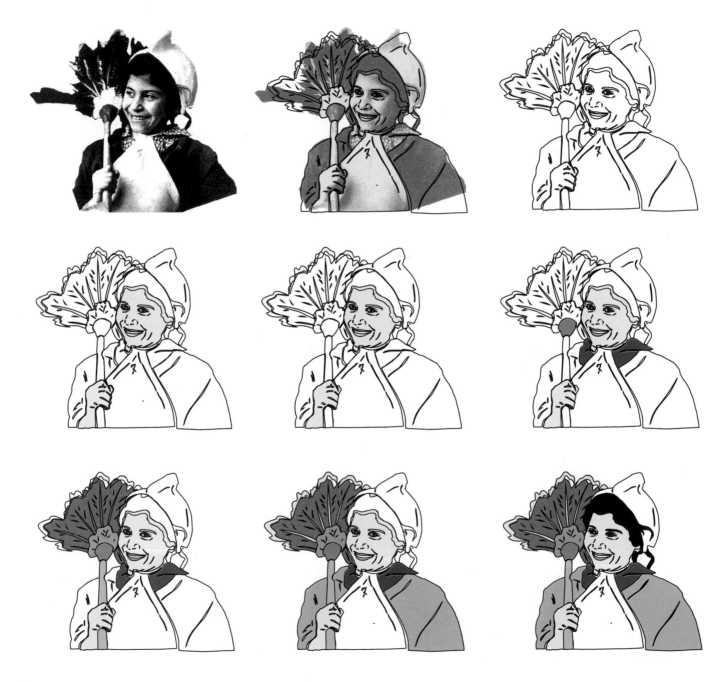

Selection of shapes and progress of colouring

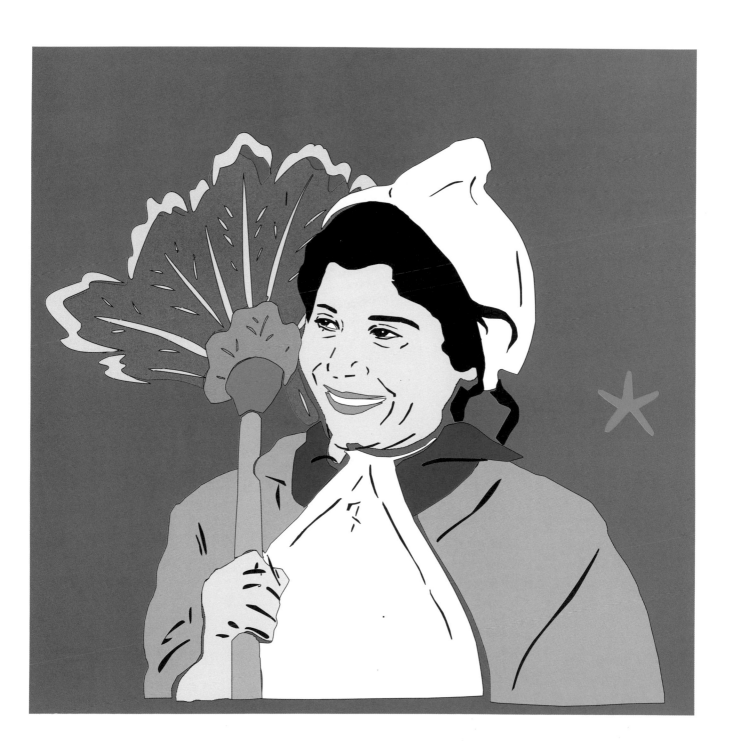

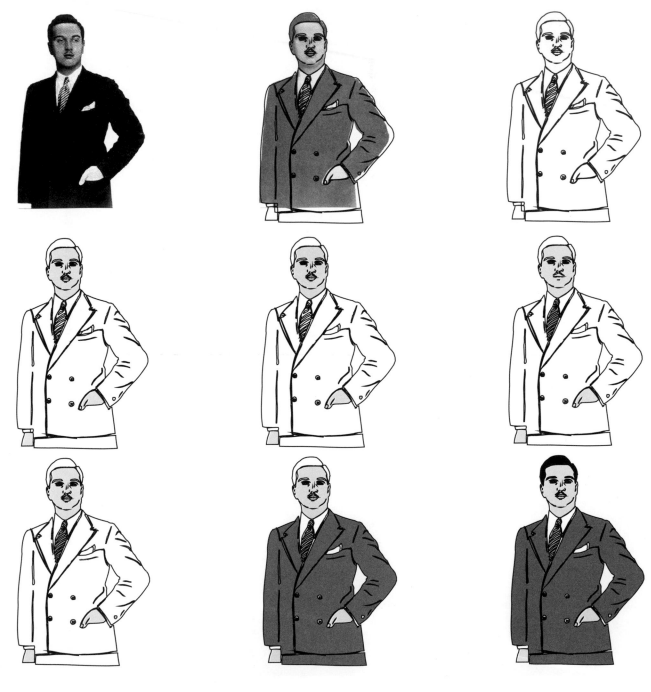

Selection of shapes and progress of colouring

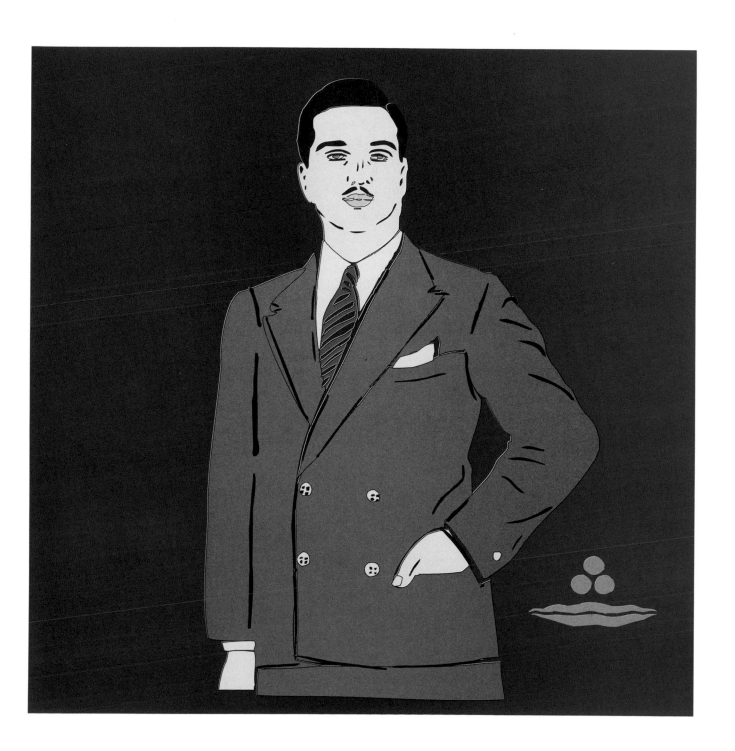

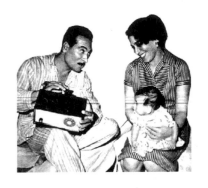

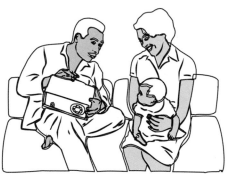
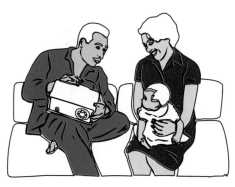
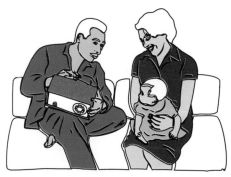
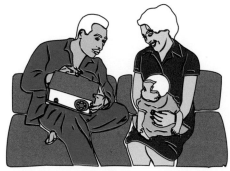
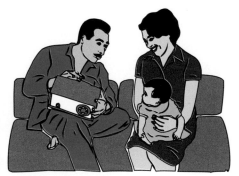

Selection of shapes and progress of colouring

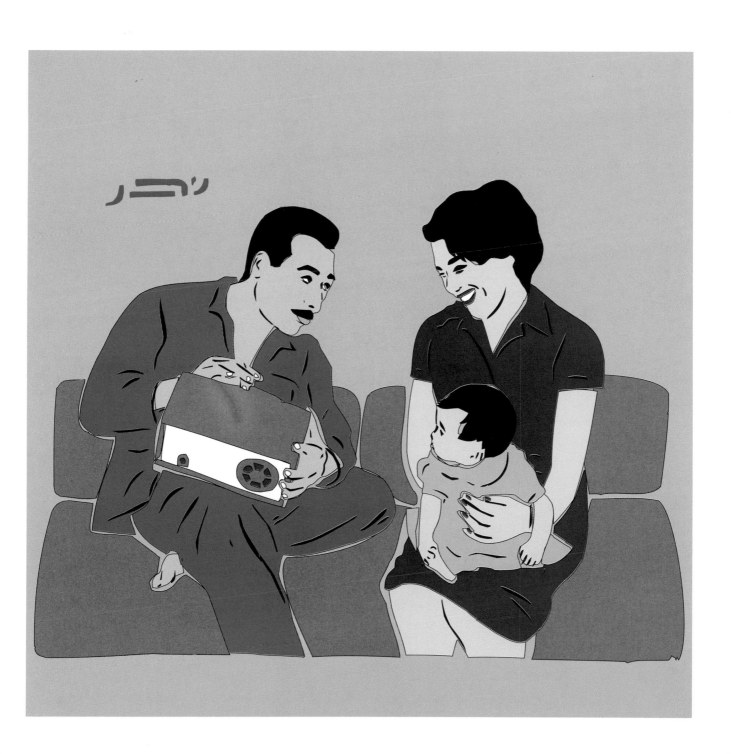

Recreating an image in stencil is a process similar to printing, which involves assembling given forms like a brick wall or a patchwork to create a pattern. This is very far removed from the 'drawing from nature' of the realistic schools of art.

The original images used here to create the stencils had been created by several people: photographers, editors and propagandists who invented stories for a given purpose.

Flags, soldiers, titles, background texts or blown-up images of political symbols are all there to convey the seriousness of the message that should get through, but they all are just a few millimetres of decoration, made up of pigments, digital or otherwise.

The stencils realized from these photos have preserved the original texts or titles of articles in the newspapers, which at the time were almost sacred but in fact, and with the distance of time, reveal more about the imagination of their creators/ inventors than about the factual, objective reality.

These images today tell stories not just about what they depict, but also about the kind of people who constructed the images to convey a specific message and their intentions.

Stencils from images created by
propaganda committees and the state media

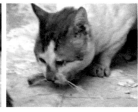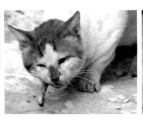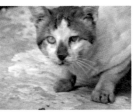

Hayat, 1960s

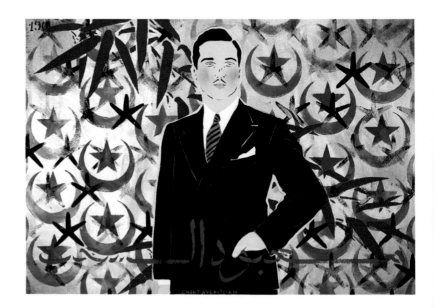

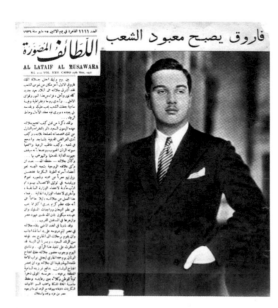

The adored of the people, 1930s

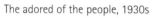

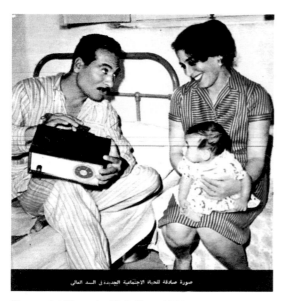

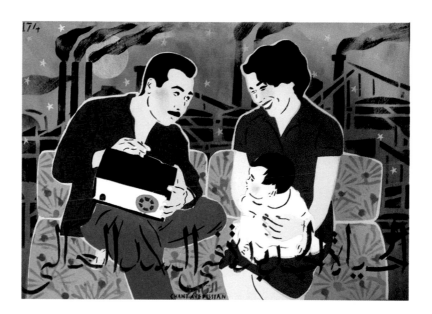

New social life at the High Dam, 1960s

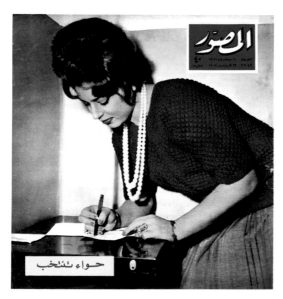

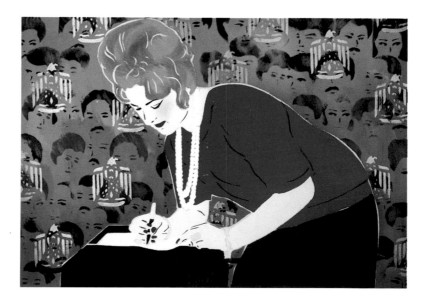

Eve votes, 1960s

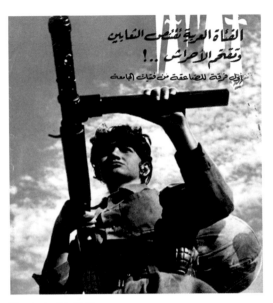

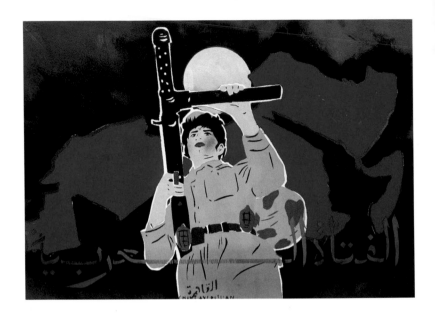

The Arab girl, 1960s

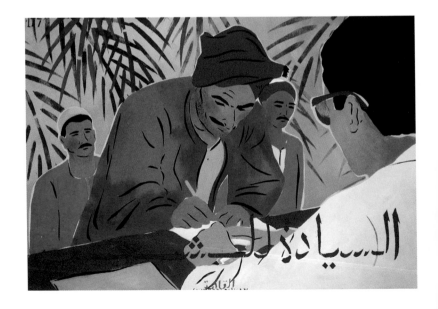

Power to the people, 1960s

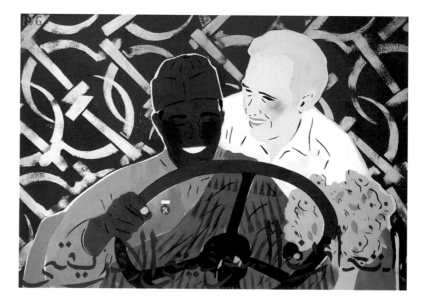

Military training, 1960s

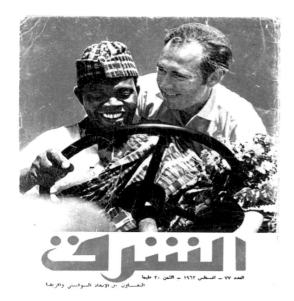

African and Soviet cooperation, 1960s

Soviet astronaut Tovarishch Yuri Alekseyevich Gagarin was seen in Egyptian magazines meeting president Gamal Abdel Nasser and his family. He visited Egypt during the years of the construction of the High Dam of Aswan, the 'Eighth wonder of the world' according to Soviet propaganda. Former Soviet Premier Nikita Sergeyevitch Khrushchev travelled in 1964 to Aswan for the opening of the first stage of the High Dam to celebrate the inauguration of a period of prosperity and electrification that the dam was going to bring to Egypt, again according to Soviet propaganda.

The four stencils that follow represent Gagarin, that northern astronaut who visited Egypt at the time of the 'close cooperation' between the revolutionary Egypt and 'the Soviet brother'; Sayyid Jamal al-Din al-Afghani, a revolutionary intellectual and a modernist who fought Colonialism with his teachings and writings during the Ottoman Empire and the British colonial presence in Egypt; HRH Princess Fawzia Fouad, the exceptionally beautiful Egyptian princess whose brother, King Farouk, was the last descendant of Mohamed Ali's dynasty who ruled Egypt, a monarchy abolished by the Free Officers Movement under Muhammad Naguib; and the late president Gamal Abdel Nasser on the next page.

These images taken from magazines represent the era they lived through; they are stencilled for that purpose.

Stencils

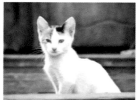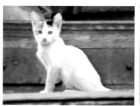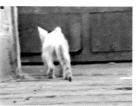

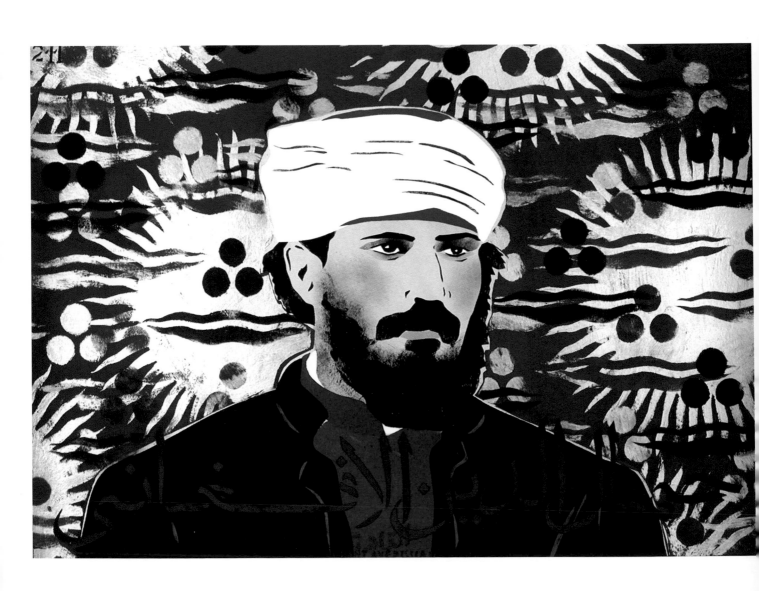

Sayyid Jamal al-Din al-Afghani

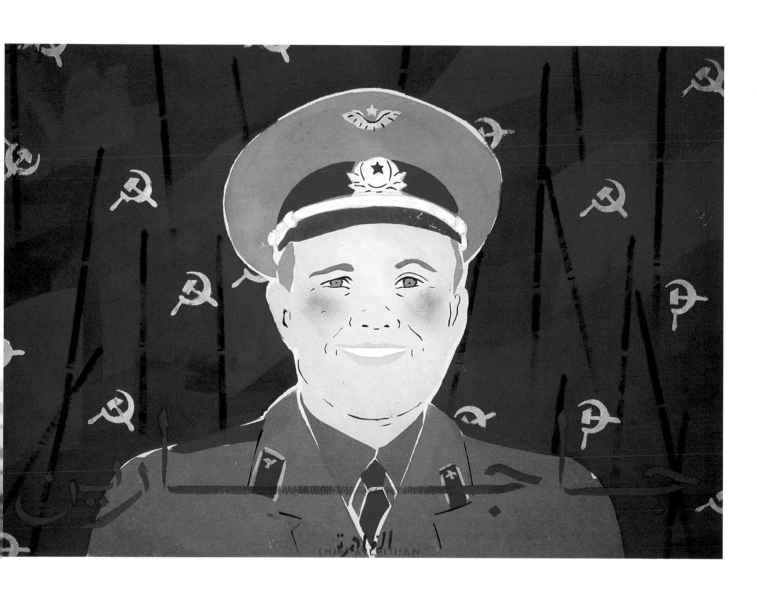

Tovarish'ch Yuri Alekseyevich Gagarin

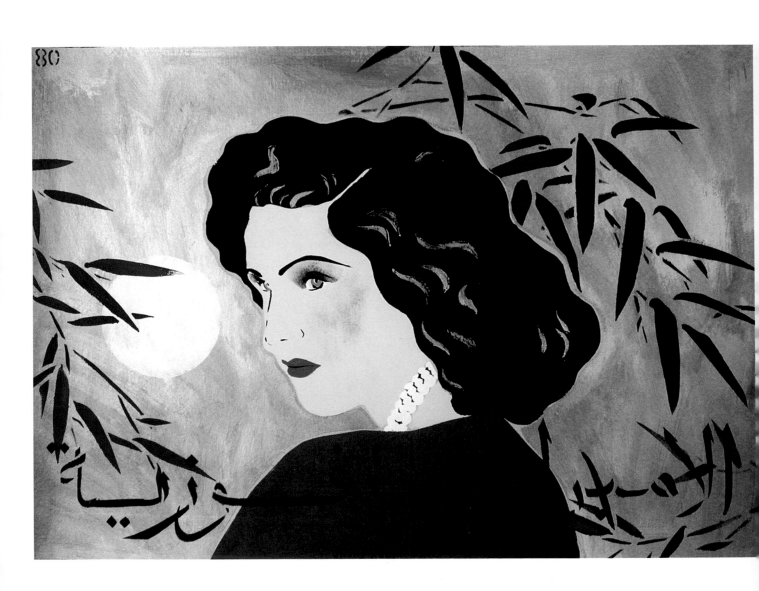

HRH Princess Fawzia Fouad

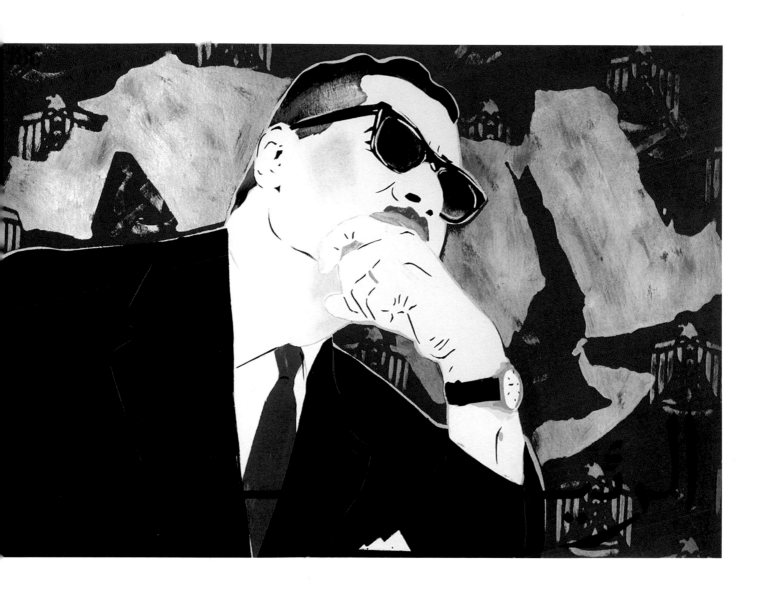

President Gamal Abdel Nasser

Like the painted walls of ancient temples, the panels assemble different stencils to tell a story.

On the panel called *Colonial*, the stencils address development, technical assistance, colonial tourism, and the backing of dictators who would protect all these interests. In the background there are hints about the slave trade, which has existed since times immemorial.

The two alphabets are on a background of Egyptian insects, which were documented along with fish, birds, stones, monuments and even human beings during the military invasion of Egypt by French colonial armies at the end of the eighteenth century, which in some circles is still mentioned as 'The Discovery of Egypt'.

Additional panels tell other stories with different themes.

Stencils assembled to form triptych panels

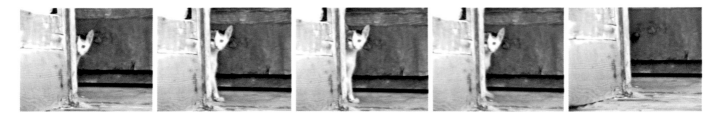

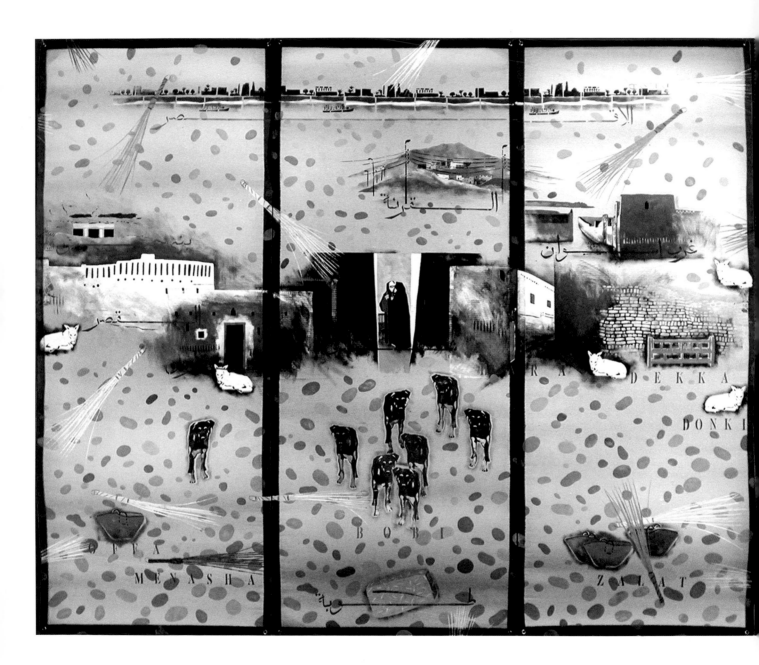

Rural

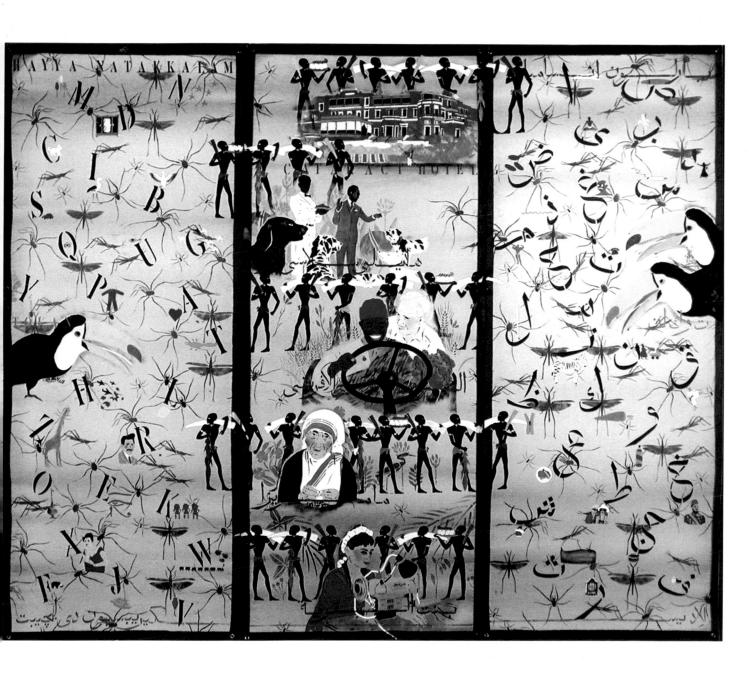

Colonial

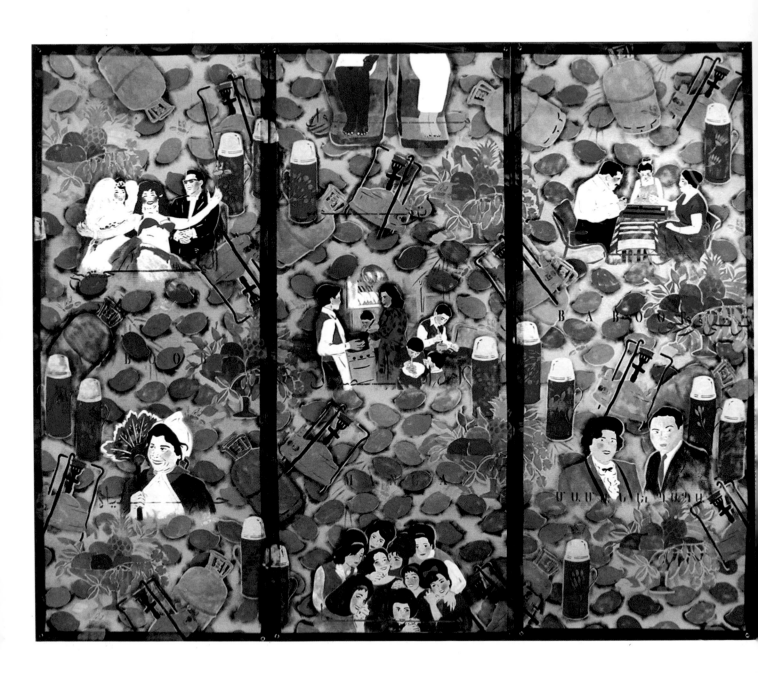

Social

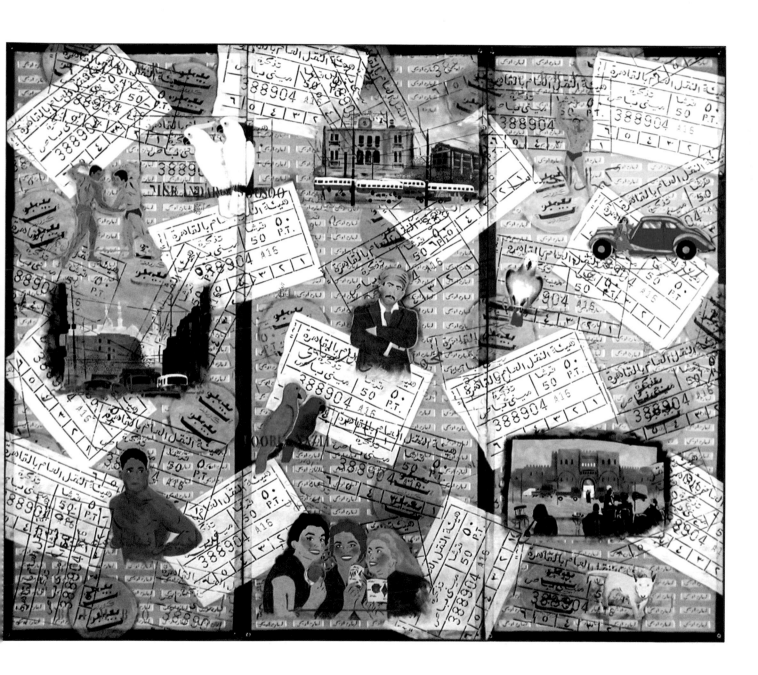

Urban

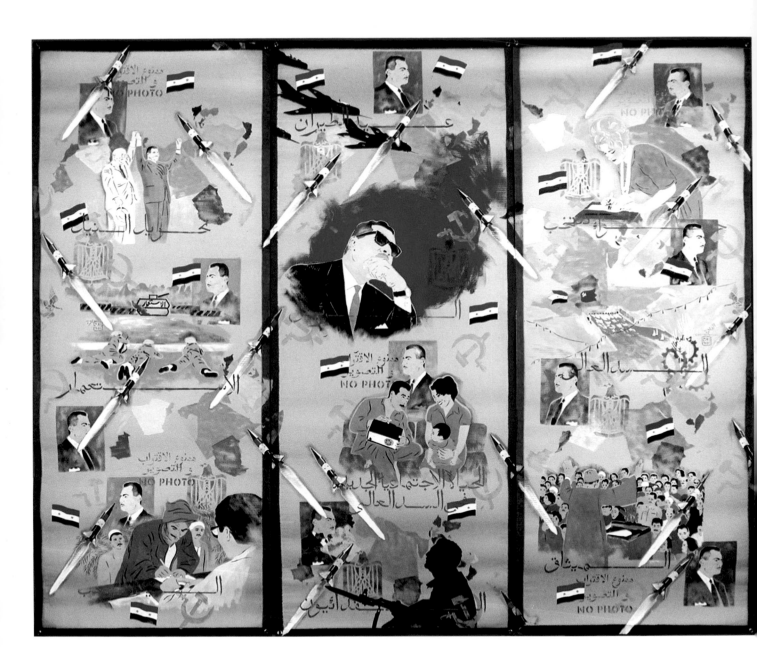

Socialism

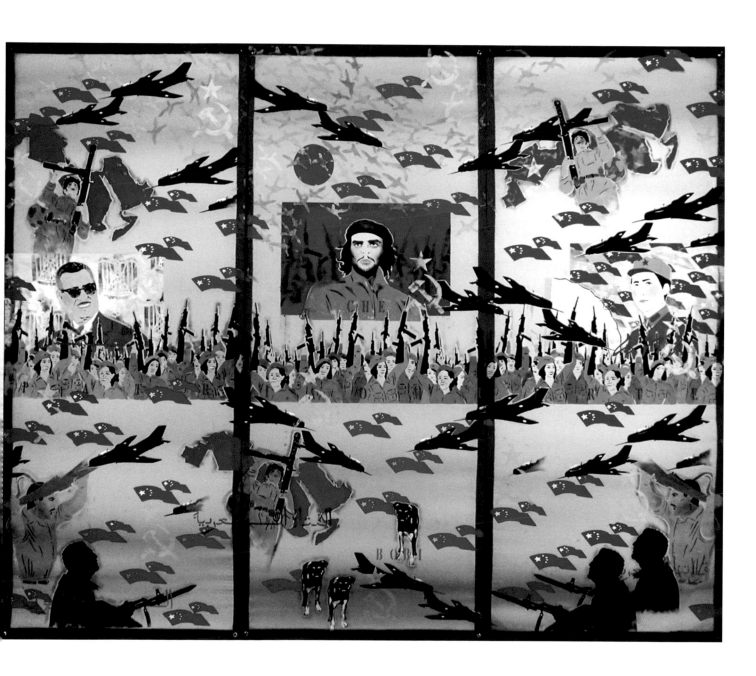

Revolutionary

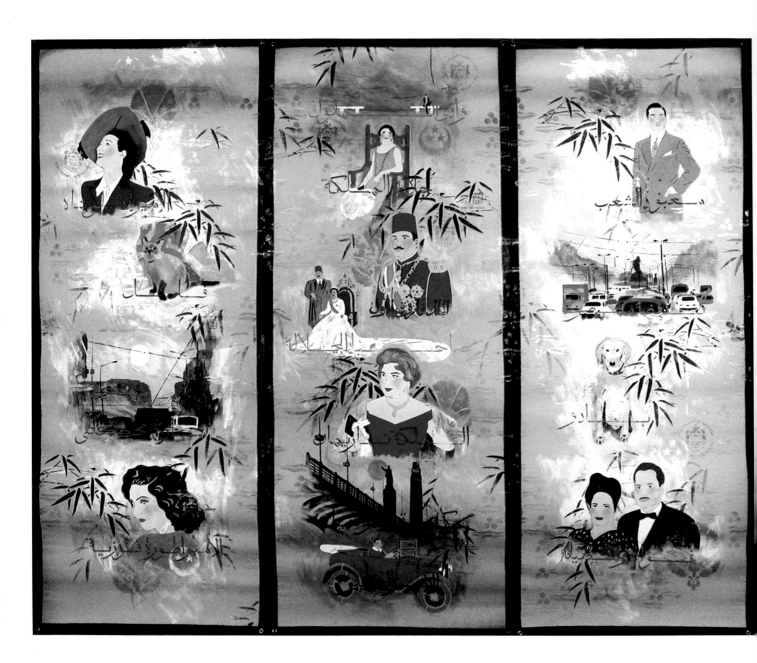

Royal

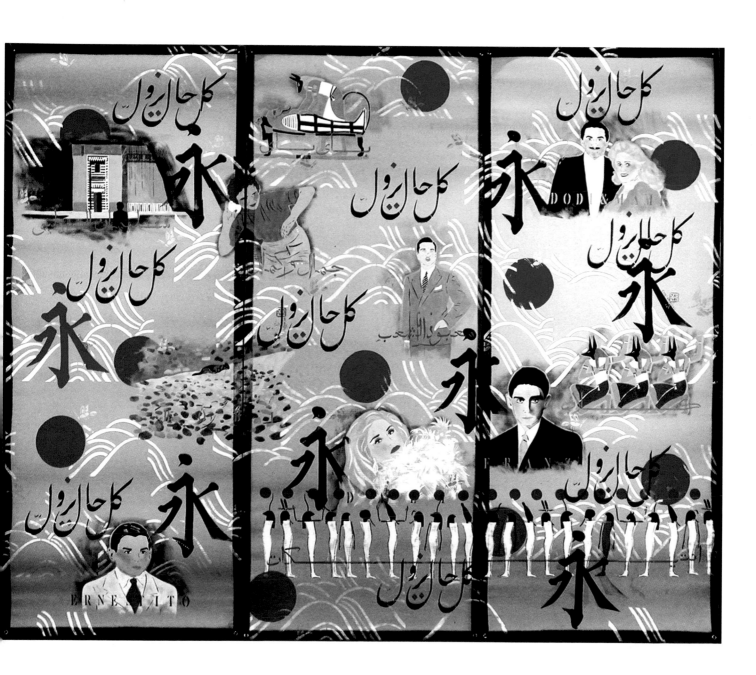

And all shall pass

There is a thread that links all the cities of the Silk Road.

Jaisalmer resembles parts of Cairo, and old Delhi reminds one of Aleppo. Links of manners and forms are found all along that road.

Various cities have the same covered streets, their markets sell almost the same everyday objects, their buyers and sellers have almost identical manners and customs.

This cultural thread causes the closure of a weaver's shop in Aleppo to be felt in Cairo and the foundation of a calligraphy school in Kashgar to have an impact in Fez.

The richness of dialogue and therefore of learning, from cultures which have different styles but preserve the same strokes in their calligraphy, is a very different unifying phenomena from the closing or opening of an international fast food chain.

It is through my encounters with master artisans or their disciples in their workshops, or their work in markets, that I discovered another way of working which has a different approach to learning than that of traditional western art schools' drawing techniques.

Sources, masters and places

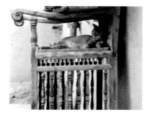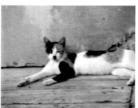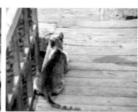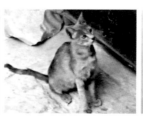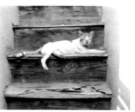

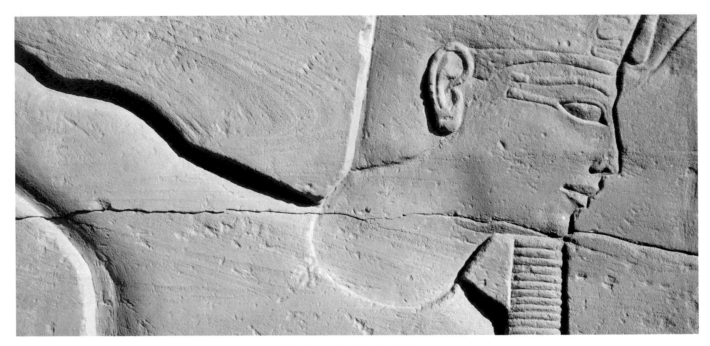

Karnak temples, East Bank, Luxor

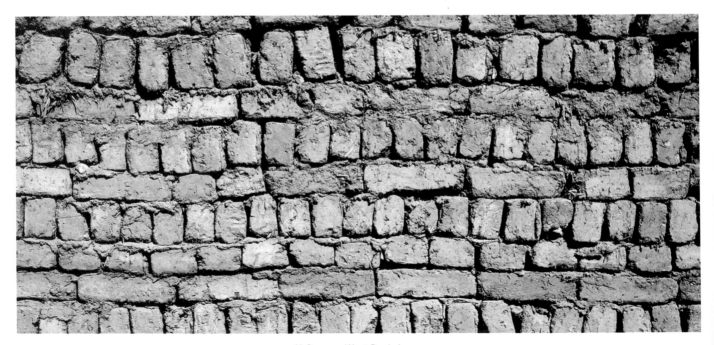

Al Gourna, West Bank, Luxor

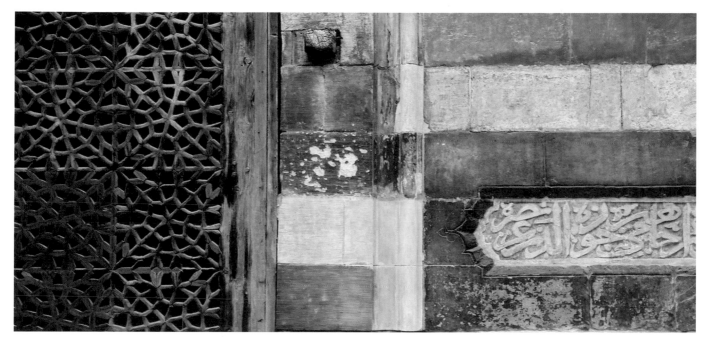

Madrasa Umm al-Sultan Sha'ban, Cairo

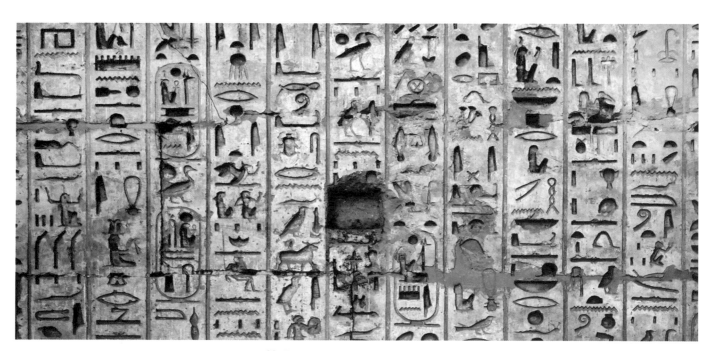

Madinat Habu Temple, West Bank, Luxor

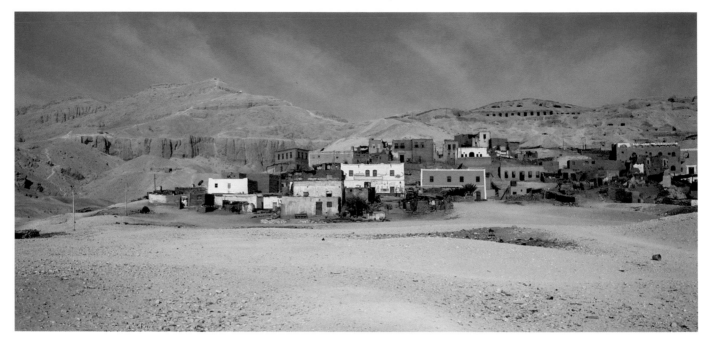

Gourna al-Gebel, West Bank, Luxor

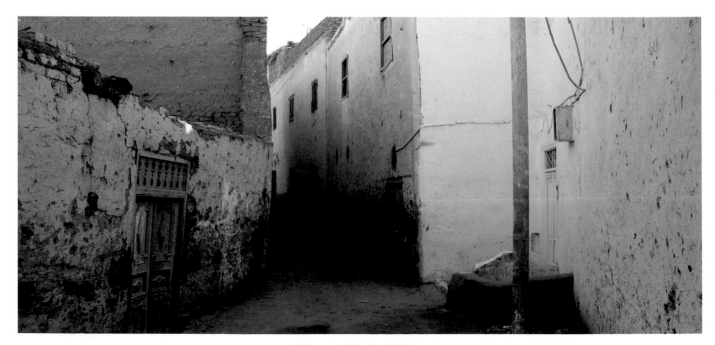

Al Gourna, West Bank, Luxor

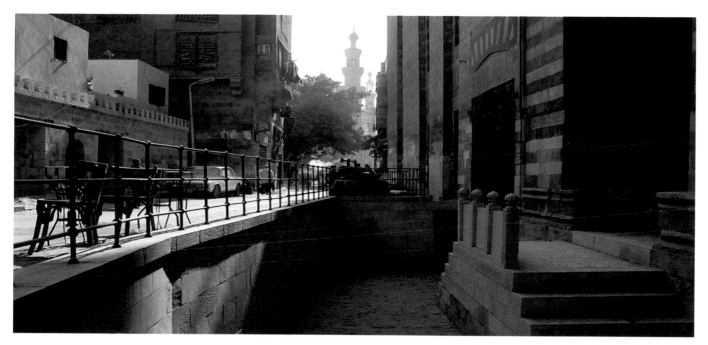

Bab al-Wazir street, Cairo

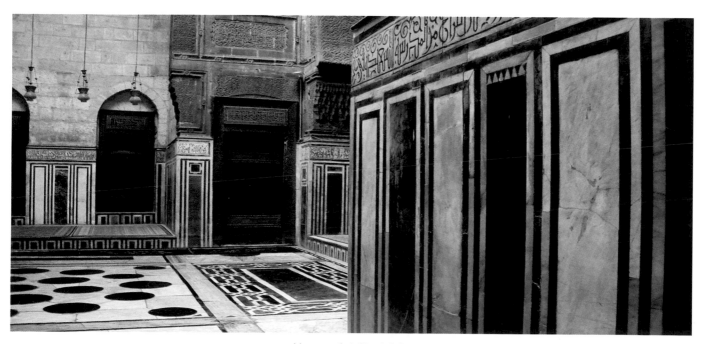

Mosque of al-Ghuri, Cairo

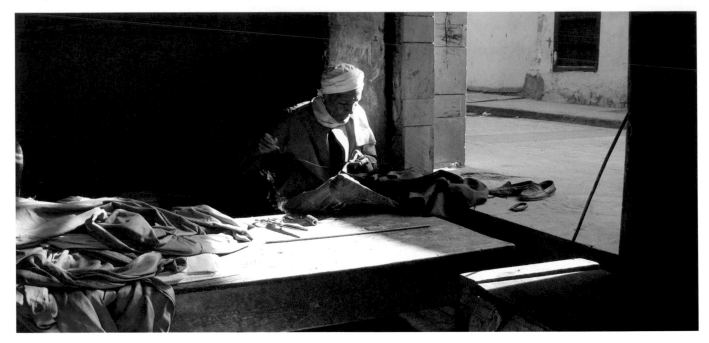

Farouk Fahmi al-Sharif, East Bank, Luxor

House of Jamal ad-Din adh-Dhahabi, Cairo

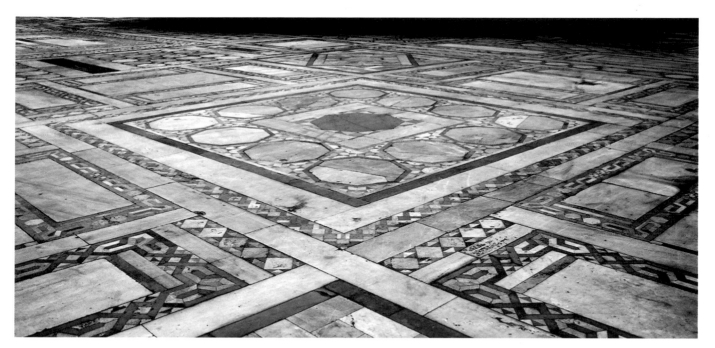

Mosque of Sultan Hassan, Cairo

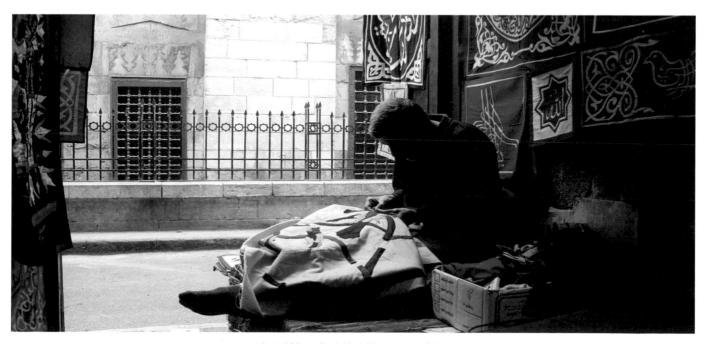

Jamal Mustafa al-Lissi, Khayameya, Cairo

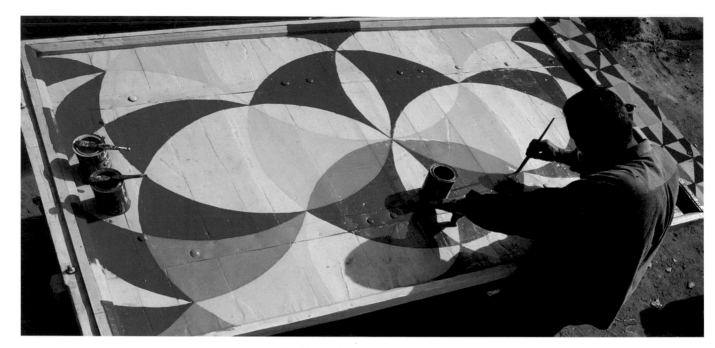

Hag Hassan Abbas, Gamaleya, Cairo

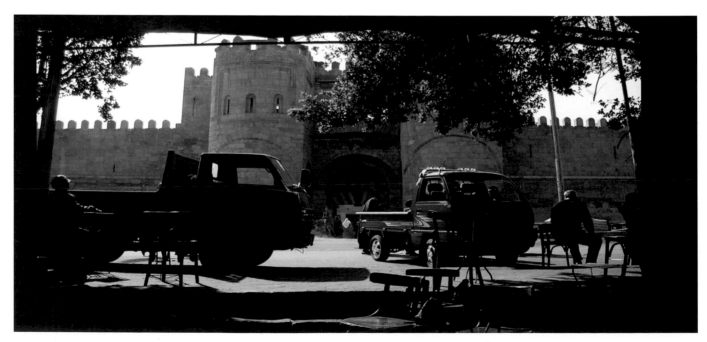

Bab al-Futuh, Cairo

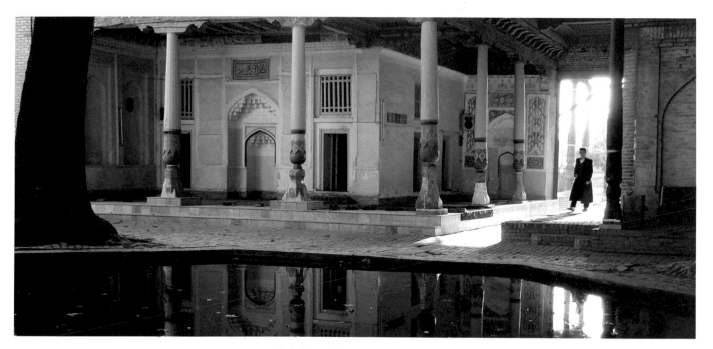

Abdi-Darun Mausoleum, Samarkand

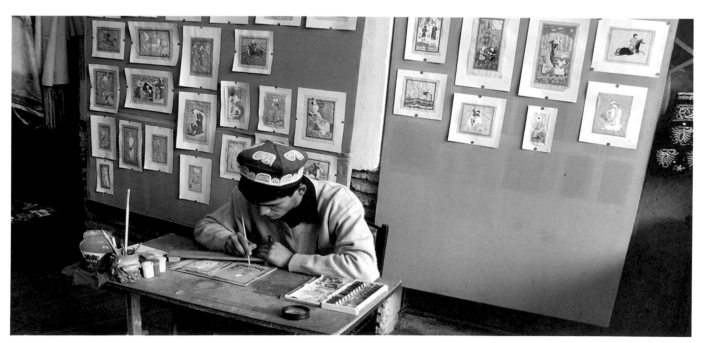

Zakhr Ul-Din, Bukhara

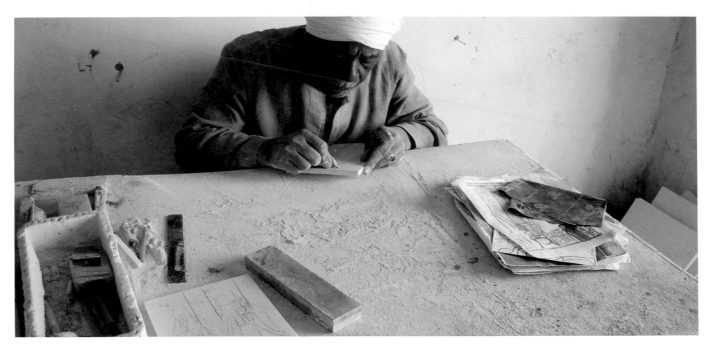

Al-Tayeb Metawee Ibrahim, West Bank, Luxor

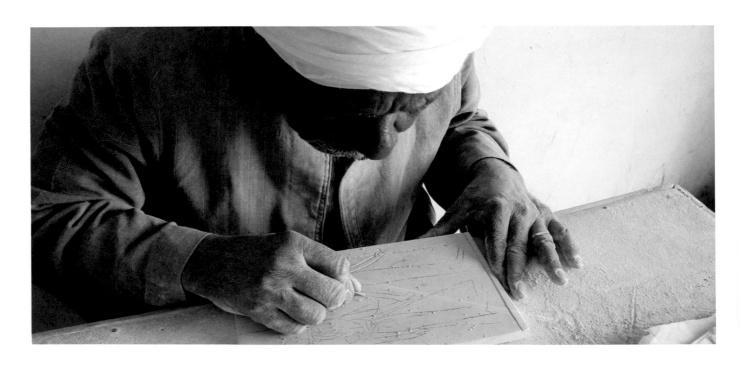

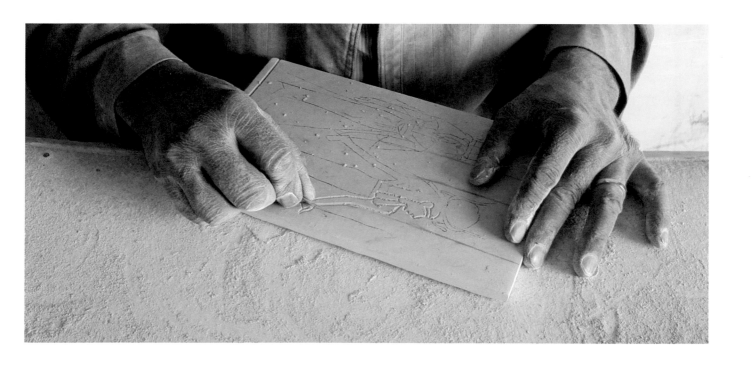

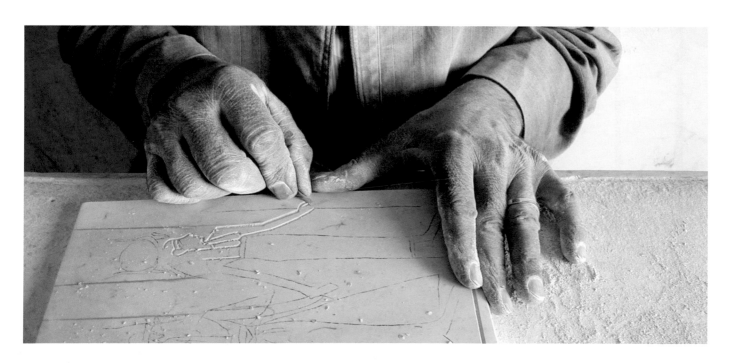

Profession, profit, trade are what we've burnt;

Song, poetry, and verse are what we've learnt;

We've given heart and soul and sight to love

And heart and soul and sight are what we've earnt.

Rumi

All the images of the cats in this book are from a home video that I prepared in 1988 for the late architect Hassan Fathy, about his cats, while since 1981 assisting him in filing his papers.

It's partly out of gratitude and partly as an homage to Hassan Fathy that these photos are included here. I know he would have liked them, as while watching that home video he made endearing comments about his cherished cats, which were fed lovingly and ceremoniously three times daily by his housekeeper sett Karima.

After the viewing Hassan bey said, 'All is fine, the music, the cats and the décor.'

For Hassan Fathy

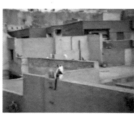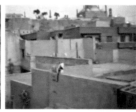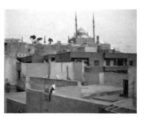

A few years ago, I was watching a TV programme in one of the many western Asian colonies of the former Soviet Empire. The programme was about the importance of reading the labels on food products before buying them, for self-protection and consumer awareness.

The young Asian woman who was presenting this programme and who is from one of the most unique Caucasian cultures, after giving all sorts of advice about reading expiry dates, composition of ingredients, contacting the authorities about expired products, etc., concluded her educational speech by saying that we should comply with all her advice, and added:

'Either we are going to become civilized Europe or remain the bazaars of Asia.'

I am disagreeably amazed by this mode of thinking, this self-imposed colonial mentality that constantly, and without any critical spirit, considers Europe as civilized, apparently versus uncivilized Asia and always casts non-Europeans in a negative light.

It is the result of long years of colonial mechanism and its aftermath that people living in the heart of the Caucasus still think and act as if they are the far-away Europeans, or take their sources and ideals from what is happening in far-away Europe, while sometimes denigrating their own Asian culture.

Despite the near impossibility of travel in the Middle East and some parts of Asia today due to recurrent wars, it is in the 'bazaars of Asia' that I personally found much inspiration and discovered much of what represents 'civilization'.

A museum of ethnographic museums should be created, in which non-Russians and non-Europeans could show how Russians and Europeans presented them in books, movies, objects, photographic archives and scholarly studies.

Culture, like humans, develops by dialogue during encounter, by learning from one another, and grows together by enriching each other. No culture can develop by building walls around itself, even if the walls are continuously maintained.

Epilogue

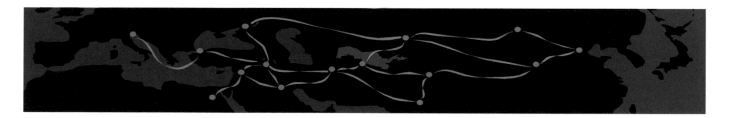

All drawings and photos by the author except:

Page 9 – Roads to the western oases, from Map of Egypt, printed and published by the Survey of Egypt, Giza, 1948.

Page 67 – Al-Mu'izz Street, Cairo, from Map of Cairo monuments, printed and published by the Survey of Egypt, Giza, 1950.

Page 121 – With the kind permission of Dick Davis, from *Borrowed Ware: Medieval Persian Epigrams*, Anvil Press Poetry, 1996, p. 97.

Acknowledgments

My thanks to André Gaspard who supported and encouraged this book and to Lara Frankena for her support and assistance with the text.

This book is a companion to a previous book, *Cairo Stencils*. I am grateful to Rose Issa, who had the idea and is the author of *Cairo Stencils*, and Dr Anwar M. Gargash, who was instrumental in bringing *Cairo Stencils* to life.

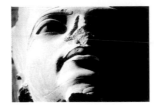

10–13 Scans from black and white negatives, 1975/1980

16–19 Digital photographs, 2006

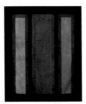

28–35 Hand-dyed cotton, 1985

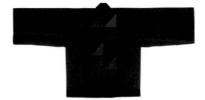

44–49 Hand-dyed cotton, 1988

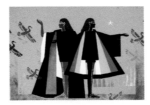

52–55 Pigments on recycled cardboard, 45 x 35 cm, 1990

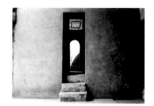

68–71 Scans from black and white negatives, 1975/1980

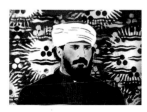

94–97 Pigments on recycled cardboard, 50 x 70 cm, 1991/1998

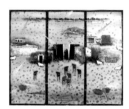

100–107 Pigments on corrugated cardboard, 250 x 300 cm, 1999

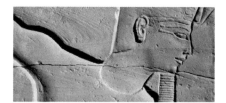

110–119 Digital photographs, 2007

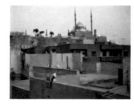

All series digital transfers from video, 1988

Debbie Brown's

50
Easy Party Cakes

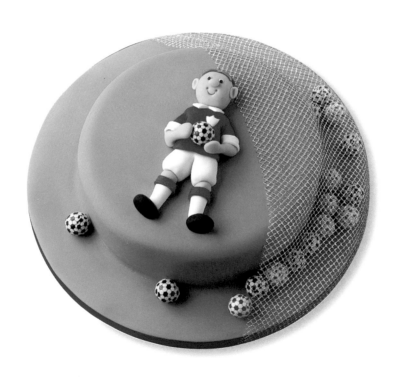

MEREHURST

contents

introduction

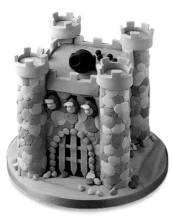

Young boys will enjoy the 'castle guards' cake (above), see page 70. Teenage girls, meanwhile, will appreciate 'shopping frenzy' (above right), see page 42.

Each child is unique in their likes and dislikes; some are enthusiastic about dinosaurs and dragons, others are unable to go anywhere without their favourite teddy in tow. Even tiny children have their favourite subjects, such as boats, cars and tractors. Having three children of my own and coming from a family bursting at the seams with little ones, I know the sorts of things children adore.

In this book, I have put together a collection of cakes that are all exceptionally easy to make and require minimum equipment. Many of the designs are aimed at small children, who love simplified images like the 'toy boat' and 'cute chick'. Other designs will be firm favourites of older children, even teenagers. I have to dedicate 'shopping frenzy' to my daughter, Laura, as she drags me out to the shops all too frequently. The 'camping out' cake made me nostalgic for the time when Lewis, my eldest son, was mad on having garden sleepovers – if only because it was a brilliant excuse for raiding the larder. When my younger son, Shaun, saw the 'castle guards' cake finished, I knew what request I would get for his next birthday!

All children love the idea of 'camping out' in the garden (below), see page 54.

Birthdays are terribly important to children, so I feel that any effort to make their day as special as possible is not wasted. One of the best moments in my cake-making career has to be the sight of a child's face lighting up with wonder and excitement when they see their very own special birthday cake. The little time involved in making it is worth every minute.

4

equipment

The cakes featured in this book require the minimum of equipment. A **large rolling pin** and **sharp knife** are essential tools. A **sugar shaker** filled with icing/confectioners' sugar is recommended, as are **cocktail sticks**/toothpicks, which are ideal for indenting small details and handy for applying food colouring to the sugarpaste/rolled fondant. Also have to hand a **fine paintbrush**, a **bone modelling tool** and a **small rolling pin**. A smooth, washable kitchen work surface is ideal to work on or, if you prefer, **non-stick work boards** can be obtained in many sizes. Some of the other tools I have used in this book are detailed below. They are all available from cake decorating suppliers and will make useful additions to your workbox.

CAKE SMOOTHER

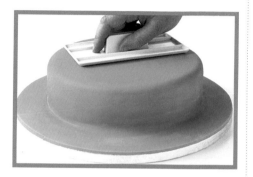

Used to create a smooth surface on sugarpaste. Different types of smoother are available, but the most useful is a cake smoother with a handle incorporated. Smooth the cake smoother over the sugarpaste in a circular motion to remove bumps and to level out an uneven surface.

CRIMPING TOOL

Using a crimping tool is a simple way to add texture and pattern to sugarpaste. The crimping tool pinches up sugarpaste between the pinchers at the end of the tool. Lines are pinched horizontally, letting the serrated teeth scratch vertical lines. First practise on a spare piece of sugarpaste.

PLUNGER CUTTERS

Flowers can be cut quickly using a blossom plunger cutter. Roll out the sugarpaste quite thinly, making sure that it is not sticking to the work surface. Press the cutter down into the sugarpaste and lift out. Rub your finger over the bottom of the cutter to remove excess and ensure a clean shape.

basic recipes

MADEIRA SPONGE CAKE

The secret of successful cake decorating is to use a firm, moist cake that can be cut and shaped without crumbling. Madeira cake is a good choice and can be flavoured for variety. To make a Madeira cake follow the steps below. For the ingredients and bakeware required, see pages 8–9.

1 Preheat the oven to 160°C/325°F/Gas 3, then grease and line the bakeware.

2 Sift the self-raising and the plain/all-purpose flour together in a bowl.

3 Put the soft margarine and caster/superfine sugar in a large mixing bowl, and beat until the mixture is pale and fluffy.

4 Add the eggs to the mixture, one at a time with a spoonful of the flour, beating well after each addition. Add any flavouring required (see panel on right).

5 Using a large spoon, fold the remaining flour into the mixture.

6 Spoon the mixture into the bakeware, then make a dip in the top of the mixture with the back of the spoon.

7 Bake in the centre of the oven until a skewer inserted in the centre comes out clean (see pages 8–9 for cooking times).

8 Leave to cool for 5 minutes, then turn out on to a wire rack and leave to cool completely. When cold, store in an airtight container until ready to use.

Madeira cake flavourings

Vanilla Add 1 teaspoon vanilla essence/extract to every 6-egg mixture.

Lemon Add the grated rind and/or the juice of 1 lemon to every 6-egg mixture.

Chocolate Add 2–3 tablespoons unsweetened cocoa powder mixed with 1 tablespoon milk to every 6-egg mixture.

Almond Add 1 teaspoon almond essence/extract and 2–3 tablespoons ground almonds to every 6-egg mixture.

friendly frog

Pop a crown on his head and he is Prince Charming in disguise

MATERIALS
- 1 x 2 litre (4 pint/10 cup) & 1 x 0.5 litre (1 pint/2½ cup) bowl-shaped cakes, see page 9
- 30cm (12in) round cake board
- icing/confectioners' sugar in a sugar shaker
- 1.9kg (3lb 13oz) sugarpaste/ rolled fondant
- green, black & yellow food colouring pastes
- 375g (12oz/1½ cups) buttercream
- sugar glue
- dark green edible dusting powder/ petal dust/blossom tint

EQUIPMENT
- large rolling pin
- sharp knife
- cake smoother
- medium paintbrush

USEFUL TIP
When covering the frog's head and body you will be left with unwanted pleats of green sugarpaste. To get rid of these pleats, either carefully stretch them out and smooth them down, or cut the pleats away and smooth the joins closed. Use the cake smoother to ensure a perfect finish.

1 Colour 375g (12oz) of the sugarpaste a muddy green using green food colouring mixed with a touch of black. Using icing sugar to prevent sticking, roll out and cover the cake board completely, trimming excess from around the edge, then put aside to dry. Trim the crust from each cake and slice the tops flat. Turn each cake upside down. Trim the sides of the small bowl-shaped cake to create a dip for the neck. Cut a layer in the large cake and sandwich with buttercream. Sandwich the cakes together, then spread with buttercream.

2 Colour 1.5kg (3lb) of the sugarpaste green. Using 45g (1½oz), pad the face as in the photograph below. Press with your finger to indent each eye socket. Roll out 1kg (2lb) of green sugarpaste and cover the top of the cake, smoothing the sugarpaste over the frog's head and body. Carefully position the cake on the centre of the cake board. Use a cake smoother to smooth the surface. Use the back of the knife to mark the mouth, indenting each corner and the nostrils with the end of the paintbrush.

3 Roll a ball with 7g (¼oz) of green sugarpaste and cut it in half to make the frog's eyelids. Colour 7g (¼oz) of the sugarpaste yellow and a small amount black. Roll two tiny yellow balls and press flat for the highlights, then roll the remaining yellow into a ball and cut it in half to make the eyes. Roll the black into a ball and press flat, then divide it to make the pupils. Assemble in the eye sockets using sugar glue to secure.

4 To make the frog's arms and hands, split a 155g (5oz) piece of green sugarpaste in half and roll two thick sausages, then round off at each end. Slightly flatten one rounded end of each sausage and make a cut in the centre with a sharp knife. Cut again on either side of the central cut, then smooth the sugarpaste to round off. Press the end of the paintbrush between each to separate and make fingers.

5 Split 220g (7oz) of green sugarpaste into two thick sausages to make the legs. Keep the centre of each sausage slightly thicker than the ends. Bend them in half and stick them together with sugar glue, then stick in place on the cake. Using the remaining green sugarpaste, make two feet in the same style as the hands. Leave the cake to dry, then carefully dust circles over the back of the frog using the dark green dusting powder.

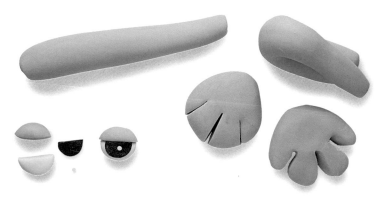

Sugarpaste shapes for the frog's eyes, arms and legs.

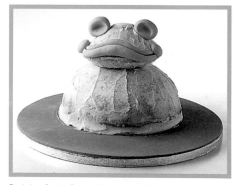

Pad the frog's face with pieces of green sugarpaste.

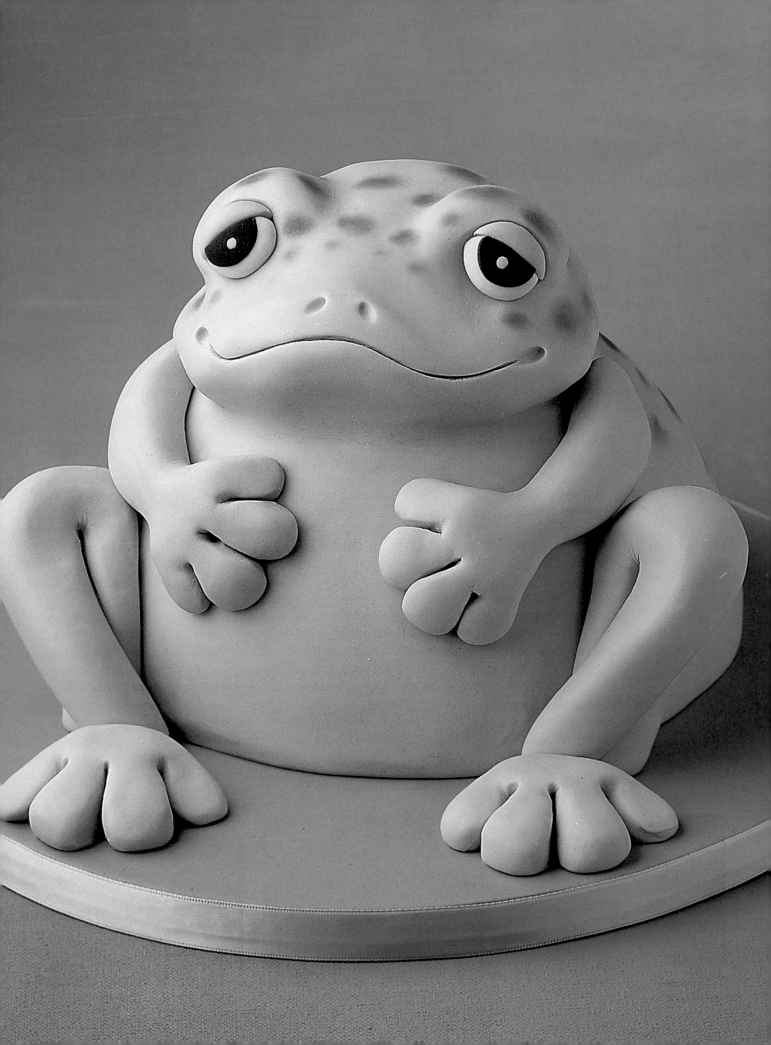

abc book

Parents will try almost anything to encourage little ones to learn their abc

MATERIALS

- 25cm (10in) square cake, see page 8
- 30cm (12in) square cake board
- 200g (6½oz/¾ cup) buttercream
- 1.25kg (2½lb) sugarpaste/ rolled fondant
- icing/confectioners' sugar in a sugar shaker
- green, yellow, brown, orange & black food colouring pastes
- sugar glue
- black food colouring pen

EQUIPMENT

- wrapping paper
- non-toxic glue stick
- scissors
- sharp knife
- large rolling pin
- sheet of greaseproof paper/ wax baking paper
- cocktail stick/toothpick
- bone tool
- 2.5cm (1in) circle cutter

USEFUL TIP

You can use foam pieces to support the modelled fruit in their poses and remove when dry.

1 Cover the cake board with alphabet-patterned wrapping paper (see page 7), securing it with the glue stick. Trim the crust from the cake and slice the top flat with a sharp knife. Trim the centre to create a dip for the book fold and trim the outer edges to slope down. Spread the cake with buttercream to help the sugarpaste stick.

2 Using icing sugar to prevent sticking, roll out white sugarpaste and cover the sides of the cake first, marking the pages with a knife. Cover the top of the cake, trimming excess from around the edge. Cut a piece of greaseproof paper to protect the underside of the cake and position on the centre of the cake board with the cake on top.

3 To create the apple, first colour 125g (4oz) of sugarpaste green. Put aside 7g (¼oz), then roll the remaining green sugarpaste into a ball and indent the top by pressing in with a cocktail stick and rolling it around. Indent eye sockets using the small end of a bone tool and mark the smile with the circle cutter. Make the nose, then model arms with rounded hands and stick in position with sugar glue. Colour 60g (2oz) of sugarpaste black. Using white and black, shape tiny balls of sugarpaste for the eyes.

4 For the banana, first colour 125g (4oz) of sugarpaste pale yellow and 7g (¼oz) brown. Put aside 7g (¼oz) of yellow sugarpaste, then roll the remaining into a sausage tapering at either end and bend it half way. Make the face, nose and arms as for the apple. Shape small, flattened pieces of brown sugarpaste for the top and bottom of the banana.

5 For the carrot, colour 60g (2oz) of sugarpaste orange and roll into a long tapering teardrop shape, marking lines with a knife. Indent the top by pressing in a cocktail stick and rolling it around. Make the face, arms and nose as before. To make the carrot leaf, model a flattened oval shape using green sugarpaste, mark a centre vein with a cocktail stick, then roll the stick along the outer edges to thin and frill. Stick in place with sugar glue.

6 Roll the remaining black sugarpaste into neat, even sausages, and use to shape the letters. Stick the letters on the cake, using sugar glue to secure them in place.

Mark the pages of the book with a knife.

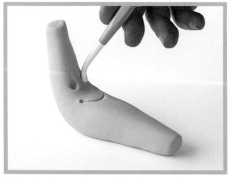
Indent the banana's eyes with a bone tool.

Use a knife to mark lines on the carrot.

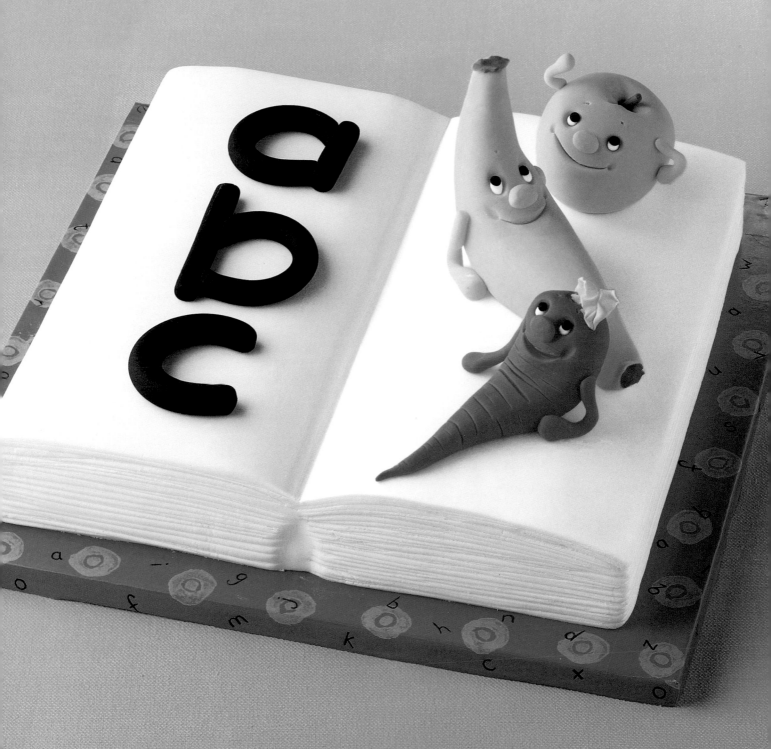

dressing up

All girls love dressing up – don't forget the feather boa and lots of pretty hats!

MATERIALS

- 20cm (8in) square cake, see page 8
- 30cm (12in) round cake board
- 1.25kg (2½lb) sugarpaste/rolled fondant
- blue, golden brown, mauve, green, pink & yellow food colouring pastes
- icing/confectioners' sugar in a sugar shaker
- 410g (13oz/1⅔ cups) buttercream
- sugar glue
- black food colouring pen

EQUIPMENT

- large rolling pin
- sharp knife
- ruler
- curved serrated crimping tool
- small circle cutter
- cocktail stick/toothpick
- small, pointed scissors
- blossom plunger cutter, see page 5

USEFUL TIP

If the buttercream has set before you have time to position the sugarpaste sides of the cake, simply add a little more buttercream, or rework the surface.

1 Colour 410g (13oz) of sugarpaste blue. Roll out 375g (12oz) and cover the cake board. Trim the crust from the cake and slice the top flat. Cut the cake in half and sandwich with buttercream. Spread a layer of buttercream over the cake, then position on the board.

2 Colour 500g (1lb) of sugarpaste golden brown. Using a ruler to measure exactly the size required, roll out and cut squares to fit the two ends of the dressing-up box. Crimp around the edge using the serrated crimping tool, then fill in with crimped lines. Carefully position the two ends on the cake. Cover the front and back in the same way.

3 Colour 45g (1½oz) of sugarpaste dark cream using a touch of golden brown food colouring. Roll a ball-shaped nose, then roll the remainder into a ball for the little girl's head. Indent a smile using the circle cutter pressed in at an angle, and dimple each corner using a cocktail stick. Stick the head in position on top of the cake.

4 Colour 125g (4oz) of sugarpaste mauve, 22g (¾oz) green, 60g (2oz) pink, 30g (1oz) cream and the remaining piece of yellow. Roll out some different coloured pieces and position on the cake around the girl's head, encouraging each piece to lie in folds. For the dress, smooth pleats with your fingers on a long, thick piece of mauve sugarpaste. Drape over the front of the basket, then push in the tip of a cocktail stick to mark the pattern.

5 For the hats, shape flattened circles, then top with a dome shape. Roll out and cut a strip for each hat band and stick in place crossing over at the back. Make pink flowers for a hat band for the white hat, using the blossom cutter. To make the bows, shape a bow and indent it in the centre to mark the tie, then indent the pleats using a cocktail stick.

6 To make the tassled scarf, cut a strip of blue sugarpaste, then make little cuts at each end, cutting downwards without pulling or the tassle will break. Create feather boas by rolling sausages of sugarpaste, then snipping up rows of little points using sharp scissors.

7 Roll three thin sausages with cream sugarpaste and plait them together for the girl's hair. Trim with a pink bow. When the cake is dry, draw the girl's eye using the black pen.

Sugarpaste shapes for a feather boa and hat.

Crimp the sides using a serrated crimping tool.

Position folds of coloured sugarpaste on the cake.

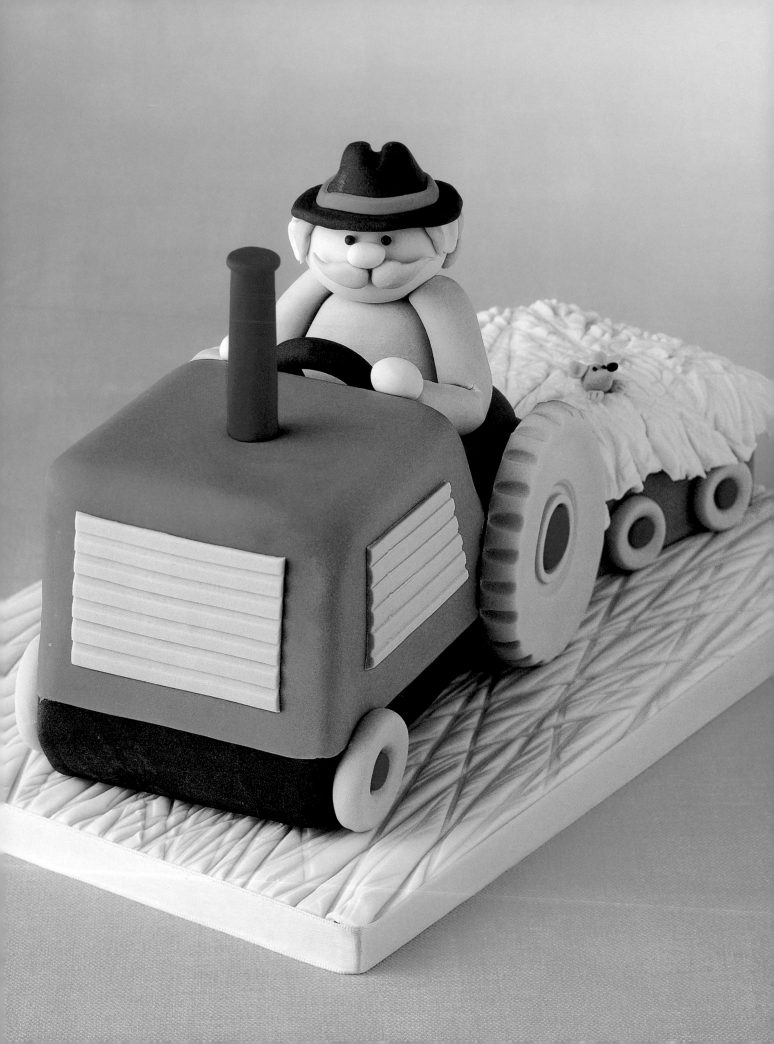

farm tractor

This farmer is ready to roll in from the fields and on to the birthday table

MATERIALS

- 18cm (7in) square cake, see page 8
- 30 x 20cm (12 x 8in) oblong cake board
- 1.75kg (3½lb) sugarpaste/ rolled fondant
- yellow, black, blue, flesh & red food colouring pastes
- icing/confectioners' sugar in a sugar shaker
- 375g (12oz/1½ cups) buttercream
- sugar glue

EQUIPMENT

- large rolling pin
- sharp knife
- ruler
- cocktail stick/toothpick
- 2.5cm (1in) & 3cm (1¼in) circle cutters
- templates, see page 109

USEFUL TIP

Instead of filling the farmer's trailer with yellow sugarpaste straw, you could pile on a few mini chocolate rolls or chocolate sticks to look like logs.

1 Colour 560g (1lb 2oz) of sugarpaste pale yellow. Using icing sugar to prevent sticking, roll out 440g (14oz) and cover the cake board. Press the edge of a ruler over the surface to indent and create a straw effect, then trim excess from around the edge.

2 Trim the crust from the cake and slice the top flat. Cut the cake exactly in half and put one half on top of the other. Cut the top layer in half and take one of the top pieces away. Trim a slope in the back of the piece left on the base. Cut the other piece of cake into an oblong shape for the trailer. Trim at an inward angle around the base of the tractor.

3 Sandwich the layers together using buttercream, then spread a thin layer of buttercream over the surface of each cake. Position the tractor on the cake board. Colour 250g (8oz) of sugarpaste black. Thinly roll out and cut a 2.5cm (1in) deep strip of black to fit around the base of the tractor. Carefully roll up, position the end against the base of the tractor, then wrap around the base, smoothing the join closed.

4 Colour 500g (1lb) of sugarpaste blue. Roll out 345g (11oz) and cover the top of the tractor. Smooth around the shape, then cut away around the base leaving the black strip showing. Roll out the remaining blue sugarpaste and cut pieces to cover all sides of the trailer, then position on the cake board. Roll out the remaining yellow sugarpaste and cut a square the same size as the trailer. Mark with a ruler to create a straw effect as before, stretching out the edges, then position on top of the trailer.

5 To make the farmer, first colour 315g (10oz) of sugarpaste grey and 60g (2oz) flesh. Model a fat teardrop for his body using 90g (3oz) of grey and stick to the tractor with sugar glue. Split a 30g (1oz) piece in half and roll two sausage-shaped arms. Bend each arm half way by pinching in at the elbow, then stick on the farmer's body. Roll 45g (1½oz) of flesh-coloured sugarpaste into a ball for the head, then with the remaining flesh model two ball-shaped hands, an oval nose and two oval ears. Press in the centre of each ear to flatten and stick in place. With 7g (¼oz) of grey sugarpaste, model two teardrop shapes for his moustache, then shape little pieces and stick over his head for the hair.

continued overleaf!

Sugarpaste shapes for the farmer.

Halve the top piece of cake to form the trailer.

Unravel the black strip around the base.

Cut pieces of blue sugarpaste to fit each side.

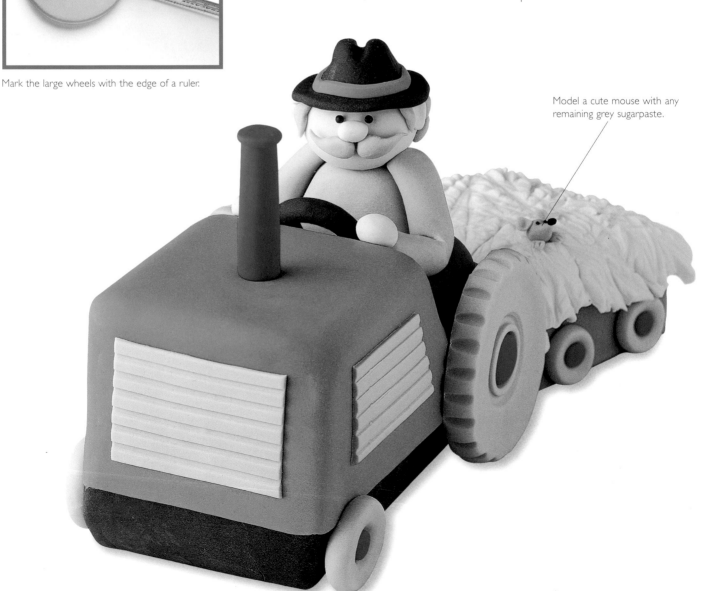

Mark the large wheels with the edge of a ruler.

6 Roll 7g (¼oz) of black sugarpaste into a sausage and loop around to make the steering wheel. With the remaining black, roll two tiny eyes, shape a circle measuring 5cm (2in) for the hat rim, then roll a ball and pinch either side for the top of the hat. Indent the hat at the top by pressing in with a cocktail stick. With some of the blue sugarpaste trimmings, roll out and cut the hat band.

7 Colour the remaining sugarpaste red. Using 22g (¾oz), roll a sausage and stick it around the base of the farmer for the tractor seat. With 7g (¼oz), roll a sausage for the funnel, cut both ends straight, then put aside to set for 10 minutes before sticking in place. To make the large tractor wheels, roll two balls from 125g (4oz) of grey sugarpaste. Flatten each ball, then mark the edges with the end of a ruler. Indent the centres of the wheels using the circle cutters, then put aside to set for 10 minutes.

8 With some of the remaining grey sugarpaste, make two small tractor wheels, pressing in the centre of each to indent, and the four trailer wheels. Then, using the templates (see page 109), cut out the grilles. Thinly roll out the grey sugarpaste trimmings and cut to size. Mark lines on the grilles with a ruler. With the remaining red sugarpaste, model flattened balls for the centres of the wheels and the top of the funnel.

Model a cute mouse with any remaining grey sugarpaste.

sporty spider

This cheeky spider is sure to pip other contenders to the birthday party table

MATERIALS

- 2 litre (4 pint/10 cup) bowl-shaped cake, see page 9
- 35cm (14in) round cake board
- 1kg (2lb) sugarpaste/rolled fondant
- green, yellow, black, blue & red food colouring pastes
- icing/confectioners' sugar in a sugar shaker
- sugar glue
- 185g (6oz/¾ cup) buttercream
- 140g (4½oz/½ cup) royal icing
- lengths of liquorice/licorice

EQUIPMENT

- large rolling pin
- sharp knife

1 Colour 500g (1lb) of sugarpaste green and 75g (2½oz) yellow. Roll out the green sugarpaste and cover the cake board, trimming excess from around the edge. Thinly roll out the yellow sugarpaste and cut two strips. Stick the strips on to the cake board with sugar glue, then put the board aside to dry. Trim the crust from the cake, keeping the rounded top where the cake has risen.

2 Turn the cake upside down and spread a layer of buttercream over the surface to help the sugarpaste stick. Colour 315g (10oz) of sugarpaste black, thinly roll out and cover the cake completely, smoothing around the shape and tucking the excess underneath. Press a length of liquorice into the surface to indent the spider's smile.

3 Colour the royal icing black. Spread the royal icing over the surface of the cake, covering a little at a time, and stipple by patting with the flat of a knife. Spread a little more royal icing on the top of the cake to create higher peaks.

4 Bend lengths of liquorice and push them into the cake to create the spider's legs. Stipple some more black royal icing around the top of the legs to hold them in place. Model white sugarpaste oval shapes for the running shoes and stick the ends of the liquorice into each shoe using sugar glue. Flatten two large white oval shapes for the eyes. Model two flattened circles for the pupils using the black trimmings. Colour the remaining sugarpaste red and blue. Thinly roll out and cut tiny strips for the running shoes, sticking in place with sugar glue.

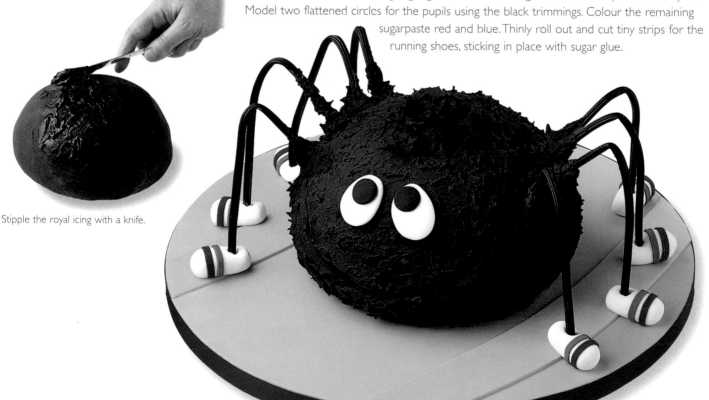

Stipple the royal icing with a knife.

playful kitten

A sweet kitten playing with a ball of wool makes an unusual but simple cake

MATERIALS
- 2 x 1 litre (2 pint/5 cup) bowl-shaped cakes, see page 8
- 25cm (10in) round cake board
- 1.75kg (3½lb) sugarpaste/ rolled fondant
- blue, pink & black food colouring pastes
- icing/confectioners' sugar in a sugar shaker
- 280g (9oz/1 generous cup) buttercream
- sugar glue

EQUIPMENT
- large rolling pin
- sharp knife
- small circle cutter

USEFUL TIP
To create a smooth, crack-free sausage shape, roll a small piece of paste into a ball, then gently roll over the work surface, stretching along the length. Don't press down too hard or you will flatten the sugarpaste. Use icing sugar to prevent sticking.

1 Colour 315g (10oz) of sugarpaste blue. Using icing sugar, roll out and cover the cake board completely. For a fabric effect, press the rolling pin on to the cake board surface to form indents, then trim excess sugarpaste from around the edge. Put aside to dry.

2 Trim the crust from each cake and slice the tops flat. Sandwich together with buttercream, then spread a thin layer over the surface to help the sugarpaste stick. Colour 1.25kg (2½lb) of sugarpaste pale pink. Using 500g (1lb), thinly roll out and cover the cake completely. Do not worry if the covering is untidy as this will be hidden later.

3 To make the strands of wool, roll long, thin sausages of sugarpaste and stick over the cake with sugar glue. Apply six or seven strands right across the top of the cake, from the bottom all the way round to the base at the other side. Cover the two remaining sides with diagonal strands which will leave a small triangular shape uncovered at the base. Cover this with vertical strands. Roll a few extra strands and stick them randomly over the cake.

4 Colour 155g (5oz) of sugarpaste black. Using 60g (2oz), roll a teardrop shape for the kitten's body. With 45g (1½oz), roll an oval shape for the head. Roll a thick sausage using 30g (1oz) and cut four short lengths for the legs. With the remaining black, make two triangular-shaped ears, two tiny flattened balls for the pupils and then roll a little pointed tail. Cut two small triangular shapes from the remaining pink sugarpaste to fill in each ear; also model a flattened ball for a collar and shape an oval nose.

5 With a little white sugarpaste, flatten a tiny ball for a muzzle and stick it on to the oval-shaped head. Using a knife, mark a line on the muzzle with a knife, then indent a smile using the circle cutter pressed in at an angle. Just above the muzzle, stick on two small flattened balls of white with two slightly smaller flattened balls of blue at the base, then finally secure the pupils made earlier. Stick the kitten's nose in place.

6 Assemble the kitten on top of the cake. Roll balls of white sugarpaste for the paws and stick in place with sugar glue. To finish, roll a final strand of wool using the last of the pink sugarpaste and stick in position draped around the kitten, falling on to the cake board.

Sugarpaste shapes for the kitten.

Cover with a thin layer of pink sugarpaste.

Stick strands of wool to the cake with sugar glue.

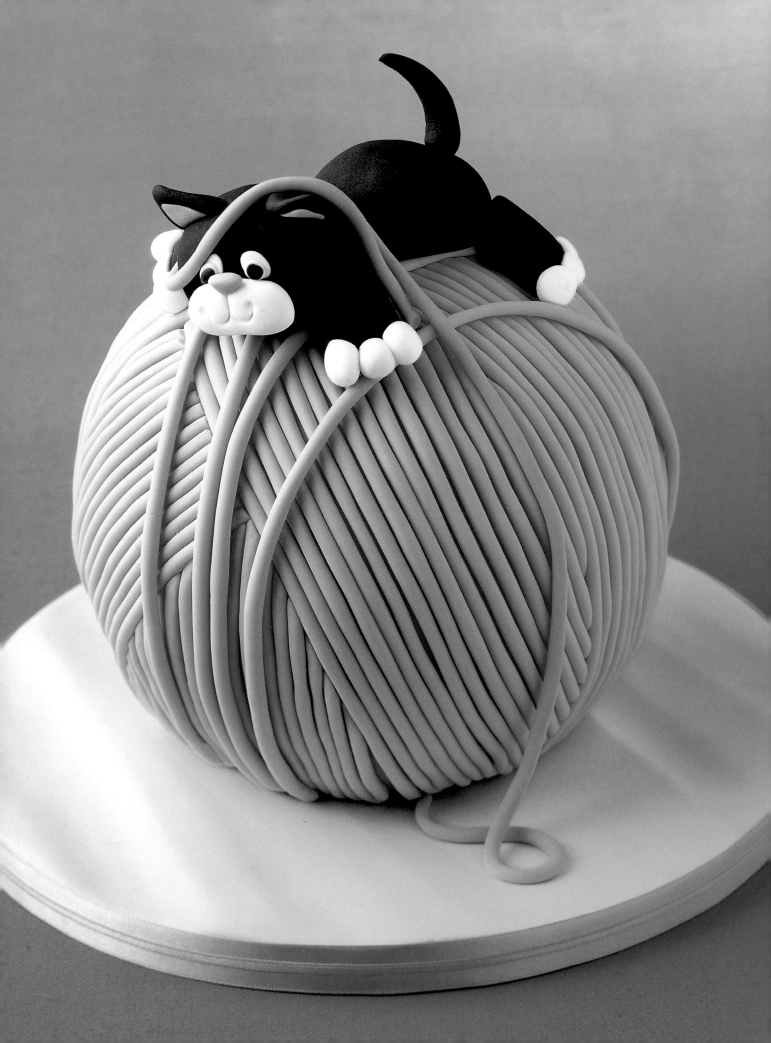

dotty dragon

A dotty dragon with a big round tummy – full of cake I suppose!

MATERIALS
- 2 x 1 litre (2 pint/5 cup) bowl-shaped cakes, see page 8
- 25cm (10 in) round cake board
- 2kg (4lb) sugarpaste/ rolled fondant
- mauve, green, yellow & black food colouring pastes
- icing/confectioners' sugar in a sugar shaker
- 280g (9oz/1 generous cup) buttercream
- sugar glue

EQUIPMENT
- large rolling pin
- sharp knife
- cake smoother
- food-safe plastic dowelling rod
- templates, see page 110
- fine paintbrush

USEFUL TIP
You could stick sugar-coated chocolate buttons, or similar sweets on his back, instead of making sugarpaste dots.

1 Colour 315g (10oz) of sugarpaste mauve. Roll out and cover the cake board, trimming excess from around the edge. Trim the crust from each cake and slice the tops flat. Sandwich the cakes together using buttercream, then spread a layer over the surface.

2 Colour 1.6kg (3lb 3½oz) of sugarpaste green. Using 75g (2½oz), pad out the tail area, tapering the end to a point. Roll 45g (1½oz) into a ball and use to pad the neck area. Roll out 1kg (2lb) of green sugarpaste and cover the cake and tail completely, smoothing around the shape. Cut away any pleats and smooth the joins closed.

3 Position the cake on the cake board and smooth the surface with a cake smoother. To help support the head, push a dowelling rod down through the neck, leaving 5cm (2in) protruding from the top. Roll 280g (9oz) of green sugarpaste into a ball for the head, then pinch around the top to narrow and give height. Push the head down on to the dowelling rod, securing it in place with a little sugar glue at the base.

4 Cut a wide mouth, pulling down the bottom lip slightly. Push the end of the fine paintbrush into the mouth corners to dimple, then push in for the nostrils at the front. Using 7g (¼oz) of green sugarpaste, shape two pointed ears and stick in place. Roll two white balls for the eyes, then colour a tiny amount of sugarpaste black and make the pupils.

5 Colour the remaining sugarpaste yellow. Using the template (see page 110), thinly roll out and cut the dragon's tummy patch. Stick in place, then mark lines using the back of a knife. Split 75g (2½oz) of green sugarpaste in half. Create two teardrop shapes for the feet and make two cuts to separate the toes. To make the arms, split 75g (2½oz) of green sugarpaste in half. Roll a sausage with a rounded end and make two cuts to separate the fingers, smoothing to remove ridges. Stick in position, then make the other arm as before.

6 With 7g (¼oz) of green sugarpaste, shape a triangle for the pointed tail. Roll out the remaining green and cut two wings using the template (see page 110). Roll the side of the paintbrush into the surface to indent, then stick in place with sugar glue. To finish, stick small, flattened balls over the dragon's back using the trimmings of mauve sugarpaste.

Sugarpaste shapes for the dragon's head.

Indent the dragon's wings with a paintbrush.

Use sugarpaste to pad the neck and tail.

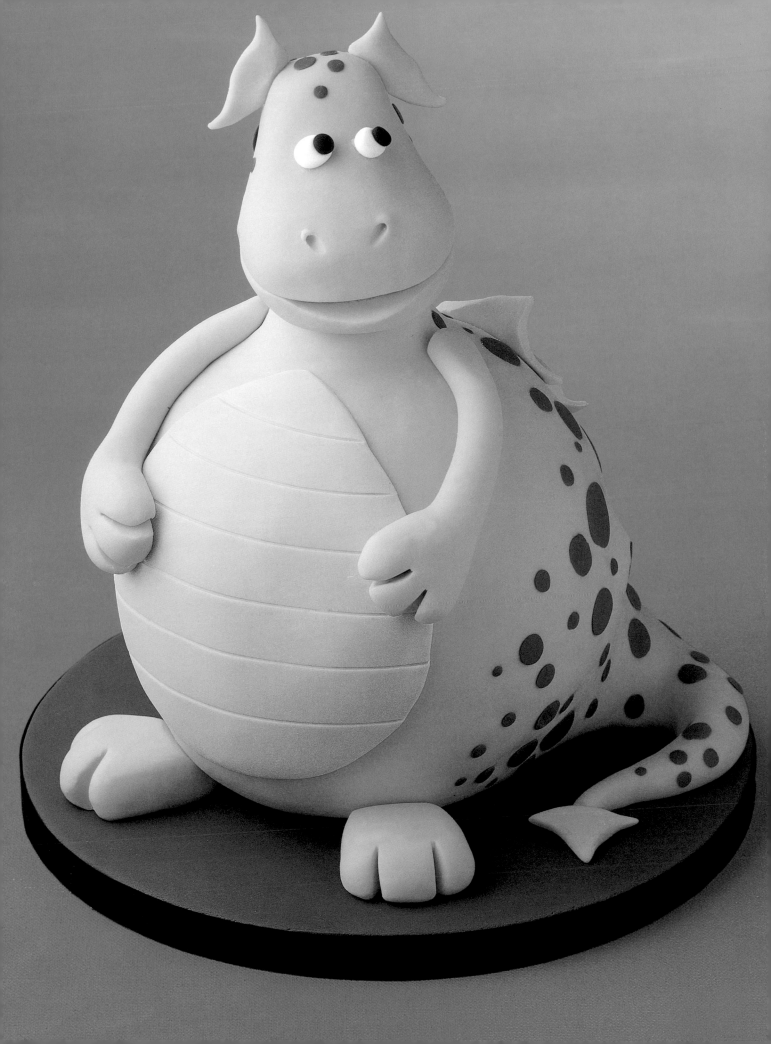

toy garage

Be prepared for a traffic jam at the party table when you serve this cake

MATERIALS
- 20cm (8in) square cake, see page 8
- 30cm (12in) square cake board
- 2kg (4lb) sugarpaste/ rolled fondant
- black, red, green, blue, yellow & cream food colouring pastes
- icing/confectioners' sugar in a sugar shaker
- 410g (13oz/1⅔ cups) buttercream
- sugar glue

EQUIPMENT
- large rolling pin
- sharp knife
- cake smoother
- miniature circle cutter

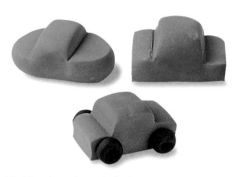

Model each car from a ball of sugarpaste.

1 Colour 750g (1½lb) of sugarpaste grey using a touch of black food colouring paste. Roll out 440g (14oz) and cover the cake board, trimming excess from around edge, then put aside to dry. Trim the crust from the cake and slice the top flat. Cut in half and put one half on top of the other. Trim one end to curve around, then sandwich the layers together with buttercream. Spread a layer of buttercream over the surface of the cake.

2 Roll out 75g (2½oz) of white sugarpaste and cut a piece to fit the square end of the cake, then press into position. Roll out 375g (12oz) of white and cut an oblong to fit around the cake sides. Roll up, position against the cake, then unroll around the cake.

3 Roll out 200g (6½oz) of grey. Carefully place the top of the cake down on to it and cut around, then turn the cake over and position on the board. Colour 280g (9oz) red. Roll out 100g (3½oz) and cut a strip to fit around the top of the cake, sticking with sugar glue.

4 Using the remaining grey, roll out and cut two strips for the road ramps, sticking securely at the top and bottom with sugar glue. To make the petrol pumps, roll a sausage with 75g (2½oz) of white sugarpaste and press a little flat, then cut in half. Colour 60g (2oz) of sugarpaste black. Make the petrol pump hoses using a little red and black.

5 Colour 15g (½oz) of sugarpaste cream, 30g (1oz) yellow and 200g (6½oz) blue. To make the little people, model a ball of paste, pressing a little flat. Cut the bottom straight to make the body. Roll balls of cream sugarpaste for each head, marking a smile using the circle cutter pressed in at an angle. Roll tiny noses and eyes, sticking in place with sugar glue. For the caps, model flattened circles, then pinch up one side for a peak. Make the ramps and road markings with black, white and yellow sugarpaste.

6 Colour the remaining sugarpaste green. To make the cars and truck, model a ball of sugarpaste and press gently on the top to flatten slightly. With the flat of a knife, press into the sugarpaste to mark the front window, then press down to flatten the bonnet. Shape the back of the car in the same way. Cut straight edges all around each car. Make the truck, but keep the back square. Shape tyres from black sugarpaste, indenting each with your finger.

Unroll the white sugarpaste around the cake.

Stick a strip of red sugarpaste around the cake.

Create the ramps with strips of grey sugarpaste.

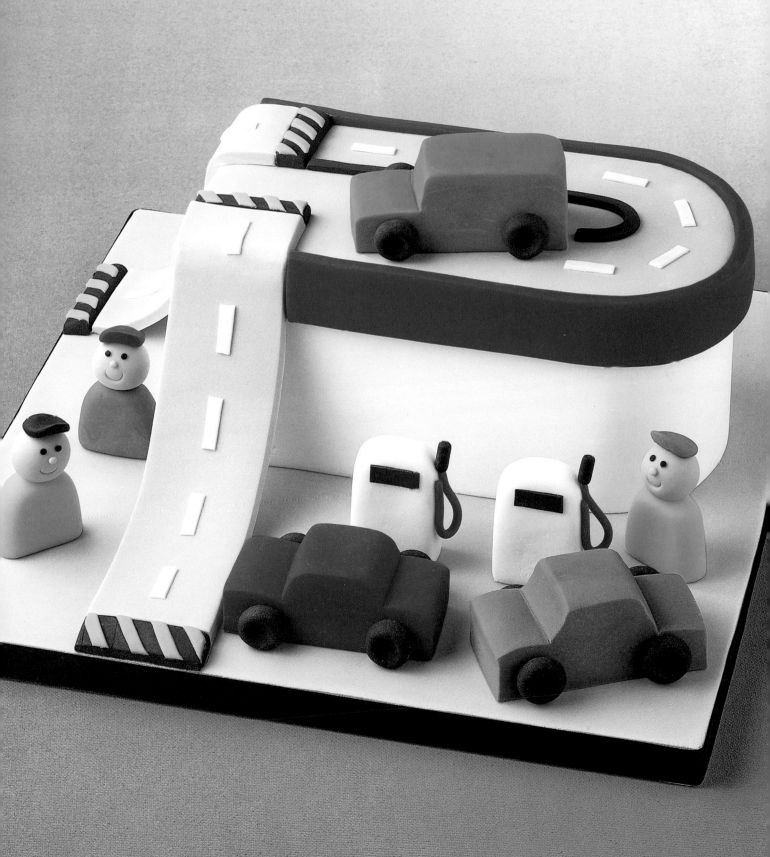

fairy toadstool

All little girls will love this magical house with sparkling fairies all around

MATERIALS

- 2 x 1 litre (2 pint/5 cup) bowl-shaped cakes, see page 9
- 25cm (10in) petal-shaped cake board
- 1.25kg (2½lb) sugarpaste/rolled fondant
- green, pink, yellow, mauve, blue, peach & cream food colouring pastes
- icing/confectioners' sugar in a sugar shaker
- 375g (12oz/1½ cups) buttercream
- sugar glue
- tiny star-shaped sweets/candies
- hundreds and thousands/sprinkles
- edible sparkle powder/ petal dust/blossom tint

EQUIPMENT

- large rolling pin
- sharp knife
- templates, see page 109
- miniature, small, medium & large circle cutters
- cocktail stick/toothpick
- No. 2 plain piping tube/tip
- silver ribbon
- medium paintbrush

1 Colour 315g (10oz) of sugarpaste green. Roll out and cover the cake board, trimming around the edge before putting aside to dry. Trim the crust from each cake and slice the top of one of the cakes flat. Turn this cake over to form the base of the toadstool.

2 Hollow out the centre of the second cake to make the roof. Keep a rounded edge and level off where the cake has risen before cutting down a further 2.5cm (1in). Trim the sides so the roof edge is slightly uneven. Turn the cake upside down and trim a ridge around the top to create a sloping roof. Spread a layer of buttercream over both cakes.

3 Cover the base of the toadstool with 345g (11oz) of white sugarpaste, trimming the excess from around the edge. Place on the board. Colour 470g (15oz) of sugarpaste pink. Roll a 60g (2oz) ball and use to pad the roof. Roll out 375g (12oz) and cover the roof cake, tucking the sugarpaste underneath. Using sugar glue, stick the roof on the base.

4 Roll out the remaining pink sugarpaste and cut out the door and windows using the templates (see page 109) and the miniature circle cutter. Mark a woodgrain effect on the door with a knife. Cut wedges of white sugarpaste for the frames. To make the petal shutters, press a tiny ball of sugarpaste flat and pinch around the edge to thin and frill. Stick in place with sugar glue. Thinly roll out and cut white sugarpaste circles for the roof.

5 To make the fairies, split 7g (¼oz) of sugarpaste into five pieces, one slightly larger. Colour the largest piece yellow and the others dark pink, mauve, blue and peach. Colour 7g (¼oz) cream. Create a long, tapering teardrop shape for each body. For the arms, roll a thin sausage tapering at the ends with cream sugarpaste and stick on the body. Roll tiny cream heads and indent the smiles by pressing in the piping tube at an angle. Mark the eyes with a cocktail stick. For the hair, roll a sausage of yellow tapering in at either end and press flat, then curl the ends. Tie five silver bows and stick to each fairy with sugar glue.

6 Moisten the cake board with sugar glue, then sprinkle on the stars to make a path. Stick stars to the front of each fairy and use one for a door handle. Sprinkle hundreds and thousands around the cake. Dust with sparkle powder using a medium paintbrush.

Sugarpaste shapes for the fairies' heads and bodies.

Shape the two cakes to form the toadstool.

Stick the doors and windows on to the cake.

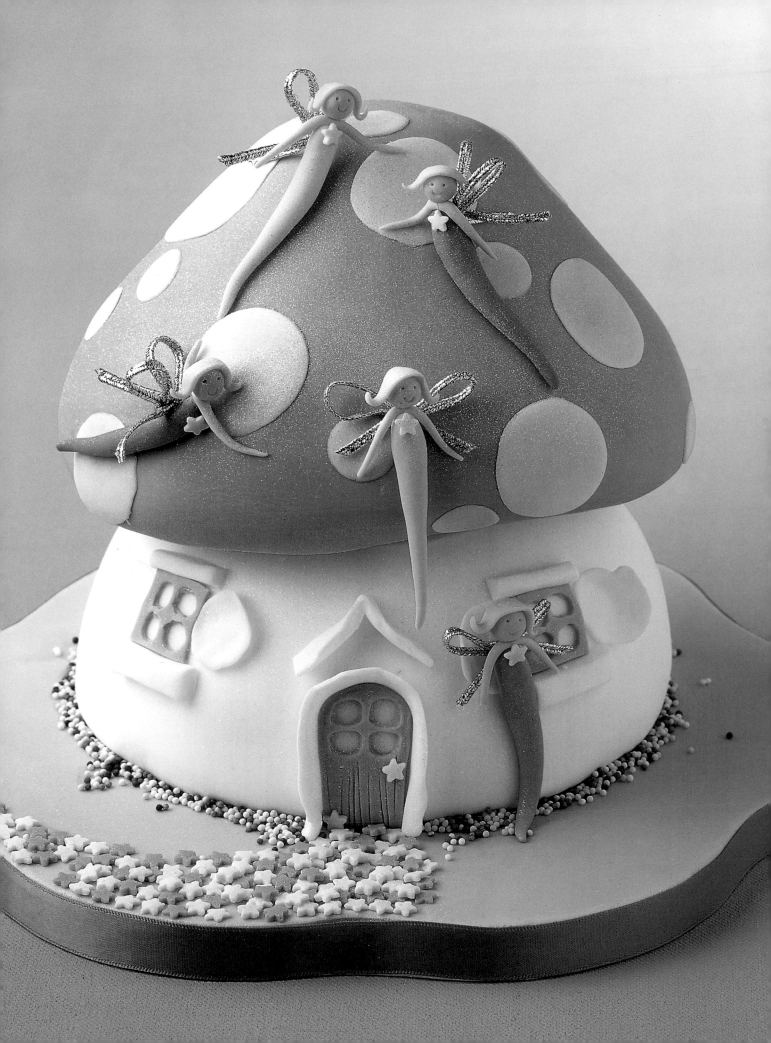

play wigwam

Cowboy and Indian fans will love this cake made in the shape of a wigwam

MATERIALS

- 20cm (8in), 18cm (7in) & 10cm (4in) round cakes, see page 9
- 25cm (10in) round cake board
- 1.35kg (2¾lb) sugarpaste/ rolled fondant
- green, black, yellow, red, blue, cream & brown food colouring pastes
- icing/confectioners' sugar in a sugar shaker
- 440g (14oz/1¾ cups) buttercream
- sugar glue
- chocolate stick

EQUIPMENT

- large rolling pin
- sharp knife
- 4cm (1½in), 2.5cm (1in) & 1cm (½in) square cutters
- miniature circle cutter
- cocktail stick/toothpick

USEFUL TIP

Press the circle cutter in at an angle when marking the little boy's smile. Create dimples by pushing the tip of a cocktail stick into each corner of the smile and lifting slightly.

1 Colour 315g (10oz) of sugarpaste green. Roll out and cover the cake board, trimming excess from around the edge, then put aside to dry. With trimmings, shape two cactus and put aside. Trim the crust from each cake and slice the tops flat. Stack the cakes together, graduating in size. Trim from the top, cutting downwards, removing the top edge of each cake to create the sloping sides of the wigwam. Sandwich the layers together with buttercream, then spread a layer over the surface of the cake to help the sugarpaste stick.

2 Colour 30g (1oz) of sugarpaste black. Reserve a tiny amount for the boy's eyes, then thinly roll out the remainder and cover the front of the cake for the opening. Place the cake on the board. Colour 875g (1¾lb) of sugarpaste yellow. Using a small piece, cover the top of the cake. Roll out the remaining yellow and cut an oblong measuring 50 × 22cm (20 × 8½in). Carefully roll up, place a straight edge against the front of the cake by the black strip, then unroll around the cake, keeping the top smooth and neat against the cake. This will create excess at the bottom, so trim away until level with the opposite side. Trim at the join, smoothing open at the centre. Pinch around the top of the wigwam, creating a lip.

3 Colour 45g (1½oz) red and 22g (¾oz) blue. Thinly roll out red and cut squares from squares using the cutters. Cut in half to make 'v' shapes, and stick around the wigwam creating a zigzag pattern. Thinly roll out blue and cut small squares, sticking in place following the zigzag pattern. Mark two line patterns using a knife. Using sugar glue, stick the cactus in place. Break the chocolate stick into three pieces and push gently into the top of the wigwam.

4 Colour 35g (1¼oz) of sugarpaste cream and 7g (¼oz) brown. For the boy, model two teardrop shapes for hands, an oval nose and two ears, pressing in the centre of each to indent, then roll the remaining piece into an oval-shaped head. Stick the nose in place. Mark his smile by pressing in with the circle cutter. Stick in place with sugar glue.

5 Thinly roll out blue trimmings and cut a strip for the head band and stick around his forehead. Model three teardrop shapes for the feathers using trimmings and press flat. Indent down the centre of each and gently cut lines either side. Stick on two oval-shaped eyes. Stick different sized pieces of brown sugarpaste over the boy's head for his hair.

Cut decorative shapes with the square cutters.

Stack the layers of cake together with buttercream.

Unroll the yellow sugarpaste around the cake.

wise owl

Certainly a different way of encouraging children to do their sums

MATERIALS

- 18cm (7in) round cake, see page 8
- 30cm (12in) square cake board
- 1.35kg (2¾lb) sugarpaste/ rolled fondant
- black, orange & yellow food colouring pastes
- icing/confectioners' sugar in a sugar shaker
- 315g (10oz/1¼ cups) buttercream
- sugar glue

EQUIPMENT

- large rolling pin
- sharp knife
- 8cm (3in) square cake card
- template, see page 110
- 8cm (3in), 5cm (2in) & 4cm (1½in) circle cutters
- large petal cutter
- number cutters

USEFUL TIP

Leave the number answers loose on the cake board and ask the child to push them into the correct place.

1 Colour 375g (12oz) of sugarpaste black. Using icing sugar to prevent sticking, roll out and cover the cake board completely, trimming excess from around the edge and put aside to dry. Cover the square cake card in the same way, using the black trimmings. Trim the crust from the cake and slice the top flat. Cut a 2.5cm (1in) wedge from the cake to create the base of the owl. Cut two more wedges from either side, slanting up to the top to shape the owl. Spread the cake with buttercream to help the sugarpaste stick.

2 Knead orange and yellow food colourings into 750g (1½lb) of sugarpaste until it is slightly streaky. Thinly roll out 100g (3½oz) of this orange-yellow sugarpaste and place the back of the cake down on to it. Cut around the shape of the cake. Cover the front of the cake in the same way and then position the cake on the board. Thinly roll out another 100g (3½oz) of orange-yellow and cut a strip to cover the top of the cake and down the sides. Don't worry if the cake covering is untidy as this will be covered later.

3 Roll out 75g (2½oz) of white sugarpaste and cut the tummy patch using the template (see page 110). Roll out 30g (1oz) of white and cut a circle using the large cutter. Trim a 'v' from the top and bottom to make the owl's face. Using 315g (10oz) of the orange-yellow sugarpaste, thinly roll out and cut petal shapes for the owl's feathers, sticking them around the base first, then build up around the cake and cover the first layer of sugarpaste.

4 With the remaining orange-yellow sugarpaste, model two pointed ears, indenting in the centre of each with your finger. Create six long teardrop shapes. Stick three teardrop shapes on to either side of the cake for each wing. Colour 100g (3½oz) of sugarpaste yellow. Using 45g (1½oz), shape three tapering teardrop shapes into a foot, sticking in place graduating in size. Make the other foot in the same way. With the remaining yellow, shape a pointed beak with two teardrop shapes, the top one thicker than the other.

5 With sugar glue, stick the cake card on top of the owl's head. With black, model small flattened ovals for the pupils, then roll out and cut the glasses using the circle cutters and cut strips for the hat tassle. Using white, model flattened oval shapes for eyes and a tiny highlight for each eye. Thinly roll out and cut numbers to decorate the cake board.

Shape the cake with a sharp knife.

Use white sugarpaste for the owl's tummy and face.

Cut petal shapes to create the owl's feathers.

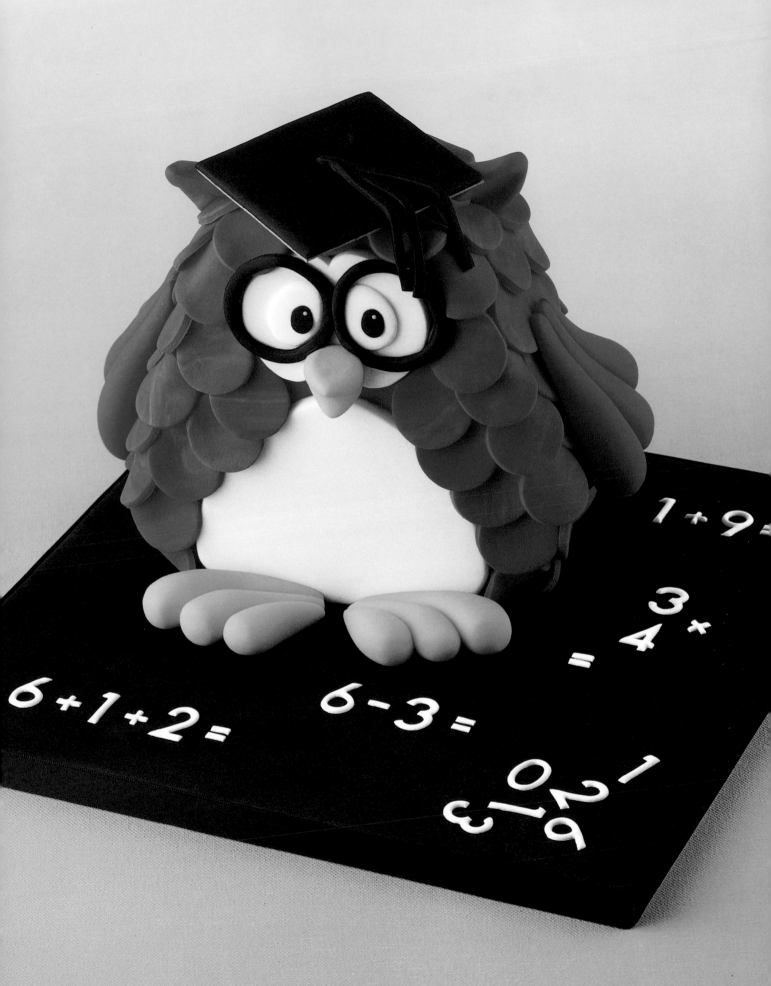

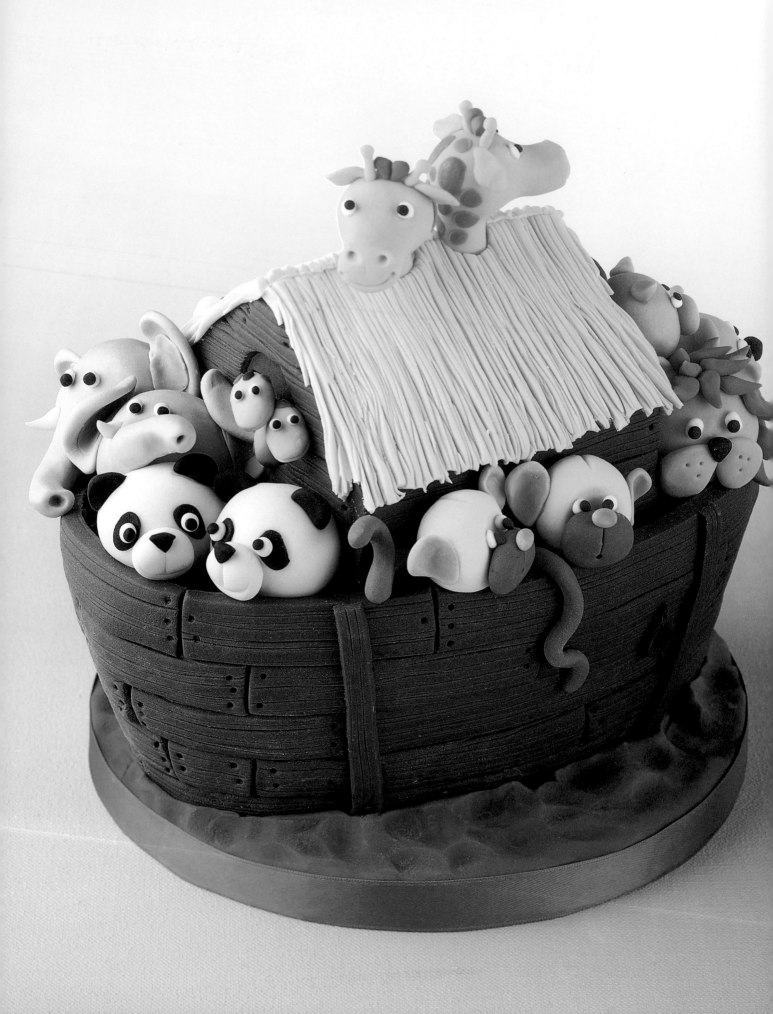

Noah's ark

If time is short, use small animal toys instead of these modelled animals

MATERIALS

- 1 x 1.5 litre (3 pint/7½ cup) oval cake & 1 x 20cm (8in) square cake, see page 9
- 20cm (8in) round cake board
- 440g (14oz/1¾ cups) buttercream
- 2kg (4lb) sugarpaste/ rolled fondant
- black, brown, yellow, blue, pink & golden-brown food colouring pastes
- icing/confectioners' sugar in a sugar shaker
- sugar glue

EQUIPMENT

- sharp knife
- large rolling pin
- cocktail sticks/toothpicks
- fine paintbrush
- small circle cutter
- small pieces of foam sponge

USEFUL TIP

Instead of colouring the sugarpaste brown, you could use chocolate sugarpaste as a delicious alternative.

1 Cut the crust from each cake and slice the tops flat. Cut the square cake into four equal sized squares and stack one on top of the other. Make sure they sit evenly, then trim either side to create the sloping roof, cutting down two layers only. Sandwich the layers together with buttercream. Cut a layer in the oval-shaped cake and sandwich back together with buttercream, then spread a thin layer of buttercream over both cakes.

2 Colour 280g (9oz) of sugarpaste black. Using icing sugar to prevent sticking, roll out 220g (7oz) of black and place the top of the oval-shaped cake down on to it. Cut around the shape, then pick the cake up and position on the centre of the cake board.

3 Colour 875g (1¾lb) of sugarpaste brown. Roll out and cut strips about 2cm (¾in) wide. Cut these strips into different lengths and texture the surface of each, using a knife to give a wood effect. Cover the bottom cake with these strips, working from the base upwards. Mark little holes at the end of each plank using the end of a cocktail stick. Cover the cabin in the same way, leaving the roof uncovered. Cut four thin strips and secure vertically on each side of the ark with sugar glue.

4 Cut two holes on either side of the cabin and remove the sugarpaste. Thinly roll out some black sugarpaste and cut two circles to fill these gaps. Roll a thin sausage of black sugarpaste and twist into a loop for the door on the side of the ark.

5 Colour 155g (5oz) of sugarpaste pale yellow. To make the roof, roll out 125g (4oz) of yellow and cut two pieces to fit either side of the roof. Keeping the cut pieces of yellow sugarpaste flat on the work surface, mark a straw effect with a sharp knife, taking care not to cut too deeply into the sugarpaste. Pull the knife downwards to stretch and fray the bottom edge, then position the pieces on the top of the cake.

6 Colour 185g (6oz) of sugarpaste blue. Roll out the blue sugarpaste and press it on to the cake board around the ark. Use your fingertips to create an uneven water effect, then trim any excess from around the edge of the cake board.

continued overleaf!

Model the giraffe's head from yellow sugarpaste.

Sugarpaste shapes for the elephant's head and ears.

Stack the cut cakes together to form the ark.

Cover the sides with strips of brown sugarpaste.

Create a straw effect using a sharp knife.

7 To make the animals, first colour 170g (5½oz) of sugarpaste yellow, 125g (4oz) grey, 30g (1oz) pink, 15g (½oz) pale brown and 15g (½oz) golden brown. Use these pieces of coloured sugarpaste and the remaining pieces of pale yellow, black and white sugarpaste.

8 Each animal head is shaped from a ball of coloured sugarpaste. When a long muzzle is needed, pinch at one side of the ball, twisting the sugarpaste to form a rounded end. To create the giraffe, also pinch underneath the ball of sugarpaste to make the neck. For the elephant, twist the sugarpaste until long for the trunk and taper it in at the end.

9 Indent the nostrils with the end of a paintbrush, or use a cocktail stick. Mark smiles using the circle cutter pressed in at an angle. The zebra and tiger stripes are created with tiny uneven sausages of black sugarpaste pressed flat. The patches on the giraffe and snake are tiny different sized balls of sugarpaste, also pressed flat.

10 When all the animals have been made, place them on the ark in pairs. Cut two holes in the top of the roof for the giraffes' heads, and secure them in position with sugar glue. You may need to use small pieces of foam sponge for support whilst drying.

Decorate the cake with a variety of different animals. Remember that all the animals should be in pairs!

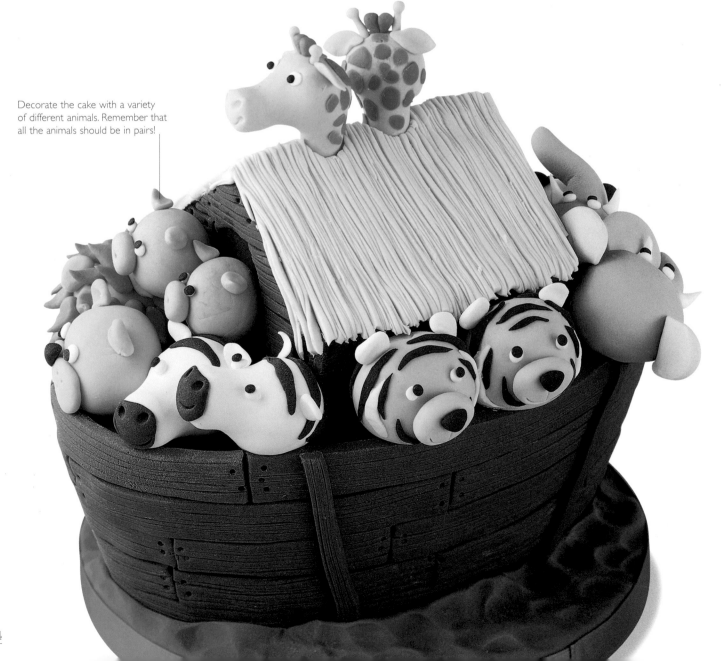

adorable dolphins

Two cute dolphins make the perfect cake for any child who loves the sea

MATERIALS

- 1 x 2 litre (4 pint/10 cup) & 1 x 0.5 litre (1 pint/2½ cup) bowl-shaped cakes, see page 9
- 35cm (14in) round cake board
- 1.75kg (3½lb) sugarpaste/rolled fondant
- mauve, dark green, dark blue, pink & black food colouring pastes
- icing/confectioners' sugar in a sugar shaker
- 375g (12oz/1½ cups) buttercream
- sugar glue

EQUIPMENT

- large rolling pin
- sharp knife
- bone tool

Pad the cakes with grey sugarpaste.

1 Split 500g (1lb) of sugarpaste into four and colour mauve, dark green, dark blue and pink. Put aside 15g (½oz) of dark green, then knead the remaining colours into one another until streaky. Roll out and cover the cake board. Press over the surface with your fingers to indent. Trim excess from around the edge and put aside to dry.

2 Trim the crust from each cake, keeping the tops rounded where they have risen. Spread the surface with buttercream to help the sugarpaste stick. Colour the remaining sugarpaste grey using a little of each of the black and mauve food colouring pastes.

3 Using 155g (5oz) of the grey sugarpaste, model a teardrop shape and place at the base of the large bowl cake to form the padding for the tail end. Roll tapering sausages using 60g (2oz) and press on to the opposite side of the large cake to pad the dolphin's face. Roll out the remaining grey sugarpaste and cover the cake completely, smoothing around the shape, then trim the excess sugarpaste from around the edge.

4 With your finger, smooth into the mouth to indent a smile, then position the dolphin on the cake board. Gently push the large end of a bone tool into the sugarpaste to indent eye sockets. Cover the other bowl cake in the same way, using 75g (2½oz) of sugarpaste to pad the tail end and 30g (1oz) to pad the face.

5 Shape all the fins using the remaining grey sugarpaste and stick in place with sugar glue. Colour a pea-sized amount of sugarpaste trimmings black and model four tiny eyes. For the seaweed, roll different sized sausages of dark green sugarpaste, then pinch along the length to indent. Leave to set for a few moments before sticking them in position around the dolphins with sugar glue.

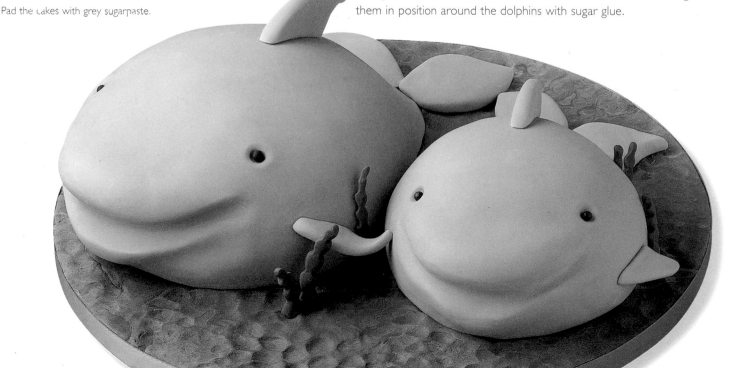

goody bag

A dream cake – so many sweets spilling out that there is no room for the candles!

MATERIALS

- 15cm (6in) square cake, see page 8
- 25cm (10in) round cake board
- 1kg (2lb) sugarpaste/rolled fondant
- pink, orange & yellow food colouring pastes
- icing/confectioners' sugar in a sugar shaker
- 345g (11oz/1⅓ cups) buttercream
- assorted sweets/candies
- sugar glue

EQUIPMENT

- large rolling pin
- sharp knife

USEFUL TIP

As an alternative, fill the bag with sugar-coated chocolates, and use the chocolates to decorate the bag instead of flattened balls of sugarpaste.

1 Colour 750g (1½lb) of sugarpaste pink and 185g (6oz) orange. Using icing sugar to prevent sticking, roll out all the orange sugarpaste and 185g (6oz) of the pink sugarpaste and cut 2.5cm (1in) wide strips. Following the photograph below, stick alternate coloured strips over the cake board, trimming excess sugarpaste from around the edge. Put the covered board aside to dry.

2 Trim the crust from the cake with a sharp knife and slice the top flat. Cut the cake in half and put one half on top of the other. Trim the cake at each corner to round off. Sandwich the two cakes together with buttercream, then spread a thin layer of buttercream over the surface of the cake to help the sugarpaste stick.

3 Using the remaining pink sugarpaste, roll out and cut a strip measuring 42 × 15cm (17 × 6in). Carefully roll up this pink sugarpaste strip, position it against the side of the cake, then unroll it around the cake, securing the join with sugar glue.

4 Pinch around the top edge of the sugarpaste to thin and to frill the edges of the bag. Dampen your fingers with water when pinching around the top of the bag – this will help prevent the sugarpaste cracking and will ensure that the edges remain smooth.

5 Position the cake on the centre of the cake board. Colour the remaining sugarpaste yellow. Thinly roll out and cut two oblong shapes for the front and the back of the bag. Stick in place with sugar glue, then press different sized orange and pink balls of sugarpaste over the surface, pressing each ball flat.

6 Fill the top of the bag with a variety of colourful sweets, allowing them to spill out of the bag and on to the cake board. If using boiled sweets, bear in mind that these may start to melt slightly, so don't leave the cake too long before serving. Alternatively, keep the pretty wrappers on the sweets.

Cover the cake board with strips of sugarpaste.

Unroll the pink sugarpaste around the cake.

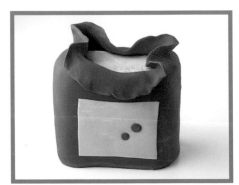

Press balls of sugarpaste on the sides of the cake.

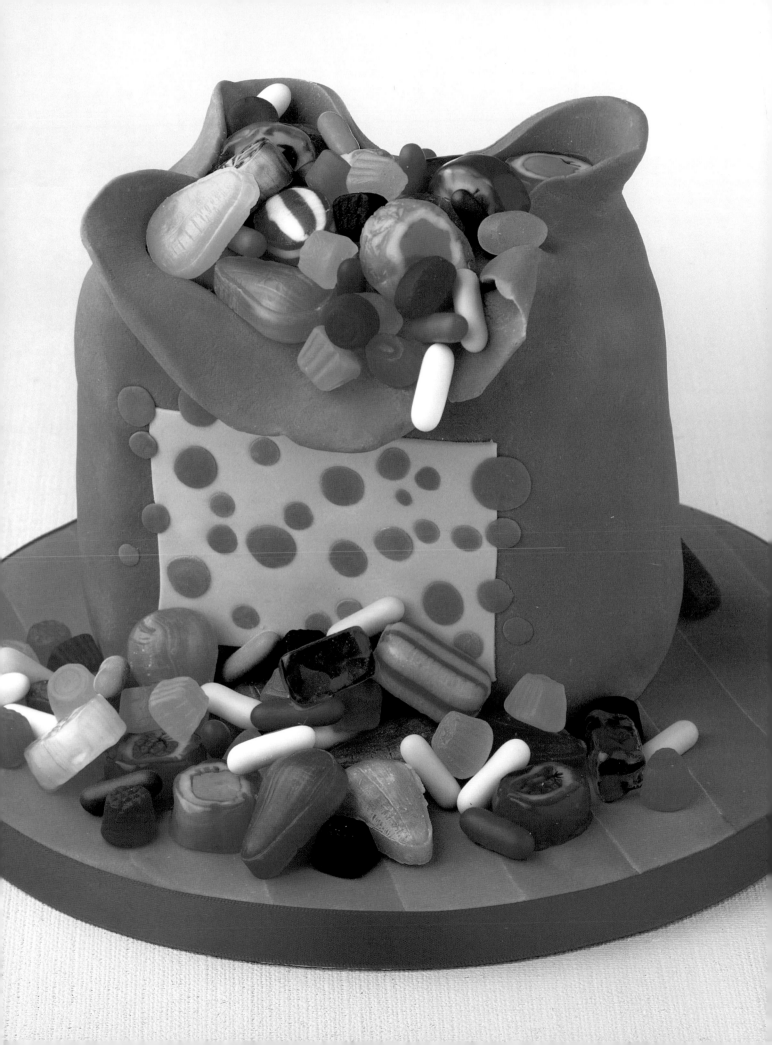

Little Bo Peep

The story of Little Bo Peep is one of the most popular nursery rhymes ever

MATERIALS

- 2 litre (4 pint/10 cup) bowl-shaped cake, see page 9
- 30cm (12in) round cake board
- 345g (11oz/1⅓ cups) buttercream
- 1.5kg (3lb) sugarpaste/ rolled fondant
- yellow, green, blue, cream & pink food colouring pastes
- icing/confectioners' sugar in a sugar shaker
- 60g (2oz/¼ cup) royal icing
- black food colouring pen

EQUIPMENT

- large rolling pin
- sharp knife
- cake smoother
- templates, see page 109
- 5cm (2in) circle cutter
- cocktail stick/toothpick
- piping bag

USEFUL TIP

Pinch around the front of the base of Little Bo Peep's teardrop-shaped dress to create the edge of the skirt. Place the dress so that it is sitting over the legs.

1 Trim the crust from the cake and slice the top flat. Cut a layer in the cake, then sandwich together with buttercream. Position on the board and spread with buttercream. Colour 1kg (2lb) of sugarpaste yellow-green using green food colouring paste with a touch of yellow. Roll out and cover the cake and board. Smooth around the shape and trim the excess from around the edge. Use a cake smoother to create a smooth surface.

2 To make the bushes, first colour 410g (13oz) of sugarpaste green. Thickly roll out and cut two of each of the bush shapes, using the templates as guides (see page 109). Smooth the edges of the bushes to round off, then position around the base of the cake, securing them in place with dabs of royal icing.

3 Colour 30g (1oz) of sugarpaste blue, 7g (¼oz) cream and 7g (¼oz) yellow. Following the photograph, model Little Bo Peep's dress and shoes. Using cream, model two legs, tapering in at the ankle. Stick in place with royal icing. Roll two tiny balls of white for the socks. Stick the shoes on next. Roll out a piece of white and cut out the apron, using the template (see page 109). Roll a cocktail stick over the surface to thin and frill, then stick on to the dress. Model two white balls for the sleeves, pressing firmly on to the dress and sticking with royal icing. Model a flattened circle and from it cut a 'v' to shape a collar.

4 Roll a ball of cream sugarpaste for Little Bo Peep's head, indenting her mouth with a cocktail stick. Roll a tiny nose and two arms, rounding off the ends for hands. Roll out yellow sugarpaste and cut a circle, then cut in half. Stick in position for the front of her bonnet, smoothing up at the front, then model a flattened ball with the remaining yellow and stick on the back of her head. Roll a long, thin sausage of white and bend to make her crook.

5 Colour 30g (1oz) of sugarpaste pale pink and 7g (¼oz) dark pink. To make the sheep, split the pale pink sugarpaste into five. Model a rounded teardrop for each head, and two teardrop-shaped ears. Indent the bottom of each face with the side of a cocktail stick. Roll dark pink noses. Put the royal icing into the piping bag and cut a small hole in the tip. Stick the sheep in place, peeping out of the bushes, then pipe their hair, swirling the royal icing into curls. When the cake is dry, gently draw on little black dots for eyes.

Sugarpaste shapes for Little Bo Peep.

Cover the cake and the board with sugarpaste.

Cut out the bushes, using the templates as a guide.

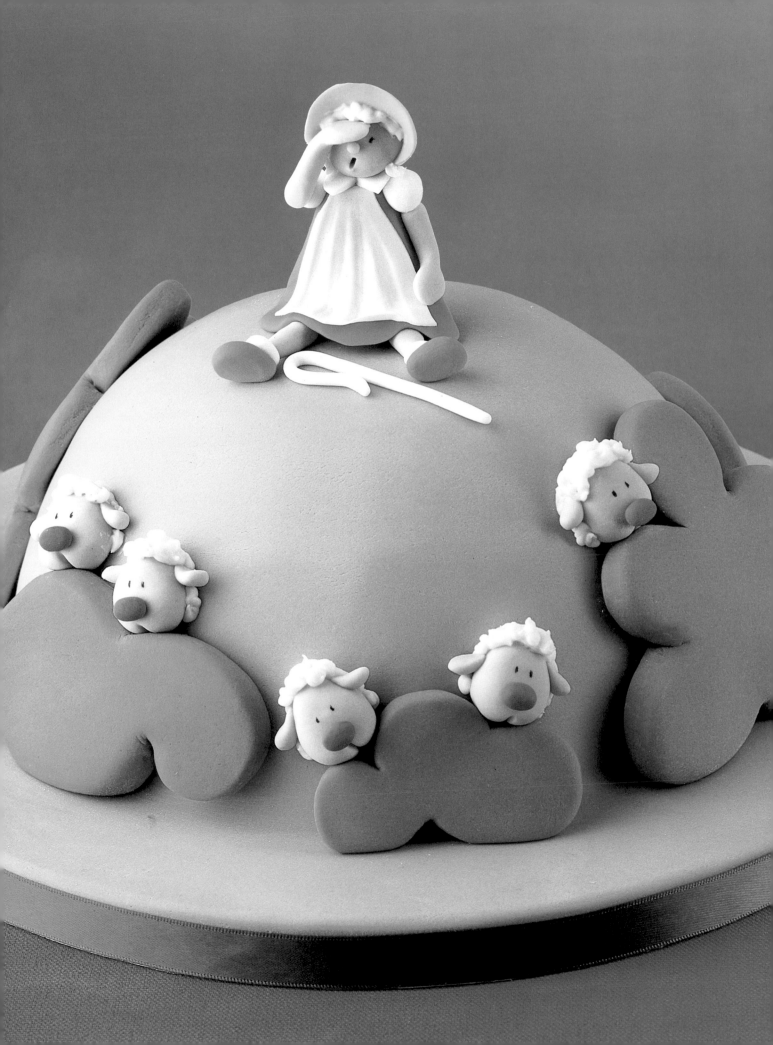

mouse house

A sweet little pumpkin-shaped mouse house that is quick and easy to make

MATERIALS

- 2 x 2 litre (4 pint/10 cup) bowl-shaped cakes, see page 9
- 30cm (12in) round cake board
- 1.5kg (3lb) sugarpaste/ rolled fondant
- mauve, orange, black, golden brown & green food colouring pastes
- icing/confectioners' sugar in a sugar shaker
- 345g (11oz/1⅓ cups) buttercream
- sugar glue

EQUIPMENT

- large rolling pin
- sharp knife
- cake smoother
- small circle cutter

1 Colour 375g (12oz) of sugarpaste mauve. Using icing sugar to prevent sticking, roll out and cover the cake board, trimming excess from around edge. Put aside to dry. Trim the crust from each cake and slice the tops flat. Put the two cakes together to form a ball.

2 Trim the pumpkin shape, cutting 2cm (¾in) deep into the cake from top to bottom to mark eight sections. Trim to create eight grooves spaced evenly around the cake. Sandwich the cakes together with buttercream, then spread a thin layer over the surface.

3 Colour, then roll out 1kg (2lb) of orange sugarpaste and cover the cake, smoothing around the ball shape and into the grooves. Stretch out the pleats around the base and tuck the sugarpaste underneath, or cut away the pleats and smooth the joins closed.

4 Position the cake on the cake board, then use a cake smoother to smooth the surface. Cut out small circles for the windows and remove the sugarpaste. Colour 15g (½oz) of sugarpaste black, thinly roll out and cut circles to slot in the openings.

5 Colour 45g (1½oz) of sugarpaste golden brown to make the mice. Using 15g (½oz), model a teardrop-shaped head, turning up the point slightly for the muzzle. Indent the eye sockets using your finger, then stick at a window with sugar glue, holding for a moment until secure. Make another mouse head and mark an open mouth with a knife.

6 Model brown, flattened teardrop-shaped ears. Knead orange and golden brown together to make tiny teardrop shapes for the centre of each ear and make small oval-shaped noses. Roll black eyes. Stick in position. Create brown teardrop-shaped paws, flatten slightly, then make three small cuts at the rounded end. Roll tapering shapes for the tails.

7 Colour the remaining sugarpaste green. Roll tapering sausage shapes for the stalks, including a thick stalk for the top of the pumpkin and stick in place. Make flattened leaf shapes, pressing down with your finger to create the leaf edges, then use a knife to mark the centre vein. Model a small sausage of mauve sugarpaste for the base of the chimney and the cone-shaped top, then slot into a hole in the side of the pumpkin house.

Shapes for the mouse's head, paws and tail.

Green sugarpaste stalks and leaves.

Cut eight grooves in the sides of the cake.

Fill the holes with circles of black sugarpaste.

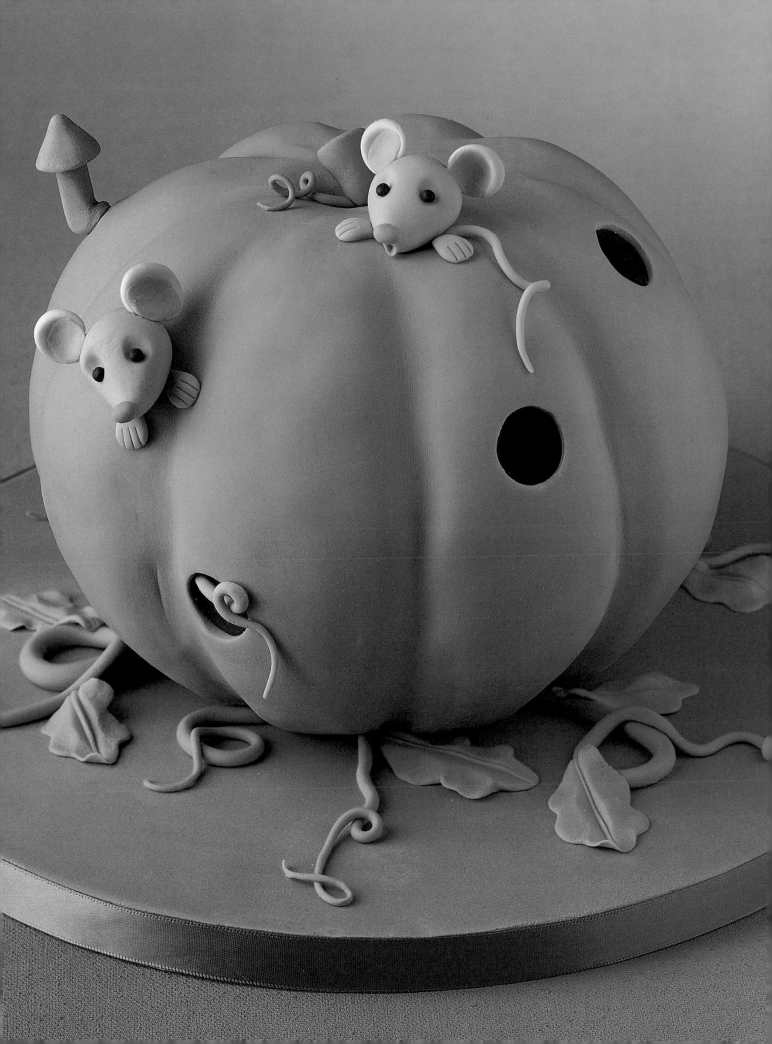

shopping frenzy

Inspired by my daughter, Laura, this is a fun idea for any fashion mad teenage girl

MATERIALS
- 20cm (8in) square cake, see page 8
- 30cm (12in) square cake board
- 315g (10oz/1¼ cups) buttercream
- mauve, purple, pink, aqua, green, yellow, cream & black food colouring pastes
- 1.5kg (3lb) sugarpaste/rolled fondant
- icing/confectioners' sugar in a sugar shaker
- sugar glue
- lengths of liquorice/licorice

EQUIPMENT
- hologram wrapping paper
- non-toxic glue stick
- large rolling pin
- sharp knife
- large heart cutter
- large flower cutter
- cocktail stick/toothpick
- fine paintbrush

1 Cover the cake board with the hologram wrapping paper (see page 7). Trim the crust from the cake and slice the top flat. Cut the cake into four equal squares. Trim each square to taper in at one end. Spread a layer of buttercream over the surface of each cake.

2 Colour 315g (10oz) of sugarpaste mauve, 375g (12oz) purple, 315g (10oz) aqua, 315g (10oz) green, 15g (½oz) yellow and 60g (2oz) cream. Roll out the mauve sugarpaste and cut two 13cm (5in) squares. From the top of each, trim a little handle opening. Place a cake down on to a mauve square and smooth the sides up around the cake. Put the other sugarpaste square on top and glue the joins together.

3 Cover the green bag in the same way, also with cut-out handles. Then make a purple and an aqua bag, without cut-out handles. Position the bags on the cake board. Using 7g (¼oz) of yellow and some of the mauve sugarpaste trimmings, decorate the bags using the heart and flower cutters. Roll two thin sausages of white sugarpaste to make the handles for the aqua bag and stick in place. For the purple bag handles, roll two thin sausages of cream and indent along the length using the side of a cocktail stick to give a rope effect.

4 To make the girl, first colour 45g (1½oz) of sugarpaste dark pink. Make the dress by modelling a teardrop shape, flattening around the base and bending slightly. Using 45g (1½oz) of cream sugarpaste, roll a ball for her head, and stick on to the dress with sugar glue. Position on the cake board, sticking the back of her head against the mauve bag.

5 With the remaining cream sugarpaste, shape two hands and a nose. Push liquorice arms and legs into the dress, using sugar glue to secure. Stick the hands in place. Using 15g (½oz) of purple sugarpaste for each, shape the platform shoes and press on to the legs. Roll long, yellow teardrops for the hair strands. Stick on each side of her head, curling up the ends.

6 Shape purple balls to decorate her dress. Flatten two white balls for eyes and two tiny aqua balls for the iris. Press in the end of a paintbrush to mark the lip centre. Dilute the black and pink food colouring pastes separately with a few drops of water and paint her face. Roll out any trimmings and cut the clothes, folding and sticking them into each bag.

Sugarpaste shapes for the teenage girl.

Cut the cake into four equal squares, then trim.

Cover the cake pieces with sugarpaste squares.

football crazy

The chocolate footballs filling the net make this cake a high scorer!

MATERIALS

- 20cm (8in) round cake, see page 8
- 30cm (12in) round cake board
- 410g (13oz/1⅔ cups) buttercream
- 1.125kg (2¼lb) sugarpaste/ rolled fondant
- green, red, cream, black & brown food colouring pastes
- icing/confectioners' sugar in a sugar shaker
- sugar glue
- foil-covered chocolate footballs

EQUIPMENT

- large rolling pin
- sharp knife
- cake smoother
- small circle cutter
- flat-tipped cocktail stick/toothpick
- silver net
- strong adhesive tape

USEFUL TIP

Before securing the silver net to the cake board, add a length of coloured ribbon or any other cake board edging.

1 Trim the crust from the cake and slice the top flat. Split in half and fill with buttercream, then spread a layer of buttercream over the surface of the cake. Scoop out buttercream at the join to create a slight dip. This will prevent a bulge of excess buttercream when the cake is covered with sugarpaste. Position the cake on the centre of the cake board.

2 Colour 1kg (2lb) of sugarpaste green. Roll out, using icing sugar to prevent sticking and cover the cake and board completely, trimming the excess sugarpaste from around the edge of the board with a knife. Smooth the surface with a cake smoother.

3 Using the photograph below as a guide, make the footballer's shorts using 22g (¾oz) of white sugarpaste. Colour 45g (1½oz) of sugarpaste red. Using 35g (1¼oz), make his red top, smoothing out any ridges. Indent his top at the base to hollow it out and then stick over the top of the shorts. Model a flattened circle in white sugarpaste and cut out a 'v' to make a collar. Shape the badge in white sugarpaste, cutting the top with the small circle cutter. Roll two white socks, cutting the end of each straight. Remember that you can alter the footballer's colours to suit a favourite team if you want.

4 Colour 30g (1oz) of sugarpaste cream and use this to make the footballer's head, nose, ears and knees, as well as two sausages for the arms. Pinch around the top of the arms to create a rounded end for the hands, then flatten each hand slightly. Indent the ears with the tip of your finger. Mark his smile using the small circle cutter pressed in at an angle and create dimples at each corner with the end of a cocktail stick.

5 Make the tops of the socks with red, and the sleeve edging with white. Model two oval-shaped eyes. Colour 7g (¼oz) of sugarpaste black. Make the pupils of the eyes, then roll two oval-shaped boots. Colour a small amount of sugarpaste brown and cut into thin strips for the hair. Use the side of a cocktail stick to indent his centre parting.

6 Lay the piece of silver net over the side of the cake. Trim, leaving a 2.5cm (1in) overlap at the edge of the cake board. Secure this overlap underneath the board using strong adhesive tape. Add the foil-covered chocolate balls, putting one in the footballer's hands.

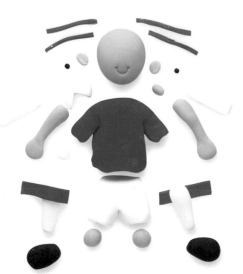
Sugarpaste shapes for the footballer.

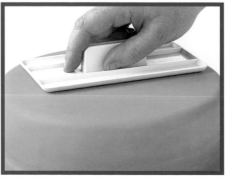
Smooth the cake's surface with the cake smoother.

Secure the net under the board with adhesive tape.

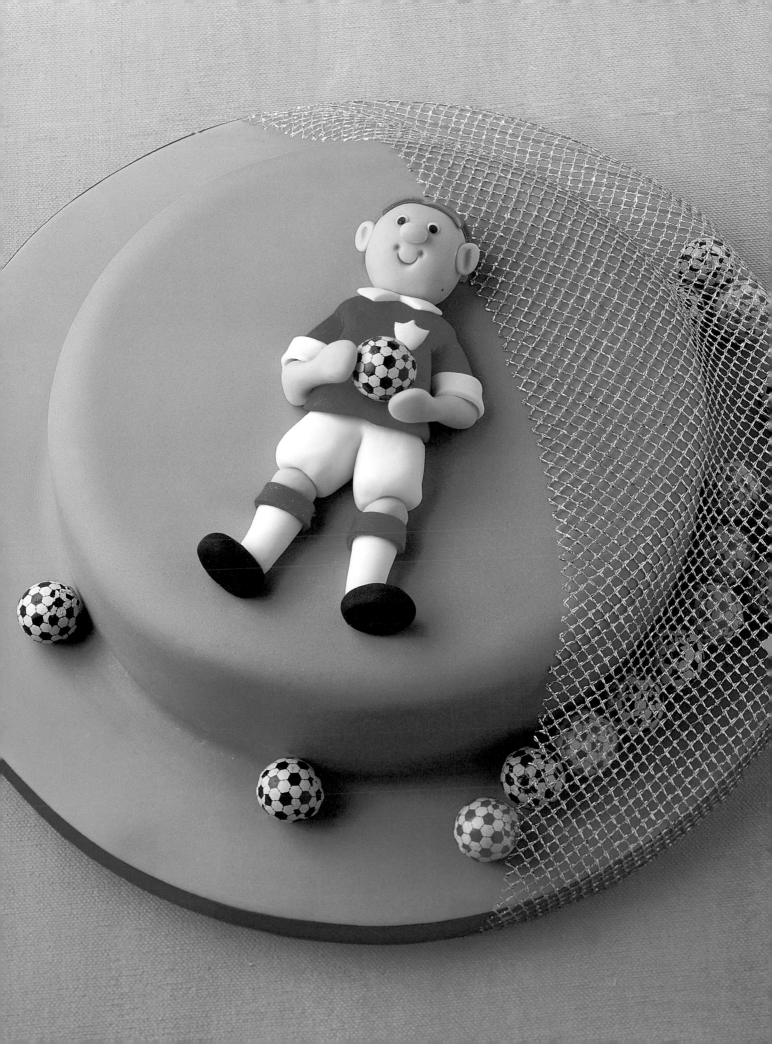

busy bees

Busy bees buzzing around their
beehive make an unusual birthday cake

MATERIALS
- 1 x 20cm (8in) &
1 x 15cm (6in) round cakes,
see page 9
- 25cm (10in) round cake board
- 1.35kg (2¾lb) sugarpaste/
rolled fondant
- green, yellow & black
food colouring pastes
- icing/confectioners' sugar
in a sugar shaker
- 440g (14oz/1¾ cups) buttercream
- sugar glue

EQUIPMENT
- large rolling pin
- sharp knife
- small circle cutter
- small rose petal cutter
- large daisy cutter

USEFUL TIP
When a large piece
of sugarpaste is rolled out,
lift by folding over the
rolling pin. This will make
it easier to position the
sugarpaste on the cake.

1 Colour 315g (10oz) of sugarpaste green. Using icing sugar to prevent sticking, roll out and cover the cake board, trimming any excess from around the edge, then put aside to dry. Trim the crust from both cakes and slice the tops flat.

2 Cut a layer in the larger cake, then trim both layers to round off the edges, trimming more from one to make it smaller than the other. Trim the smaller cake in the same way then, using buttercream, sandwich one on top of the other, graduating in size to make the beehive shape. Cut out a wedge of cake from the base for the door. Spread a layer of buttercream over the surface of all the cakes to help the sugarpaste stick.

3 Colour 1kg (2lb) of sugarpaste yellow. Using 30g (1oz), pad the top of the cake to make it dome shaped. Roll out 875g (1¾lb) of yellow sugarpaste and cover the cake completely, smoothing around the shape, stretching out pleats and smoothing downwards. Trim the excess from around the base and position on the centre of the cake board.

4 Reserve a little yellow sugarpaste for the flower centres, then roll the remaining yellow into oval shapes for the bees. Stick the bees over the beehive using sugar glue. Indent little smiles by pressing the circle cutter in at an angle.

5 Colour some of the yellow sugarpaste trimmings black. Thinly roll out and cut a piece of black to fill the doorway, then cut black strips for the bee stripes. Roll tiny black eyes, then stick everything in place with sugar glue.

6 Thinly roll out a piece of white sugarpaste and cut out petal shapes for the bees' wings, using the small rose petal cutter. Stick two wings in place on each bee, positioning the wings just behind the first black stripe.

7 Cut out five daisy shapes using the large daisy cutter and press in the centre of each to indent. Stick the daisies on to the cake board, around the base of the beehive, then stick a small flattened ball of yellow sugarpaste into the centre of each daisy.

Sugarpaste shapes for the bees.

Sandwich the cakes together with buttercream.

Cut out the daisy shapes using the cutter.

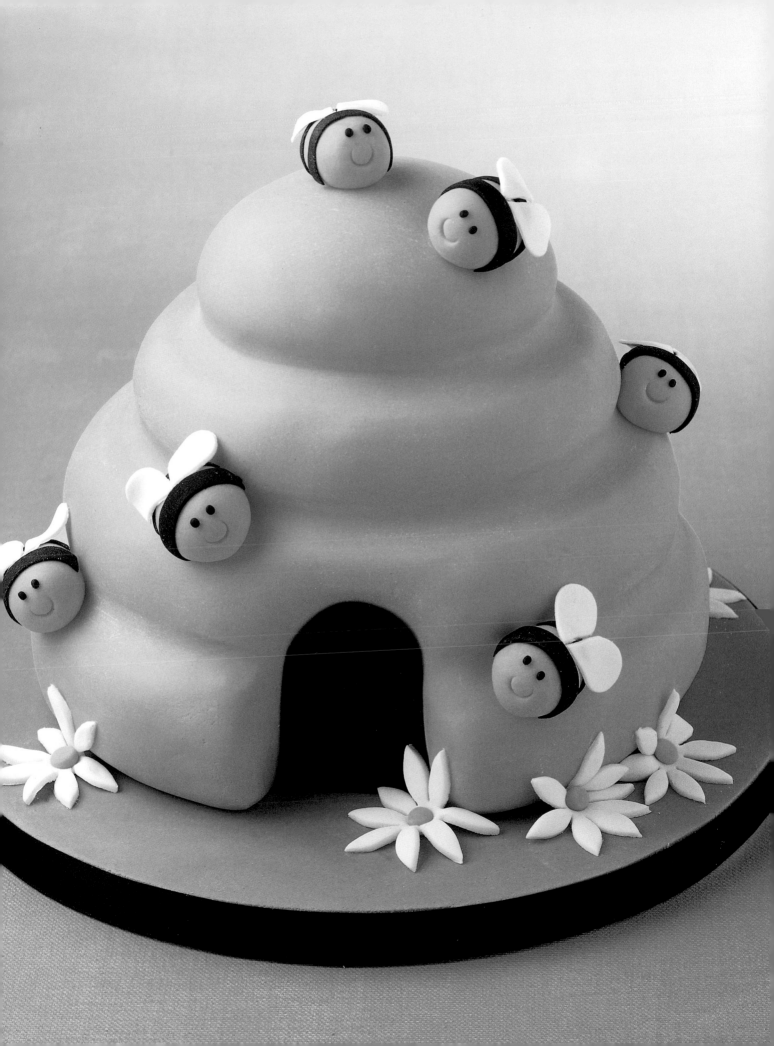

building blocks

A rag doll and number building blocks are one way of learning to count

MATERIALS

- 2 x 15cm (6in) square cakes, see page 8
- 30cm (12in) round cake board
- pink & cream food colouring pastes
- 1.75kg (3½lb) sugarpaste/rolled fondant
- icing/confectioners' sugar in a sugar shaker
- 470g (15oz/1¾ cups) buttercream
- sugar glue
- hundreds and thousands/sprinkles

EQUIPMENT

- large rolling pin
- sharp knife
- medium paintbrush
- 2 cake smoothers
- small circle cutter
- cocktail stick/toothpick

Sugarpaste shapes for the rag doll.

1 Colour 375g (12oz) of sugarpaste pink. Roll out and cover the cake board and put aside to dry. Trim the crust from each cake and slice the tops flat. Cut each cake into four equal sized squares. Sandwich the squares together with buttercream to make four cubes, then spread a layer of buttercream over the surface of each cube. Colour 1.25kg (2½lb) of sugarpaste cream. Roll out a little of the cream sugarpaste, then place one side of a cube down on to it and cut around the shape. Cover all sides of each cube in the same way.

2 Tip the hundreds and thousands on to a plate. Decorate one side of a cube at a time. Moisten the edge of the cube with sugar glue and paint a number in the centre with sugar glue. Press the side of the cube down into the hundreds and thousands. As long as the glue is applied liberally, the hundreds and thousands should stick immediately. Use the cake smoothers to move the cubes around to prevent your fingers from knocking the sweets off. Leave one side of each cube undecorated for the base, then assemble all cubes on the cake board and stick them in place with sugar glue.

3 To make the rag doll, colour 90g (3oz) of sugarpaste dark pink, 15g (½oz) flesh, using a touch each of the pink and cream food colouring pastes, and finally 7g (¼oz) yellow. Using the photograph as a guide, model the dress with 75g (2½oz) of dark pink, pressing the bottom to stretch and frill. With the remaining piece of dark pink, model two oval-shaped shoes, two ball sleeves, a small, flattened circle for the collar and two small bows.

4 Moisten the shoes and collar with sugar glue, then press into the hundreds and thousands. Roll a flesh-coloured sugarpaste sausage and cut in half to make legs. Roll two sausages for arms, shaping rounded ends for hands. Stick everything in place. For the head, roll a flesh-coloured ball, then press in the small circle cutter to indent the smile. To dimple the corners, press in the end of the paintbrush. Model a nose and use hundreds and thousands for eyes.

5 Press small pieces of yellow sugarpaste over the head for the hair. To make the plaits, roll tiny sausages, then press along the edges with a cocktail stick. Stick in place with the bows. Decorate the dress and around the cake board edge with hundreds and thousands. Paint the cheeks with a tiny amount of pink food colouring diluted with a drop of water.

Sandwich the cakes together with buttercream.

Place each cube on the sugarpaste and cut around.

Press each cube into the hundreds and thousands.

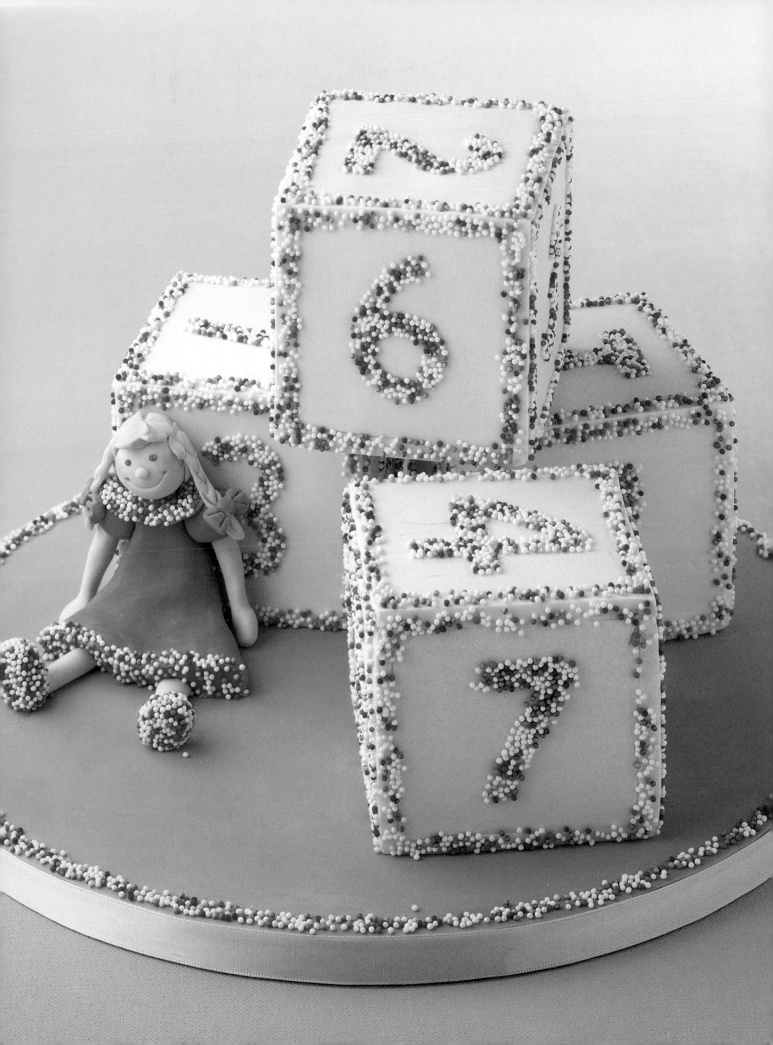

dippy dinosaur

A big, scary dinosaur? Certainly not – this one has far too silly a grin

MATERIALS

- 2 litre (4 pint/10 cup) bowl-shaped cake, see page 9
- 30cm (12in) round cake board
- 1.4kg (2lb 13oz) sugarpaste/ rolled fondant
- yellow, blue & black food colouring pastes
- icing/confectioners' sugar in a sugar shaker
- 345g (11oz/1⅓ cups) buttercream
- sugar glue

EQUIPMENT

- large rolling pin
- sharp knife
- cake smoother
- food-safe plastic dowelling
- fine paintbrush

USEFUL TIP

When a large piece of sugarpaste is rolled out, lift by folding over the rolling pin. This will make it easier to position the sugarpaste on the cake.

1 Colour 375g (12oz) of sugarpaste yellow. Using icing sugar to prevent sticking, roll out and cover the cake board. Trim the excess from around the edge and put aside to dry. Trim the crust from the cake and slice the top flat, then turn the cake upside down. Cut a layer in the cake and sandwich the two halves back together with buttercream. Spread a layer of buttercream over the surface of the cake to help the sugarpaste stick.

2 Colour 1kg (2lb) of sugarpaste blue. Roll out 750g (1½lb) of blue and cover the cake completely. Stretch out any pleats and smooth the sugarpaste downwards around the shape of the cake. Trim any excess sugarpaste from around the base and position the cake on the cake board. Rub the surface with a cake smoother to remove any bumps.

3 Roll 90g (3oz) of blue sugarpaste into a sausage to create the dinosaur's neck and push the plastic dowelling through the centre. Pinch around the top of the neck to lengthen and narrow the sugarpaste, then shape the base of the neck to slant up at the back, so that it will sit comfortably on the dinosaur's bowl-shaped body.

4 Roll a ball using 60g (2oz) of blue sugarpaste for the dinosaur's head, then pinch at the front to shape a rounded muzzle. Mark the top of the head by pressing the side of the paintbrush into the centre to indent, then smooth around the eye area with your fingers. Mark a wide smile using a knife, then push the end of the paintbrush into each corner of the smile to dimple, and into the top of the muzzle to indent nostrils.

5 Carefully push the dowelling and neck down into the bowl-shaped body, securing it with sugar glue, then press on the head. Colour a tiny amount of sugarpaste black for the pupils and make the eyes with white sugarpaste. With the trimmings of yellow sugarpaste, model several flattened balls in different sizes to decorate the dinosaur's back.

6 Split the remaining blue sugarpaste in half. With one half, roll a sausage tapering into a point at one end and stick against the back of the dinosaur to create his tail. Split the remaining piece of blue sugarpaste into four and model the teardrop-shaped feet, marking the dinosaur's toes with the side of a paintbrush.

Sugarpaste shapes for the dinosaur's head.

Use the smoother to ensure a perfect finish.

Push the dowelling supporting the neck into the cake.

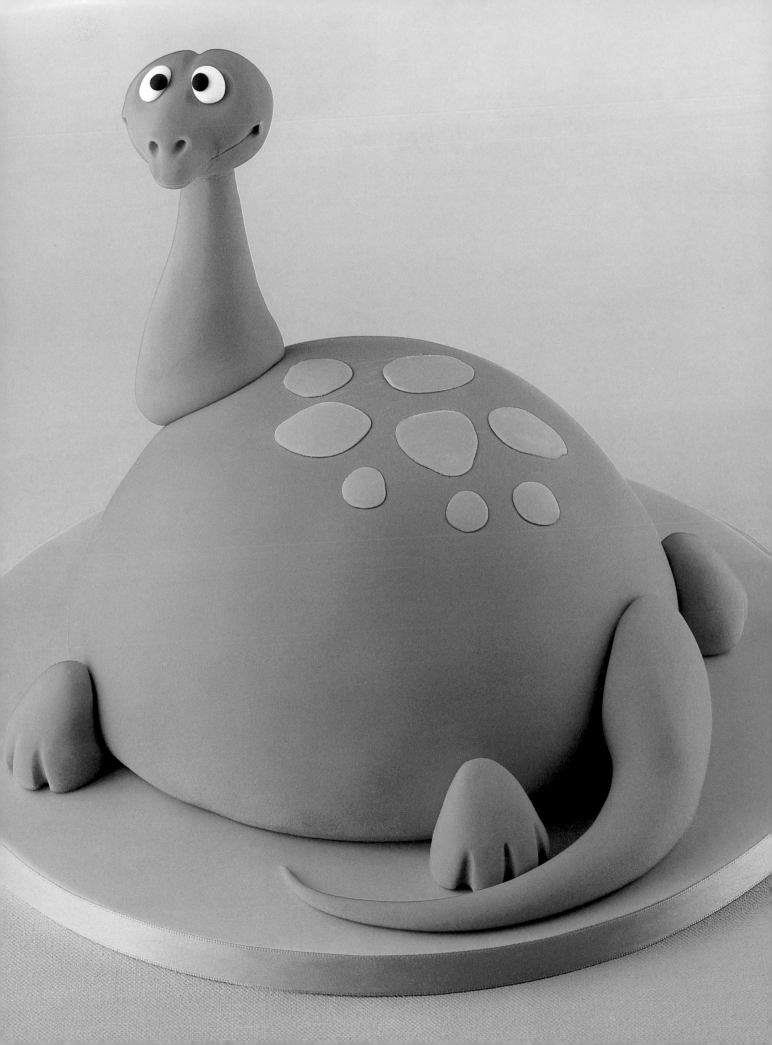

circus clown

A fun, happy clown face is always a popular choice for children's parties

MATERIALS

- 3 litre (6 pint/15 cup) bowl-shaped cake, see page 8
- 35cm (14in) round cake board
- 2kg (4lb) sugarpaste/rolled fondant
- yellow, cream, black, orange, red, blue & green food colouring pastes
- icing/confectioners' sugar in a sugar shaker
- 220g (7oz/1 cup) buttercream
- sugar glue

EQUIPMENT

- large rolling pin
- sharp knife
- cake smoother
- templates, see page 108

USEFUL TIP

Once the clown's face has been covered with sugarpaste, gently rub a cake smoother over the surface.

1 Colour 470g (15oz) of sugarpaste yellow. Using icing sugar to prevent sticking, roll out all the yellow sugarpaste and cover the cake board, trimming any excess from around the edge. Then put the covered cake board aside to dry.

2 Trim the crust from the cake and slice the top flat, using a sharp knife. Spread a layer of buttercream over the surface of the cake to help the sugarpaste stick. Colour 470g (15oz) of sugarpaste cream. Roll out the cream sugarpaste and cover the cake, carefully trimming around the base. Position the cake on the centre of the cake board.

3 Using the templates (see page 108), thinly roll out 45g (1½oz) of white sugarpaste. Cut out the eyes and mouth from this piece. Stick the eyes and mouth in place with sugar glue then, using your finger, smooth a ridge the width of the mouth and indent at each corner to create a smile. Colour 7g (¼oz) of sugarpaste black. Thinly roll out and cut four thin strips for the eyes. Stick the strips in place with sugar glue.

4 To make the clown's hair, first colour 440g (14oz) of sugarpaste orange. Thickly roll out this orange sugarpaste and cut into strips, each approximately 5–7cm (2–3in) in length. Stick these strips around the clown's face, starting at the sides and building up over the top of his head. Colour 140g (4½oz) of sugarpaste red. Make the clown's nose by rolling 45g (1½oz) of the red sugarpaste into a ball, and pressing in place.

5 Colour 250g (8oz) of sugarpaste blue. Roll out and cut the hat rim using the template (see page 108). Using 75g (2½oz) of the blue sugarpaste, roll a ball for the top of the hat. Using red sugarpaste, roll out and cut a thin strip for the hat band and press a small ball flat for the flower centre. Model small teardrop shapes with the yellow trimmings and press flat to make the petals. Using sugar glue, assemble on the clown's head.

6 Roll out the remaining blue sugarpaste and cut out a collar, measuring about 10 × 2cm (4 × ¾in). Stick in place, curling the edge. Colour the last of the sugarpaste green. Make the green, red and blue juggling balls with the remaining pieces of coloured sugarpaste and stick them in place on the board around the clown's face.

Sugarpaste shapes for the clown's hat.

Stick the clown's eyes and mouth in place.

Create the clown's hair with strips of sugarpaste.

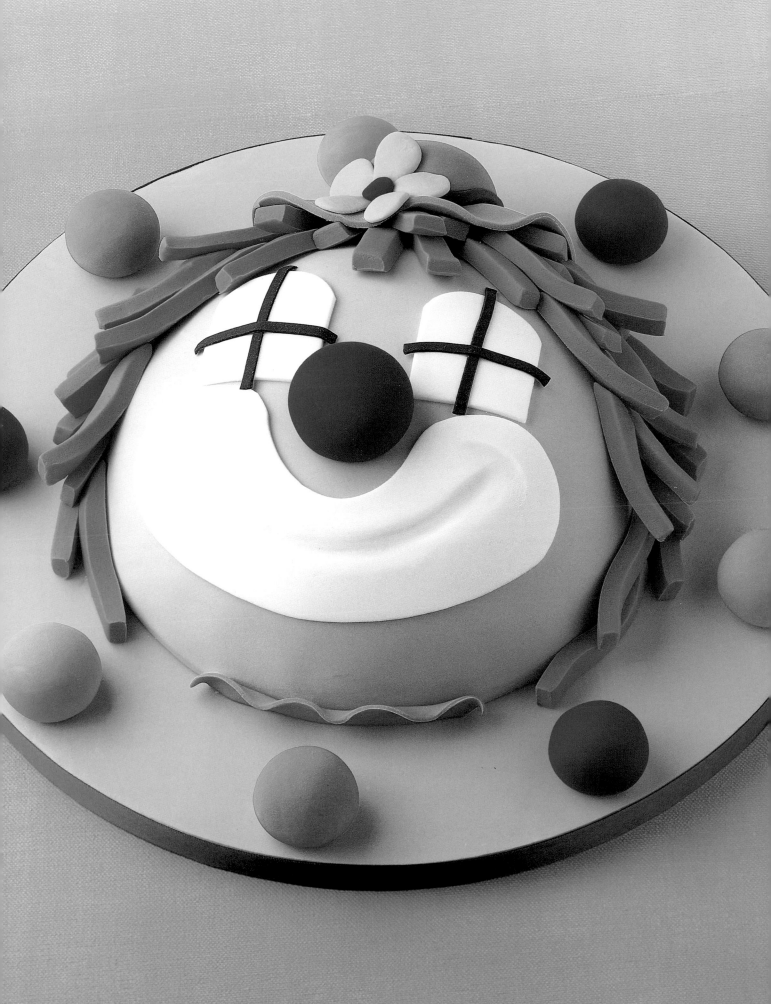

camping out

All children love the idea of a sleep-over in their own back garden

MATERIALS
- 20cm (8in) square cake, see page 8
- 30cm (12in) round cake board
- 410g (13oz/1⅓ cups) buttercream
- 1.35kg (2¾lb) sugarpaste/ rolled fondant
- black, blue, navy blue, green, yellow, cream, brown & orange food colouring pastes
- icing/confectioners' sugar in a sugar shaker
- sugar glue

EQUIPMENT
- large rolling pin
- sharp knife
- fork
- small circle cutter
- cocktail stick/toothpick

1 Trim the crust from the cake and slice the top flat. Cut the cake in half and put one half on top of the other. Cut a triangular wedge from either side, cutting down at an outward angle to the base of the first layer. Arrange these two wedges on either side of the cake to create the tent's sloping sides. Trim a dip in the top. Sandwich together with buttercream, then spread buttercream over the surface of the cake. Colour 90g (3oz) of sugarpaste black. Thinly roll out and cut pieces to cover the two ends of the tent.

2 Colour 90g (3oz) dark blue. Thinly roll out and cut four triangular shaped pieces for the inner tent covering, sticking in position with sugar glue. Colour 22g (¾oz) yellow and roll a long, thin sausage for the inner tent trim. Colour 625g (1¼lb) blue. Roll out and cut a piece slightly larger than the cake for the outer tent covering. Roll trimmings into a ball and place at the side to lift up the tent covering for the peeking boy. Lift the sugarpaste and cover the cake.

3 Colour 280g (9oz) of sugarpaste green. Roll out small pieces, position on the cake board and texture by pressing the prongs of a fork over the surface to give a simple grass effect. Colour two pieces of sugarpaste, each weighing 22g (¾oz), navy blue and red. To make the front of the sleeping bags, model two wedges of each colour, sticking one on top of the other at either end. Smooth up at the front to create a space for the heads.

4 Colour 75g (2½oz) of sugarpaste cream, 45g (1½oz) brown, 60g (2oz) pale brown and 7g (¼oz) orange. To make the blonde boy, roll 30g (1oz) of cream into a ball. Indent a smile using the small circle cutter and dimple each corner with a cocktail stick. Shape a cream nose, hands, white eyes and black pupils. Shape flattened pieces of yellow sugarpaste for his hair and arrange on his head, pinching at the front. Make the other boys in this way.

5 Make the dog using the pale brown sugarpaste. Roll two rounded sausages for paws, and stick one on each boy's head. Shape the head, pinching around the centre. Model flattened teardrops for the muzzle, indenting with the tip of a cocktail stick. Flatten teardrop shapes for ears and a tiny piece of dark brown to make the eye patch. Make a black, triangular-shaped nose. Make eyes as before. For the chocolate bar, cut a small square of pale brown and indent using a knife. Put tiny pieces of brown around the boy's mouth.

Create the dog's head with pale brown sugarpaste.

Sugarpaste shapes for the little boy's head.

Place the cake wedges cut from the top at the sides.

Cover with buttercream and attach the tent's ends.

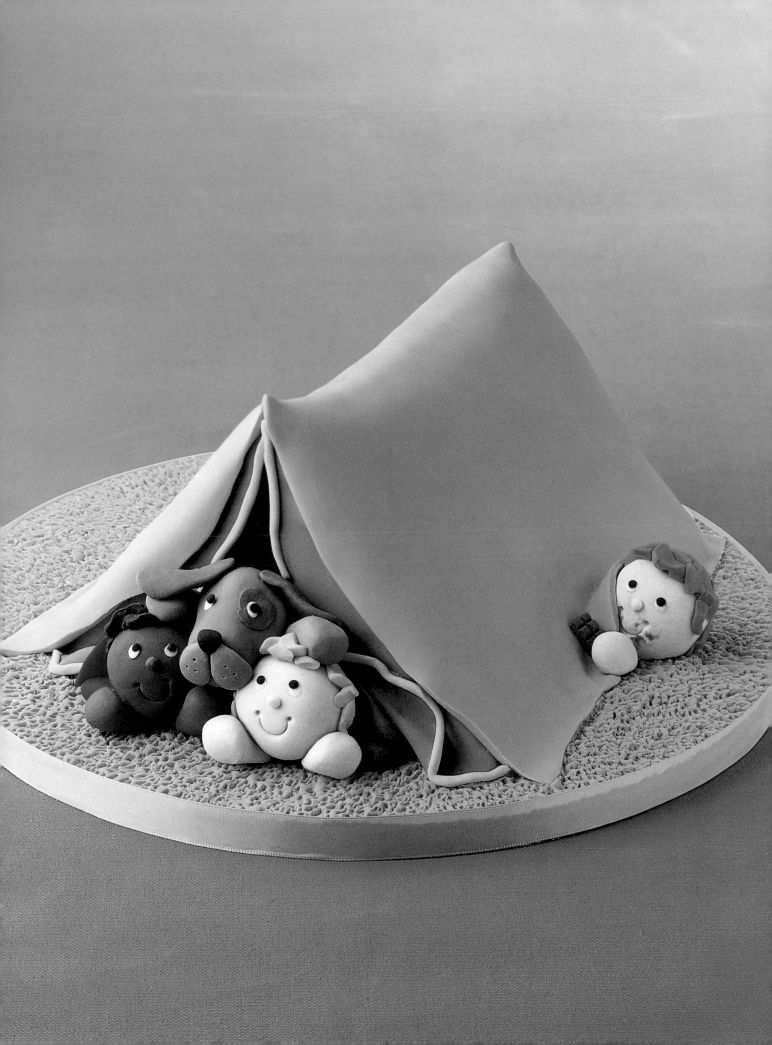

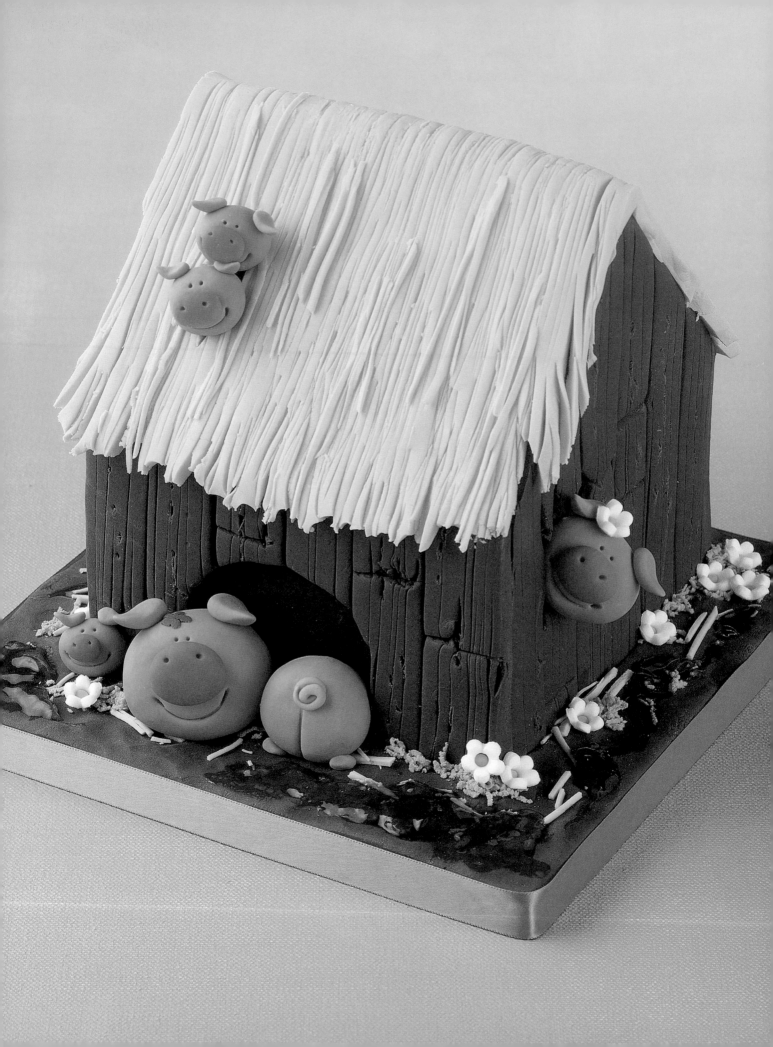

pig pen

A fun idea for any pig lover, or perhaps a hint about a teenager's messy bedroom?

MATERIALS

- 25cm (10in) square cake, see page 8
- 20cm (8in) square cake board
- 500g (1lb/2 cups) buttercream
- 1.5kg (3lb) sugarpaste/rolled fondant
- brown, black, yellow, pink & green food colouring pastes
- icing/confectioners' sugar in a sugar shaker
- sugar glue
- 1–2 tsp clear piping gel

EQUIPMENT

- large rolling pin
- sharp knife
- 2.5cm (1in) circle cutter
- cocktail stick/toothpick
- fine grater
- large blossom plunger cutter, see page 5

USEFUL TIP

Instead of colouring the sugarpaste brown, you could use chocolate sugarpaste as a delicious alternative.

1 Trim the crust from the cake and slice the top flat. Cut the cake into four equal sized squares. Trim either side of the two top layers to shape the sloped roof. Sandwich all the layers of cake together with buttercream, then spread a layer of buttercream over the surface of the cake to help the sugarpaste stick.

2 Colour 875g (1¾lb) of sugarpaste brown. Roll out and place one side of the cake down on to it, then cut around the shape. Lift carefully, then mark all the lines for the wooden planks in the brown sugarpaste with a knife. Cover the other side and the front and back of the cake in the same way, sticking the joins together with sugar glue.

3 Mark the plank ends, creating some jagged edges with a knife. Then cut out a little door in the front and a hole in the side of the pen. Remove the sugarpaste from these holes.

4 Colour 375g (12oz) of sugarpaste pale yellow. Roll out and cut an oblong to fit the roof. For the straw effect, make cuts by drawing the knife downwards to stretch and frill the edge, then lift carefully and position on the cake. Mark more lines on the roof and cut a little hole in the front of the roof, removing the sugarpaste.

5 Colour 30g (1oz) of sugarpaste black. Thinly roll out and cut pieces of black sugarpaste to fill the holes in the front, side and roof of the cake. Roll the remaining brown sugarpaste into a strip and cover the cake board around the cake. Press down to mark an uneven surface and trim the excess from the edge.

6 Colour 15g (½oz) of sugarpaste green. Make the blades of grass by rubbing the piece of green sugarpaste over a fine grater. Sprinkle the resulting tiny blades of grass in little piles on the cake board and around the edge of the pig pen, scattering unevenly. Use sugar glue to secure the piles in position.

continued overleaf!

Sugarpaste pieces for the pig's head, ears and snout.

Sandwich the layers of cake with buttercream.

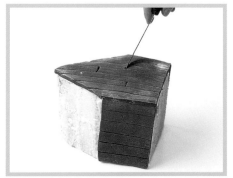

Cut a wooden plank effect with a knife.

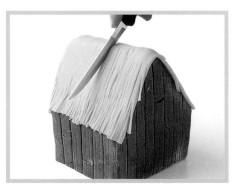

Mark a straw roof in the yellow sugarpaste.

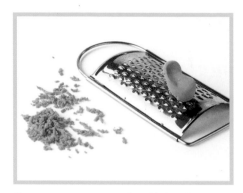

Grate green sugarpaste to form blades of grass.

7 Roll out the trimmings of yellow sugarpaste and cut thin strips to scatter as straw around the cake board. To make the blossom, roll out white sugarpaste and cut all the flowers with the blossom plunger cutter (see page 5). Roll little balls of yellow for the centres of the flowers. Spread a little clear piping gel over the cake board to create the mud.

8 Colour 125g (4oz) of sugarpaste pink and 15g (½oz) dark pink. To make a pig's head, roll a ball of pink, then mark a smile using the circle cutter pressed in at an angle. Indent two eyes using the tip of a cocktail stick. Model two triangular-shaped ears in pink sugarpaste, turning them up at the tip. Model an oval-shaped snout using the dark pink sugarpaste, again indenting with the cocktail stick.

9 Make several different sized pigs and stick them in place around the pig pen with sugar glue. For the pig's bottom, mark a line on a ball of pink sugarpaste using a knife. Then roll a thin sausage of paste and twist it round to make a curly tail, and shape two tiny feet. Stick in position outside the door of the pen.

Place the pigs' heads around the pig pen, with two heads peeking out of the holes cut in the roof.

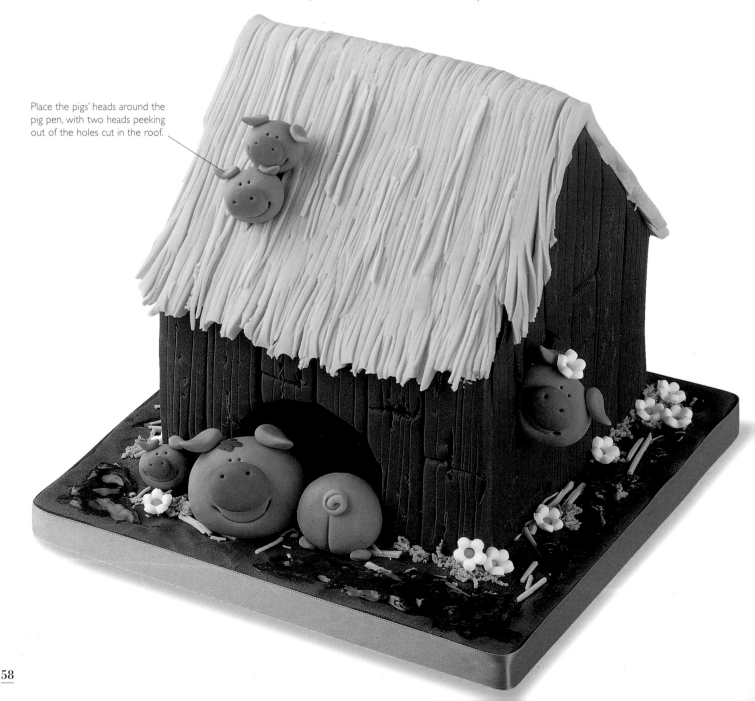

58

skull & crossbones

Would-be pirates will go goggle-eyed over this skull and crossbones

MATERIALS

- 1 x 20cm (8in) & 1 x 15cm (6in) round cakes, see page 9
- 35cm (14in) square cake board
- 2kg (4lb) sugarpaste/rolled fondant
- black food colouring paste
- icing/confectioners' sugar in a sugar shaker
- 375g (12oz/1½ cups) buttercream

EQUIPMENT

- large rolling pin
- sharp knife
- templates, see page 109

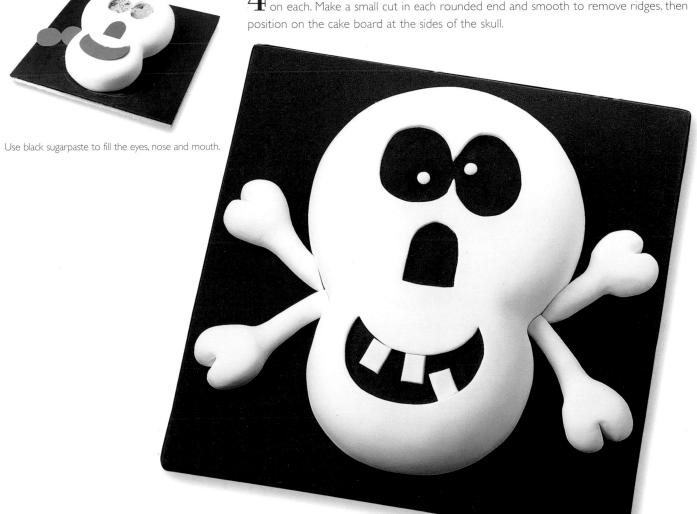

Use black sugarpaste to fill the eyes, nose and mouth.

1 Colour 625g (1¼lb) of sugarpaste black. Using icing sugar to prevent sticking, roll out 500g (1lb) of black sugarpaste and cover the cake board, trimming the excess from around the edge. Put the covered cake board aside to dry.

2 Trim the crust from each cake and slice the tops flat. Cut a 2.5cm (1in) wedge away from the side of each cake, then trim around the top edge of both cakes to round off. Spread the surface of the cakes with buttercream, then position them on the cake board with the two cut edges pressed together.

3 Roll out 1kg (2lb) of white sugarpaste and cover the cake completely, trimming carefully around the base. Using the templates (see page 109), cut out the eyes, nose and mouth from the top of the cake. Thinly roll out black sugarpaste and cut shapes to fill the spaces. Roll two small balls of white sugarpaste for the eyes, then roll out and cut the teeth.

4 To make the bones, roll four thick sausages of white sugarpaste, keeping a rounded end on each. Make a small cut in each rounded end and smooth to remove ridges, then position on the cake board at the sides of the skull.

little blue train

This bright train brimming with sweets will chug on to the birthday party table

MATERIALS

- 18cm (7in) square cake, see page 8
- 30cm (12in) hexagonal cake board
- 1.5kg (3lb) sugarpaste/ rolled fondant
- pink, blue & black food colouring pastes
- icing/confectioners' sugar in a sugar shaker
- sugar glue
- 440g (14oz/1¾ cups) buttercream
- length of liquorice/licorice
- liquorice catherine wheels/ licorice wheels
- assorted liquorice/licorice candies

EQUIPMENT

- large rolling pin
- sharp knife

USEFUL TIP

Gently rub the surface of the sugarpaste with your hands to remove excess icing sugar and give a sheen.

1 Colour 500g (1lb) of sugarpaste pink. Using icing sugar to prevent sticking, roll out the pink sugarpaste and use it to cover the cake board, trimming any excess from around the edge. Put the covered cake board aside to dry.

2 Trim the crust from the cake and slice the top flat, using a sharp knife. Cut a strip measuring 8cm (3in) from one side of the cake. Cut this slice into two pieces, one 7cm (2½in) long and the other 10cm (4in) long. Put the larger piece upright at the end of the smaller piece to form the engine. Trim a curve in the top of the larger piece. Cut the remaining cake into three equal pieces to make the carriages.

3 Sandwich the engine together with buttercream, then spread a layer of buttercream over all the cakes to help the sugarpaste stick. Colour 875g (1¾lb) of sugarpaste blue. Roll out 375g (12oz) of the blue sugarpaste and use to cover the engine completely, smoothing down and around the shape, trimming any excess from around the base. Cover the three carriages in the same way, using the leftover blue sugarpaste.

4 Colour the remaining sugarpaste black. Roll out and cut an oblong that will fit the top of the engine, sticking in place with sugar glue. Thinly roll out black sugarpaste and cut four strips for the windows and stick them in place, then model two flattened ball shapes for the pupils of the eyes and put to one side.

5 Cut three small lengths of liquorice to link the carriages and engine together and put aside. Position all the liquorice 'wheels' against the engine and carriages using a tiny amount of sugarpaste moistened with sugar glue to stick them in place.

6 Carefully place the engine and carriages on the covered cake board and link them together using the lengths of liquorice put aside earlier. Decorate the engine with the assorted liquorice candies and pile candies on to the top of each carriage, securing in place with sugar glue. Use two square pieces of liquorice to form the train's eyes, sticking on the black sugarpaste pupils made earlier.

Cut the cake into five pieces to create the train.

Cover the engine with blue sugarpaste and trim.

Place the liquorice wheels on the side of the train.

hungry bookworm

A cake for avid readers, or perhaps a subtle hint to someone who does not read enough

MATERIALS

- 18cm (7in) square cake, see page 8
- 30cm (12in) square cake board
- 1.25kg (2½lb) sugarpaste/rolled fondant
- green, blue, yellow, black & orange food colouring pastes
- icing/confectioners' sugar in a sugar shaker
- 375g (12oz/1½ cups) buttercream
- sugar glue

EQUIPMENT

- large rolling pin
- sharp knife
- cake smoother
- 1cm (½in), 2cm (¾in) & 4cm (1½in) circle cutters
- length of raw spaghetti

USEFUL TIP

A special birthday message can be added to the cake to look like the title of the book.

The worm's hat and glasses.

1 Colour, then roll out 440g (14oz) of green sugarpaste and cover the cake board. Put aside to dry, reserving the trimmings from around the edge of the cake board. Trim the crust from the cake and slice the top flat. Cut away 2.5cm (1in) from one side of the cake to make an oblong book shape. Cut a layer in the cake and sandwich together with buttercream, then spread a layer of buttercream over the surface of the cake.

2 Position the cake on the cake board. Roll out 220g (7oz) of white sugarpaste and cut a strip to fit around three sides of the cake, leaving the book bind edge uncovered. Mark all the page lines in the white sugarpaste with the back of a knife.

3 Colour, then roll out 410g (13oz) of blue sugarpaste and cut a piece slightly larger than the top of the cake and the book bind edge. Position on the cake, using the cake smoother to create a smooth surface. Cut a strip from the trimmings to fit around the base of the cake, securing it with sugar glue. Remove two circles of sugarpaste from the top. Colour, then thinly roll out 7g (¼oz) of black sugarpaste and cut circles to fill the spaces.

4 Colour 75g (2½oz) of sugarpaste yellow to make the worm. Using 60g (2oz), model a fat teardrop shape for the worm's head. Indent the smile by pressing the 2cm (¾in) circle cutter in at an angle. Push a 10cm (4in) length of raw spaghetti into the large hole, down to the base of the cake to support the worm's head. Moisten with sugar glue, then carefully push the head in position on the spaghetti. Roll the remaining yellow into a sausage tapering in at one end and stick in position coming out of the smaller hole.

5 Roll out the green trimmings. Cut a circle for the hat rim with the large cutter and put it aside to set, then model the top of the hat. Put aside two tiny balls of white for the eyes, then colour the remaining sugarpaste orange. Roll out and cut a strip for the hat.

6 Model two flattened balls of black sugarpaste and cut out the centre of each using the smallest circle cutter. Leave to set for at least ten minutes, then stick in place as the worm's glasses. Roll two white balls for the eyes and two tiny black balls for the pupils. Thinly roll out the orange sugarpaste and cut strips to edge the cake and board.

Mark pages using the back of a knife.

Place a strip of blue sugarpaste around the base.

Push the worm's head on to the piece of spaghetti.

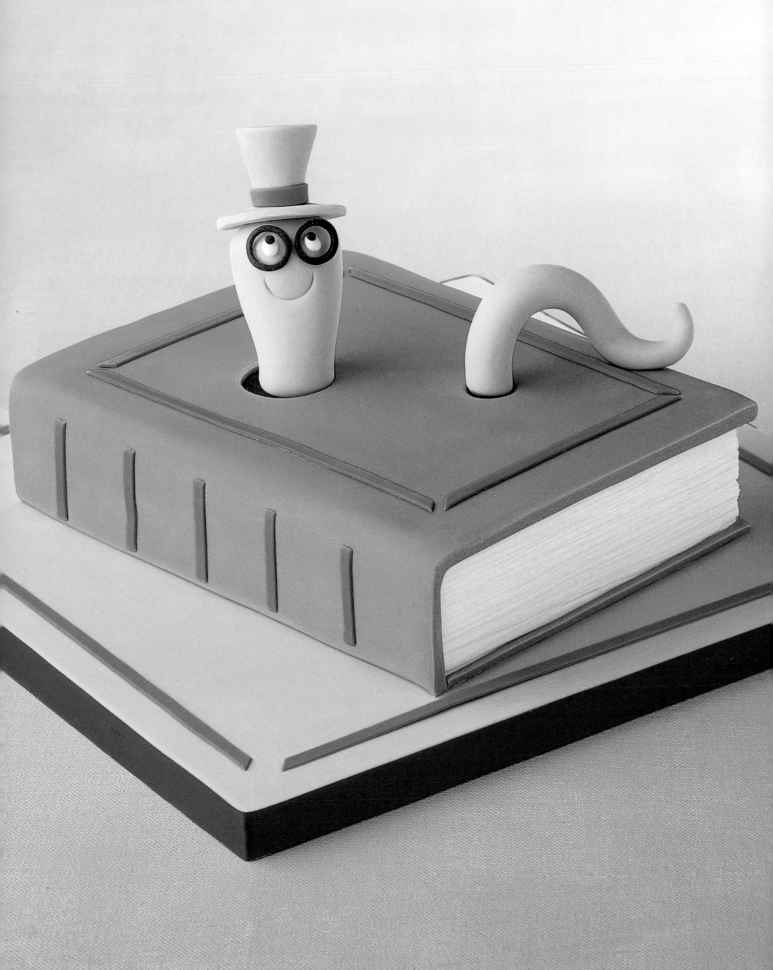

baby in a pram

A baby doll and teddy in their own pram make the perfect cake for small girls

MATERIALS

- 2 litre (4 pint/10 cup) bowl-shaped cake, see page 9
- 25cm (10in) petal-shaped cake board
- mauve, pink, cream & yellow food colouring pastes
- 1.75kg (3½lb) sugarpaste/ rolled fondant
- icing/confectioners' sugar in a sugar shaker
- 375g (12oz/1½ cups) buttercream
- sugar glue
- length of fondant-filled liquorice/licorice
- 4 liquorice/ licorice wheels

EQUIPMENT

- large rolling pin
- sharp knife
- miniature, 1.5cm (¾in) & 13cm (5in) circle cutters
- cocktail stick/toothpick

1 Colour 375g (12oz) of sugarpaste mauve. Using icing sugar to prevent sticking, roll out 315g (10oz) and cover the cake board completely, trimming any excess from around the edge and put aside to dry. Trim the crust from the cake and slice the top flat. Cut two layers in the cake and sandwich back together with buttercream.

2 Colour 1kg (2lb) of sugarpaste pink. Roll a sausage using 140g (4½oz) and place around the top edge of the cake to create a lip. Turn the cake upside down. Roll out 750g (1½lb) of pink sugarpaste and use to cover the cake completely, stretching out pleats and smoothing the sugarpaste around the shape of the cake. Turn the cake over, then smooth the sugarpaste inside the lip, trimming away excess. Position the cake on the cake board.

3 Roll out 75g (2½oz) of white sugarpaste. Cut a circle to cover the top of the cake using the large circle cutter. Shape a pillow using 125g (4oz) of white. Put aside a tiny amount of pink for the teddy's nose, then roll the remaining pink into two sausages tapering at either end and stick in position, one on top of the other, for the pram hood. Bend the liquorice stick and push in for the handle. Stick the liquorice wheels in place with sugar glue.

4 Colour 90g (3oz) of sugarpaste cream and 75g (2½oz) pale yellow. Roll a small ball nose and the doll's head with the cream sugarpaste. Indent facial features by pressing the circle cutters in at an angle. Dimple the doll's smile by pressing in each corner with the tip of a cocktail stick. Mark eyelashes with the tip of a knife. With a small piece of pale yellow sugarpaste, roll a long teardrop and twist to make the curly hair.

5 Roll 22g (¾oz) of mauve sugarpaste into a ball for the teddy's head. With 7g (¼oz), model a flattened oval muzzle, two sausage shapes for arms and two ball ears. Indent the muzzle using a knife and indent the smile. Press a cocktail stick into each ear to indent, then stick the ears in place. Press in the tip to mark eyes. Model the pink triangular nose.

6 Roll out the remaining pale yellow and cut a circle using the large circle cutter. Press to create a scalloped edge, then fold and place in the pram. Thinly roll out the remaining mauve sugarpaste and cut circles to stick over the pram using the 1.5cm (¾in) circle cutter.

Create a lip with a sausage of pink sugarpaste.

Smooth the sugarpaste around and inside the lip.

Mark the doll's eyelashes with the tip of a knife.

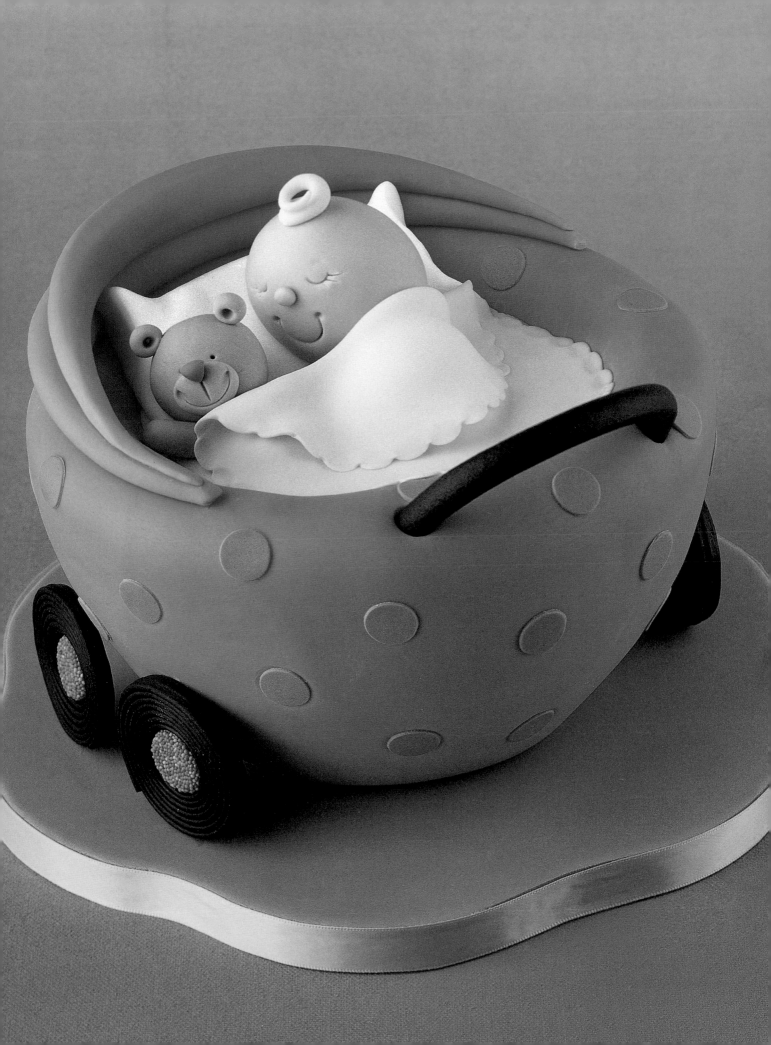

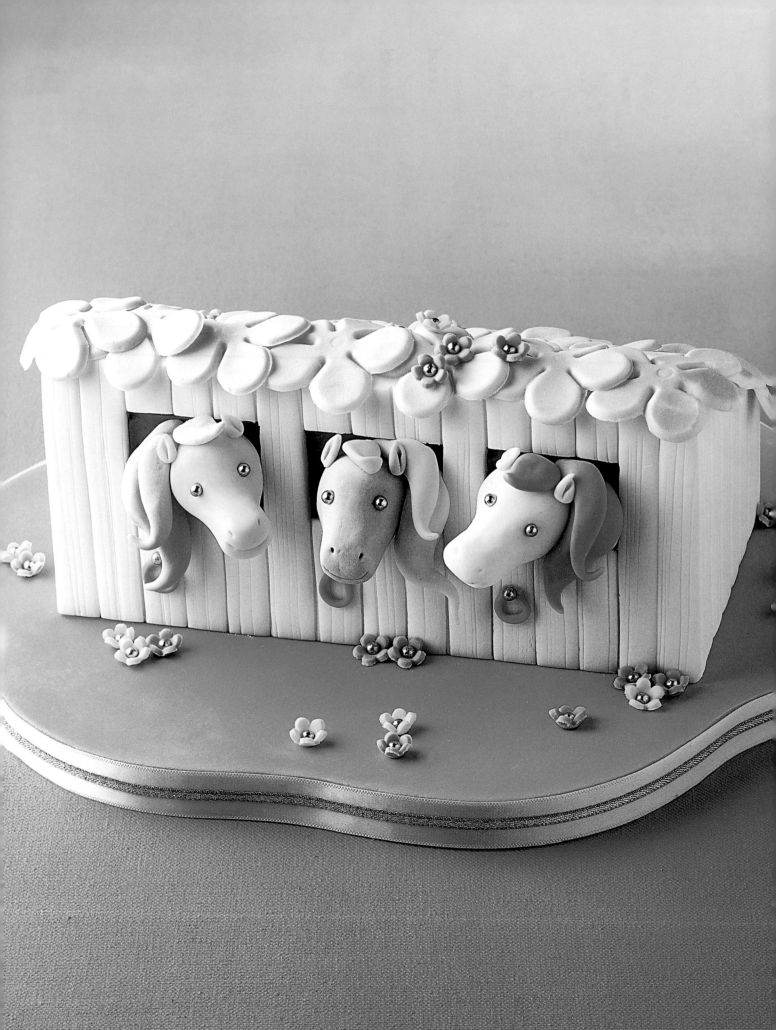

pony stable

This pretty stable and ponies will bring a sparkle to any little girl's special day

MATERIALS

- 20cm (8in) square cake, see page 8
- 30cm (12in) petal-shaped cake board
- 1.25kg (2½lb) sugarpaste/rolled fondant
- blue, green, yellow, black & pink food colouring pastes
- icing/confectioners' sugar in a sugar shaker
- 345g (11oz/1⅓ cups) buttercream
- sugar glue
- silver dragees

EQUIPMENT

- large rolling pin
- sharp knife
- large & small flower cutters
- small pieces of foam sponge
- small circle cutter
- cocktail stick/toothpick
- 3 x 2.5cm (1in) lengths of raw spaghetti
- bone tool, illustrated overleaf

USEFUL TIP

When the flower shape is in the cutter, rub the edge of the cutter to remove excess sugarpaste and create a clean edge.

1 Colour 410g (13oz) of sugarpaste turquoise with the blue and green food colouring pastes. Using icing sugar to prevent sticking, roll out 375g (12oz) and cover the cake board, trimming excess from around the edge, then put aside to dry.

2 Trim the crust from the cake and slice the top flat. Cut the cake exactly in half and put one half on top of the other. Cut a sloping roof, cutting down to the bottom of the top layer with a sharp knife. Sandwich together with buttercream, then spread a layer of buttercream over the surface of the cake to help the sugarpaste stick.

3 Roll out 750g (1½lb) of white sugarpaste and put the end of the stable down on to it. Cut around the shape. Put the cake down on its base and, using a knife, mark lines in the sugarpaste to create a wood effect. Cover the opposite end of the cake, then the back, and finally the front in the same way, before positioning the cake on the cake board.

4 Cut out three windows at the front of the stable, removing the sugarpaste. Colour 22g (¾oz) of sugarpaste dark turquoise. Thinly roll out and cut pieces to fill the spaces.

5 To make the flower-shaped roof tiles, knead turquoise and white sugarpaste together until streaky. Roll out and cut out all the flower shapes with the large flower cutter. Stick the flowers over the roof with sugar glue, starting at the base and working upwards.

6 Create door handles by modelling little loops using the dark turquoise sugarpaste trimmings. Stick the handles and a silver dragee in place on each door with sugar glue.

7 To make the ponies, first colour 30g (1oz) of sugarpaste pale yellow, 22g (¾oz) pink and 15g (½oz) grey. To make the yellow pony, roll 15g (½oz) of yellow into a smooth, crack-free ball, then pinch all the way round to shape the pony's muzzle, pressing gently to keep a smooth surface and pulling it to lengthen, then round off the end.

continued overleaf!

Sugarpaste shapes for the pony's head and mane.

Sandwich the cake together with buttercream.

Place the cake on the sugarpaste and cut to fit.

Cut flowers using the large flower cutter.

Indent the centres of the flowers with a bone tool.

8 Insert a length of raw spaghetti into one of the windows on the front of the cake and moisten the area with sugar glue. Carefully push the pony's head in place, using a piece of foam sponge for support while it is drying. Indent a smile by pressing in the circle cutter at an angle, and indent nostrils with the tip of a cocktail stick.

9 For the mane, shape the remaining turquoise sugarpaste into different sized sausages, tapering to a point at either end and stick in place. Curl up the ends, then flatten a small teardrop shape for the forelock. Model tiny ears, indenting the centre of each with a cocktail stick. Carefully press in silver dragees for eyes.

10 Model the other two ponies in the same way. Make all the small flowers using the small flower cutter and the remaining pink and yellow sugarpaste. Indent the centre of each flower with the end of a bone tool, and stick in a silver dragee to decorate. Stick the small pink and yellow flowers over the cake board and the stable roof using sugar glue.

11 Leave the finished cake to dry completely before carefully removing the pieces of foam sponge used to support the ponies' heads.

Decorative silver dragees for the ponies' eyes and in the centre of the flowers add a sparkle to this pretty cake.

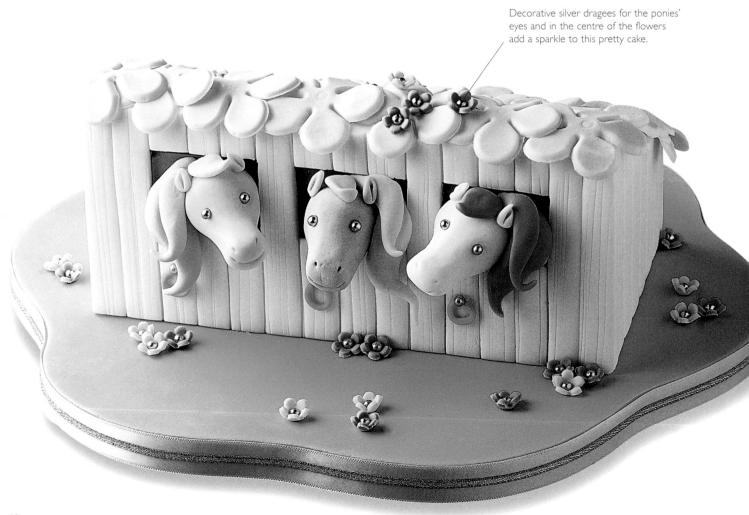

treasure map

Pirate treasure can easily be found with chocolate gold coins shining everywhere

MATERIALS

- 20cm (8in) round cake, see page 8
- 30cm (12in) round cake board
- 410g (13oz/1⅔ cups) buttercream
- 1kg (2lb) sugarpaste/ rolled fondant
- golden brown & blue food colouring pastes
- icing/confectioners' sugar in a sugar shaker
- light brown sugar
- foil-covered chocolate coins
- black food colouring pen
- edible gold sparkle powder/ petal dust/blossom tint

EQUIPMENT

- large rolling pin
- sharp knife
- gold embroidery thread
- medium paintbrush

1 Trim the crust from the cake and slice the top flat. Split the cake in two and sandwich together with buttercream, then position on the cake board. Spread a layer of buttercream over the surface of the cake to help the sugarpaste stick.

2 Colour 875g (1¾lb) of sugarpaste golden brown. Using icing sugar to prevent sticking, roll out and cover the cake and the board completely, smoothing the sugarpaste around the shape of the cake. Trim the excess from around the cake board edge. Place a length of gold embroidery thread over the top of the cake.

3 Colour the remaining sugarpaste cream using a tiny amount of golden brown food colouring. Thinly roll out and cut an 18cm (7in) square to create the treasure map. Make different sized cuts along the top and bottom edge. Roll up one side of the map and position on the cake. Arrange the gold thread ends over the map.

4 Sprinkle some light brown sugar around the cake and position all the gold coins. Leave the cake to dry, then draw on the map using the black food colouring pen and paint with diluted blue and golden brown food colouring pastes. Finally, brush the cake with the gold sparkle powder.

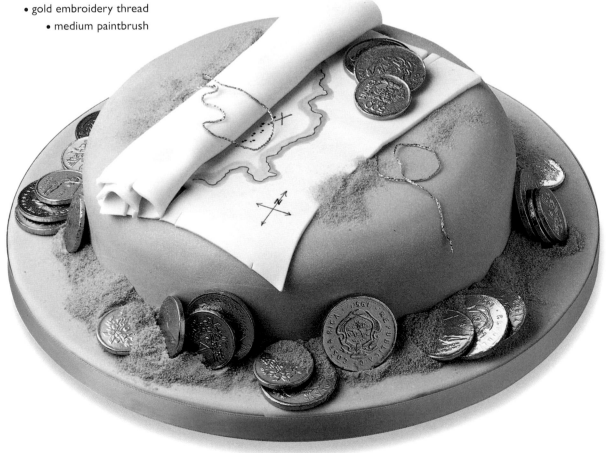

castle guards

Look-out guards will have to be extra vigilant or this cake will soon disappear

MATERIALS
- 25cm (10in) square cake, see page 8
- 12 mini swiss rolls/jelly rolls
- 25cm (10in) round cake board
- 440g (14oz/1¾ cups) buttercream
- 1.5kg (3lb) sugarpaste/ rolled fondant
- black, cream & green food colouring pastes
- icing/confectioners' sugar in a sugar shaker
- sugar glue

EQUIPMENT
- small rolling pin
- sharp knife
- 3.5cm (1½in) circle cutter
- small square cutter
- cocktail stick/toothpick

Cut the turrets using the square cutter.

1 Trim the crust from the cake and slice the top flat. Cut the cake into four equal squares and sandwich the squares together with buttercream to form the castle. Sandwich three mini swiss rolls together for each corner tower, then spread a layer of buttercream over the surface of the entire cake to help the sugarpaste stick.

2 Colour 125g (4oz) of sugarpaste black. Using icing sugar to prevent sticking, thinly roll out 60g (2oz) and cut a panel to cover the front of the cake. Colour 250g (8oz) of sugarpaste pale grey, 625g (1¼lb) grey and 250g (8oz) dark grey using a touch of black food colouring paste. Roll out 155g (5oz) of grey sugarpaste and cut a square to cover the top of the cake, then cut four circles using the cutter and position one on top of each tower. Using the different shades of grey, shape flattened pieces of sugarpaste and press on to the cake surface, covering the cake completely, apart from three windows and a doorway at the front.

3 With the remaining grey sugarpaste, roll out and cut strips measuring 2.5cm (1in) in depth. Cut the turrets using the small square cutter and stick in place with sugar glue. Thinly roll out and cut strips for the portcullis, indenting with the tip of a cocktail stick. Slightly flatten small modelled balls of grey sugarpaste to create an edging for the doorway.

4 Split 7g (¼oz) of dark grey sugarpaste into three pieces and model teardrop shapes for the guards' helmets. Stick these with the point uppermost at each window, then press to indent the centre of each. Colour a small amount of sugarpaste cream and model three ball-shaped heads and oval-shaped noses and hands, sticking in place with sugar glue. Mark the faces with a cocktail stick. Shape tiny sleeves with grey sugarpaste.

5 Shape the cannon with 30g (1oz) of black sugarpaste by rolling a ball, then pinching to shape the funnel. Push a cocktail stick into the end and twist around to open up. With the remaining black, model flattened circles for wheels and roll the cannon balls.

6 Colour the remaining sugarpaste green. Roll out and press on to the cake board, pushing up against the cake and indenting with the rolling pin to mark an uneven surface. With the remaining pieces of grey, shape rocks and scatter them over the board.

Sandwich the cake and swiss rolls with buttercream.

Place a panel of black sugarpaste on the front.

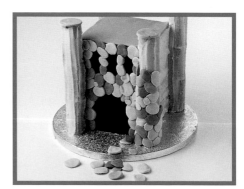

Cover the cake with flattened pieces of sugarpaste.

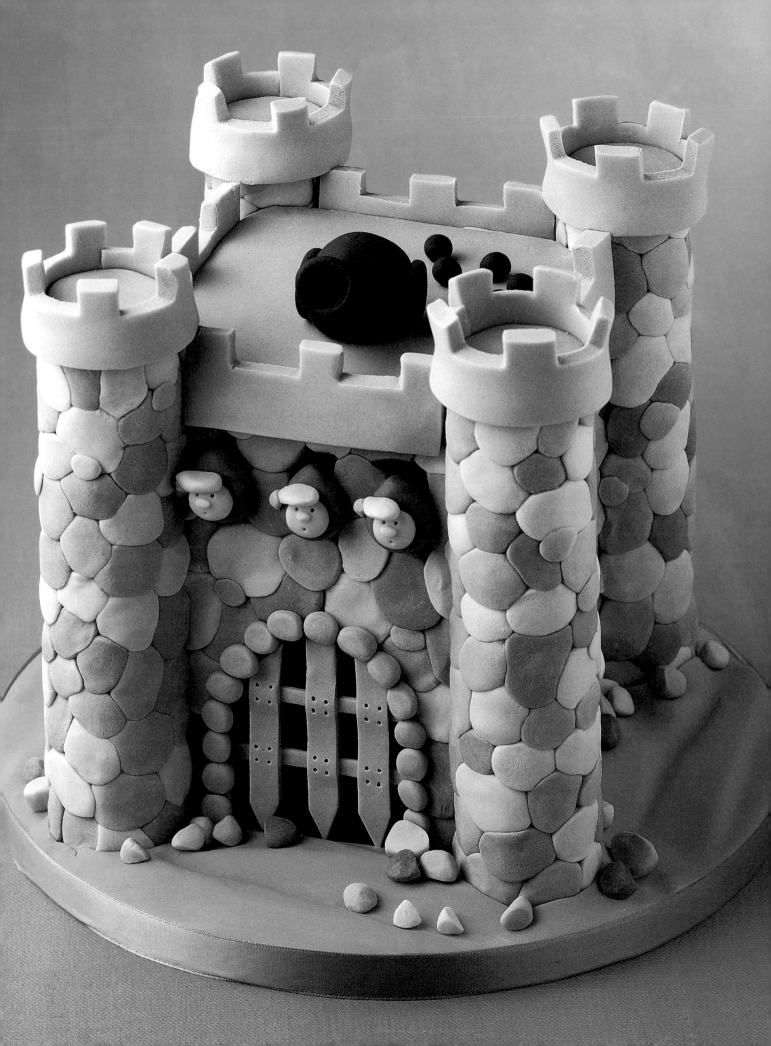

toy boat

A simply shaped boat that all pre-school children will love

MATERIALS

- 2 litre (4 pint/10 cup) bowl-shaped cake, see page 9
- 25cm (10in) round cake board
- 1.75kg (3½lb) sugarpaste/rolled fondant
- blue, red, yellow, black & green food colouring pastes
- icing/confectioners' sugar in a sugar shaker
- 345g (11oz/1⅓ cups) buttercream
- sugar glue

EQUIPMENT

- large rolling pin
- sharp knife
- small & medium bowls
- cake smoother
- small & medium circle cutters
- cocktail stick/toothpick

Sugarpaste shapes for the lifebelts and rope.

1 Colour 315g (10oz) of sugarpaste blue. Using icing sugar to prevent sticking, roll out and cover the cake board completely, trimming excess from around edge. To indent water ripples, firmly press down the rim of the two bowls several times into the sugarpaste covering.

2 Trim the cake crust and slice the top flat. Cut a layer from the top measuring 1cm (½in) in depth. Cut into squares and stack together to make the cabin. Trim so the stack tapers in at the base, then sandwich together with buttercream. Spread the surface with buttercream.

3 Turn the cake upside down. Cut a wedge off one end to form the back of the boat, then cut wedges from either side to shape the sides of the boat so they form a point at the front. Turn the cake over and spread a layer of buttercream over the surface.

4 Colour 1kg (2lb) of sugarpaste red. Roll a long sausage and position it around the top of the boat to create a lip. Roll out 875g (1¾lb) of red sugarpaste and cover the cake, smoothing around the shape. Smooth the sugarpaste and trim. Position the boat on the cake board and smooth the surface with a cake smoother.

5 Colour, then roll out 155g (5oz) of yellow sugarpaste. Cover each side of the cabin separately by putting the cake down on the sugarpaste and cutting around, then smooth the joins closed. Remove a circle of sugarpaste for each porthole. Colour, then roll out 7g (¼oz) of black sugarpaste thinly, and cut circles to slot in the spaces. Stick the cabin on the boat. Colour 125g (4oz) of sugarpaste green. Roll out 45g (1½oz) and cut a square to fit the roof.

6 Roll the remaining green and red separately into two balls. Stick the two together, and roll over the work surface into a teardrop shape using the cake smoother. Cut at either end to create a straight edge and stick in position on top of the cabin to form the funnel.

7 Roll out white sugarpaste and cut five circles using the larger circle cutter. Cut a smaller circle from the centre. Stick against the side of the boat. Roll out red sugarpaste and cut two triangles for each lifebelt. Roll thin sausages of yellow sugarpaste. Press with a cocktail stick at intervals to create a rope effect. Cut into lengths and stick between each lifebelt.

Stack layers of cake to form the boat's cabin.

Create a lip with a length of red sugarpaste.

Make portholes with circles of black sugarpaste.

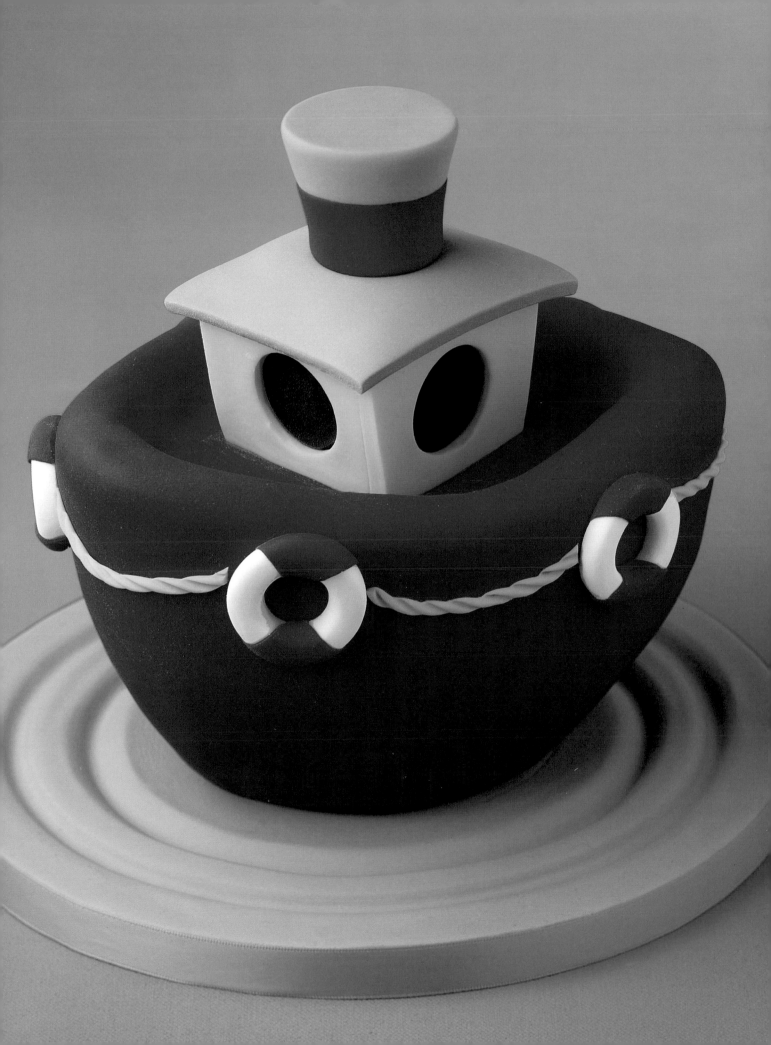

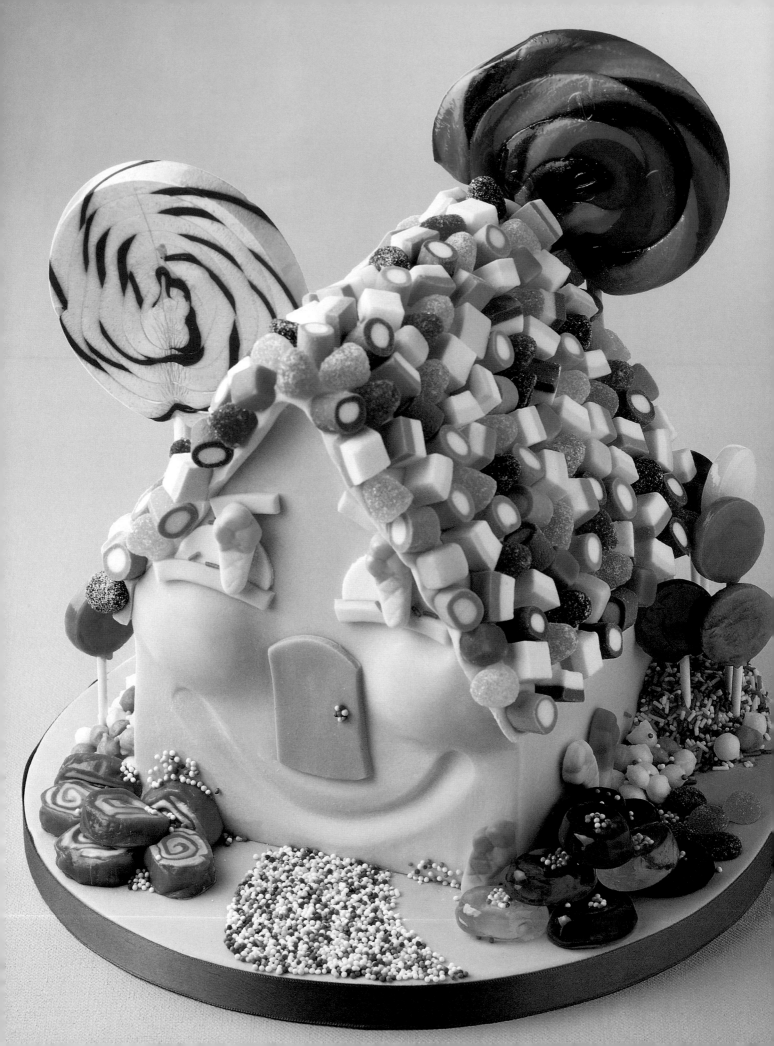

candy house

Absolutely covered in sweets – this has to be a child's dream come true

MATERIALS
- 25cm (10in) square cake, see page 8
- 25cm (10in) round cake board
- 1.5kg (3lb) sugarpaste/ rolled fondant
- green, yellow & pink food colouring pastes
- icing/confectioners' sugar in a sugar shaker
- 500g (1lb/2 cups) buttercream
- sugar glue
- assorted sweets/candies
- lollipops
- hundreds and thousands/sprinkles
- vermicelli/sugar strands

EQUIPMENT
- large rolling pin
- sharp knife
- cake smoother
- 3cm (1¼in) circle cutter

USEFUL TIP
Use any types of sweets available to decorate this simple house. As a special treat, use your child's favourite sweets.

1 Colour 440g (14oz) of sugarpaste green. Using icing sugar to prevent sticking, roll out 315g (10oz) and cover the cake board, trimming the excess sugarpaste from around the edge. Put the covered cake board aside to dry.

2 Trim the crust from the cake and slice the top flat. Cut the cake into four equal squares. Put one on top of the other, making sure that each layer sits straight. Trim a wedge from either side of the two top layers of cake to create the sloping roof.

3 Sandwich all the layers of cake together using buttercream, then spread a layer of buttercream over the surface of the cake to help the sugarpaste stick.

4 Colour 1kg (2lb) of sugarpaste pale yellow. Split 22g (¾oz) in half, roll into balls and press on to the front of the house to create padding for the cheeks. Roll out 170g (5½oz) of pale yellow sugarpaste and cut two pieces to cover the two sides of the house. Press in position and smooth with a cake smoother.

5 Roll out 220g (7oz) of yellow sugarpaste. Position the back of the cake down on to this piece of yellow sugarpaste and cut around the shape. Repeat this process to cover the front of the cake. Carefully position the covered cake on the cake board. Sugar glue the joins and smooth them closed. Using your finger, gently indent the smile.

6 Roll out the remaining pale yellow sugarpaste and cut a piece slightly larger than the two sides of the roof. Position this on top of the cake. Moisten the roof with sugar glue. Arrange some of the smaller, soft sweets over the roof, covering it completely.

7 Using the remaining green sugarpaste, model some bushes around the base of the house, positioning them where the lollipops will be. Moisten the lollipop sticks and push them into the bushes for support. For large lollipops, moisten a tiny amount of sugarpaste with sugar glue and use to stick the top of the lollipop against the house more securely.

continued overleaf!

Create eyes with sweets and sugarpaste shapes.

Trim the top layers of the cake to create the roof.

Cut around the shape of the cake with a knife.

Stick the sweets to the roof with sugar glue.

8 Arrange all the remaining sweets around the cake board, piling against the sides of the house. Moisten the front path with sugar glue, then sprinkle with hundreds and thousands which will stick to the glue. Sprinkle the bushes with sugar strands.

9 Thinly roll out 7g (¼oz) of white sugarpaste and cut a circle. Cut the circle in half for the eyes. Cut strips for the top and bottom using pale yellow trimmings. Stick on to the house using two sweets for the pupils and a sprinkling of sugar strands for the eyelashes.

10 Colour the remaining sugarpaste pink. Thinly roll out and cut an oblong for the door. Using the circle cutter, cut a curve in the top, then stick in place on the front of the cake. Use hundreds and thousands for a tiny door handle.

Sprinkle the green bushes supporting the lollipops with sugar strands.

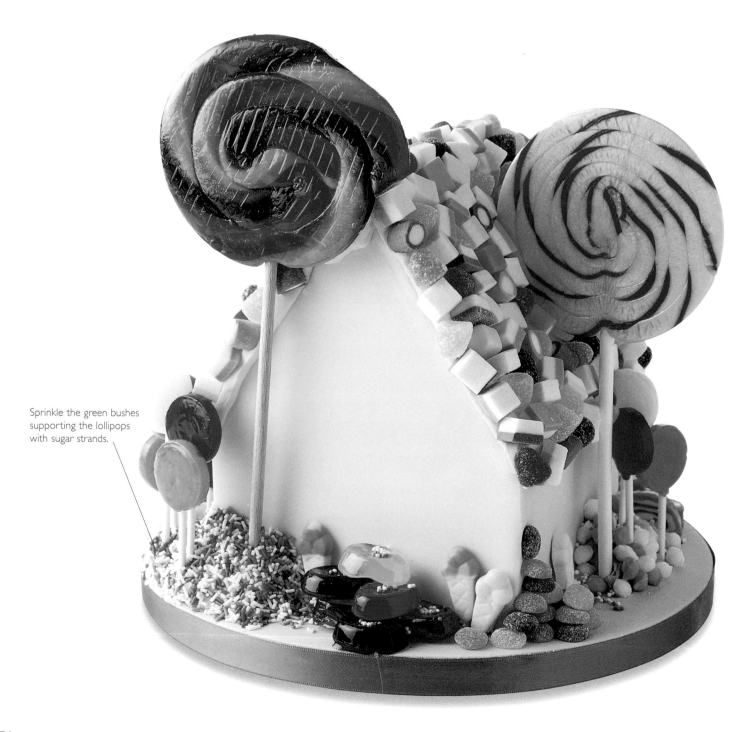

flower power

*Certainly eyecatching, this trendy
flower cake is a treat for any teenager*

MATERIALS

- 20cm (8in) petal-shaped cake, see page 8
- 30cm (12in) round cake board
- 410g (13oz/1½ cups) buttercream
- icing/confectioners' sugar in a sugar shaker
- 1kg (2lb) sugarpaste/rolled fondant
- orange, yellow & black food colouring pastes
- sheet of rice paper
- black, yellow, orange, pink, blue & green food colouring pens
- sugar glue
- small length of liquorice/licorice

EQUIPMENT

- sheet of flower print wrapping paper
- non-toxic glue stick
- sheet of greaseproof paper/ wax baking paper
- scissors
- large rolling pin
- sharp knife
- cake smoother
- templates, see page 108
- 5cm (2in) & miniature circle cutters
- cocktail stick/toothpick
- small pieces of foam sponge

1 Cover the cake board with paper, as described on page 7. Cut out the cake shape in greaseproof paper using the bakeware as a guide. This act as a barrier between the cake and the paper-covered cake board. Trim the crust from the cake and slice the top flat. Cut a layer in the cake and sandwich together using buttercream. Spread a thin layer of buttercream over the cake. Roll out 750g (1½lb) of white sugarpaste and cover the cake.

2 Colour 250g (8oz) of sugarpaste orange. Roll out and cut six petals, using the template (see page 108). Smooth the edges of each to round off, then stick in place around the cake with sugar glue. Cut out a circle in the centre and remove the sugarpaste. Colour the white trimmings yellow and cut out a flattened ball to fill the centre of the cake.

3 Cut out the butterfly's wings from a piece of rice paper using the template (see page 108). With the black food colouring pen, draw the pattern on each wing on the smooth side of the rice paper. Colour the design using the food colouring pens, then put aside to dry.

4 Colour 7g (¼oz) of the trimmings black. Roll a long teardrop shape for the butterfly's body, then roll a ball-shaped head, two pupils and two balls for the end of each antenna. Press the tiny circle cutter into the head to indent the smile. Using a cocktail stick, make two tiny holes in the top of the butterfly's head. Cut two tiny strips of liquorice and slot into the holes, securing with sugar glue. Stick the two balls on the top of each antenna. Using a tiny amount of white sugarpaste, make the eyes, sticking the black pupils in place.

5 To assemble the butterfly, stick the body and head on the cake. With a knife, make two cuts either side of the body. Moisten with sugar glue and slot in the rice paper wings. Cut strips of rice paper to fit each curve of the cake. Colour the strips different colours. Moisten with sugar glue and stick around the cake.

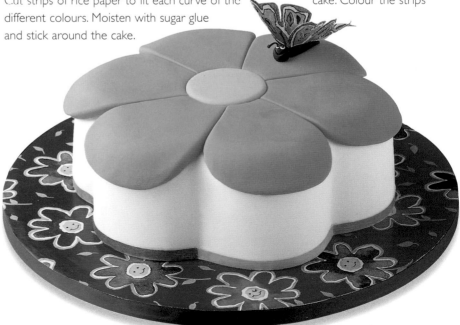

Paint the butterfly's wings with food colouring pens.

formula 1 car

Any car-mad racing fan will be unstoppable when they see this winner

MATERIALS

- 25cm (10in) square cake, see page 8
- 35cm (14in) round cake board
- 2kg (4lb) sugarpaste/ rolled fondant
- black, red, blue & green food colouring pastes
- icing/confectioners' sugar in a sugar shaker
- sugar glue
- 375g (12oz/1½ cups) buttercream

EQUIPMENT

- large rolling pin
- sharp knife
- cake smoother
- number cutter
- templates, see page 110

USEFUL TIP

Use food colouring pens if you want to add more detailing to the car. Available in a range of colours, these pens are perfect for drawing fine lines and writing on sugarpaste. Before you start, make sure that the cake is completely dry.

1 Colour 410g (13oz) of sugarpaste grey, using a touch of black food colouring paste, then colour 75g (2½oz) of sugarpaste red. Roll out the grey and cover the cake board, leaving a section uncovered on one side. Trim this side into a curve. Roll out and cut red and white sugarpaste strips and stick on the board to fill the gap, using sugar glue, then put aside to dry.

2 Trim the crust from the cake and slice the top flat. Cut the cake in half. One half is the main body of the cake. Trim either side at the front to taper in and trim to slope down. Cut a wedge measuring 5cm (2in) from the other half and use to lengthen the cake. Cut another wedge measuring 4cm (1½in) to heighten the back of the cake. From the remaining cake, cut two pieces for either side of the car.

3 Using buttercream, sandwich all the pieces of cake together, then spread a layer of buttercream over the surface of the cake. Colour 875g (1¾lb) of sugarpaste blue. To create the driving seat, roll a ball using 30g (1oz) of blue and press just in front of the raised wedge. Roll a sausage with 15g (½oz) and position in a curve on top of the cake.

4 Roll out the remaining blue and cover the cake completely, smoothing around the shape and into the grooves. Trim around the base, being careful not to mark the cake board. Roll out 75g (2½oz) of white sugarpaste and cut a wedge for the top of the back of the car, then cut two side pieces using the template (see page 110), sticking in place with sugar glue.

5 Colour 75g (2½oz) of sugarpaste green. Using the templates (see page 110), cut wedges for the front of the car at either side, then cut two side pieces. Stick in place. Roll a ball using 45g (1½oz) of green to make the driver's helmet and stick on to the top of the cake.

6 To make the tyres, first colour 375g (12oz) black. Split 345g (11oz) of this black sugarpaste into four equal sized pieces. Roll one of the pieces into a ball, then press down gently with the cake smoother to flatten. Make the three other tyres in the same way and stick in place with sugar glue. Using the remaining sugarpaste, thinly roll out and cut pieces to decorate the car, using the templates (see page 110) and a number cutter relevant to the birthday. Cut a small strip for the helmet visor using black sugarpaste.

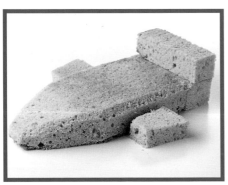

Place the shaped cakes together to form the car.

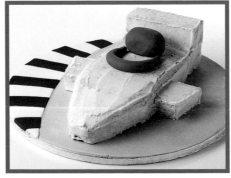

Create the driving seat with sugarpaste shapes.

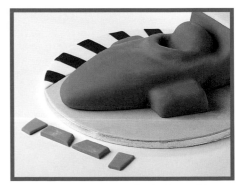

Cut green sugarpaste shapes for the front of the car.

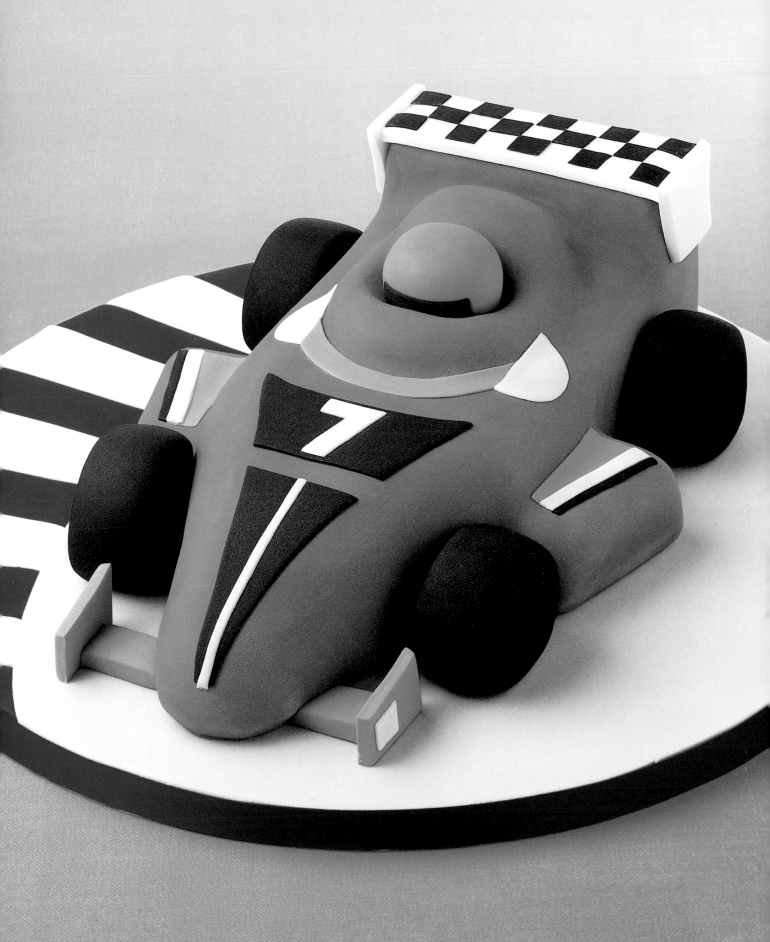

crowning glory

This jewelled crown is sure to be the centre of attention at any party

MATERIALS

- 20cm (8in) round cake, see page 8
- 20cm (8in) round cake board
- 375g (12oz/1½ cups) buttercream
- 1.25kg (2½lb) sugarpaste/rolled fondant
- icing/confectioners' sugar in a sugar shaker
- red food colouring paste
- 155g (5oz/⅔ cup) royal icing
- fruit-flavoured sweets/candies

EQUIPMENT

- large rolling pin
- sharp knife
- gold card
- scissors
- templates, see page 108
- piping bag

USEFUL TIP

If you would like to add ribbon banding to the edge of the cake board, apply before decorating the cake sides.

1 Trim the crust from the cake, keeping the top of the cake rounded where it has risen. Split the cake in two and fill with buttercream, then spread a layer of buttercream over the surface of the cake to help the sugarpaste stick.

2 Thinly roll out 500g (1lb) of white sugarpaste and cover the cake completely, stretching out any pleats around the sides, smoothing down and trimming excess. Don't worry about an uneven surface, this layer seals in crumbs and will be covered with decoration.

3 Position the cake on the centre of the cake board. Colour 250g (8oz) of sugarpaste red. Thinly roll out the red sugarpaste and place over the top of the cake, encouraging the sugarpaste to lie in folds and pleats for a fabric effect.

4 Using the templates (see page 108) cut out the crown pieces, cutting double the number required (the pieces are stuck back to back to prevent the crown being white on the inside). Stick the backs of the crown pieces together using dabs of royal icing, then stick to the cake sides with royal icing, holding in place for a few seconds until secure.

5 Roll out the remaining white sugarpaste into a strip and stick around the base of the cake with royal icing, pinching the surface to give a fur effect. Stick all the sweets in place around the white sugarpaste with royal icing.

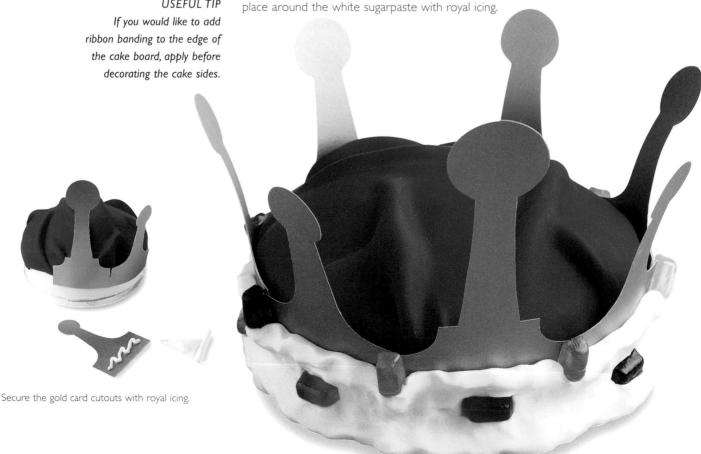

Secure the gold card cutouts with royal icing.

snake pit

One snake for every birthday year will make this cake simply wriggle with fun

MATERIALS

- 23cm (9in) ring-shaped cake, see page 8
- 25cm (10in) round cake board
- 315g (10oz/1¼ cups) buttercream
- 1.5kg (3lb) sugarpaste/rolled fondant
- brown, red, yellow, green, mauve, blue & black food colouring pastes
- icing/confectioners' sugar in a sugar shaker
- sugar glue

EQUIPMENT

- sharp knife
- large rolling pin

1 Trim the crust from the cake with a sharp knife and slice the top flat. Turn the cake over and position the cake on the centre of the cake board. Spread a layer of buttercream over the surface of the cake to help the sugarpaste stick.

2 Colour 750g (1½lb) of sugarpaste brown. Roll out and cover the cake completely, smoothing around the shape and inside the ring. Trim the excess sugarpaste from around the edge of the cake board. Using your hands, indent the sugarpaste all the way around the cake, creating an uneven surface. Model different sized flattened balls with the brown sugarpaste trimmings and stick randomly over the cake.

3 Take five 140g (4½oz) pieces of sugarpaste and colour red, yellow, green, mauve and blue. To make a snake, roll a sausage of coloured sugarpaste with a thin sausage of another colour, tapering in at one end for the tail and rounding off the other end for the head. Holding the head, curl the snake's body around and stick in position with sugar glue.

4 Make all the other snakes in this way. The amounts of sugarpaste quoted will be enough to make eight snakes. Mark each snake's mouth using a knife. To finish, model flattened white sugarpaste ovals for the eyes. Colour a small amount of sugarpaste black and model the pupils, sticking them in place quite close together on the eyes.

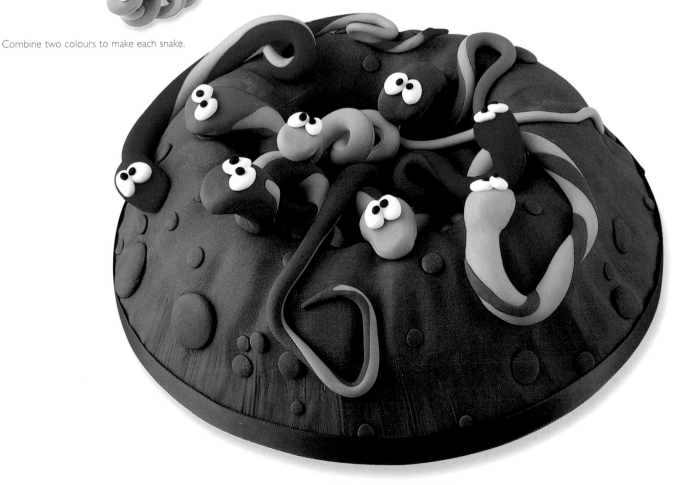

Combine two colours to make each snake.

mini monsters

Each party guest can take their own mini monster home with them

MATERIALS
- 25cm (10in) square cake, see page 8
- 30cm (12in) round cake board
- 2.25kg (4½lb) sugarpaste/ rolled fondant
- mauve, red, yellow, orange, green, blue, purple & black food colouring pastes
- icing/confectioners' sugar in a sugar shaker
- 410g (14oz/1¾ cups) buttercream
- sugar glue

EQUIPMENT
- sharp knife
- large rolling pin
- scissors
- 4cm (1½in) circle cutter
- cocktail stick/toothpick

USEFUL TIP
Polish the surface of the sugarpaste with your hands to remove excess icing sugar and to give each cake a sheen.

1 Colour 375g (12oz) of sugarpaste mauve. Using icing sugar to prevent sticking, roll out the mauve sugarpaste and cover the cake board, then put aside to dry.

2 Trim the crust from the cake and slice the top flat. Cut the cake into slightly uneven squares by cutting the cake into three strips, then cutting each strip into four, to get twelve pieces of cake. Trim the corners to round each piece off, then cover each cake with a layer of buttercream to help the sugarpaste stick.

3 To make a mini monster, first split 1.75kg (3½lb) of sugarpaste into six equally sized pieces. Colour the six pieces red, yellow, orange, green, blue and purple. Roll out the red sugarpaste and position a piece of cake on it. Then wrap the sugarpaste around the piece of cake, smoothing the join completely closed.

4 Using scissors, snip up the sugarpaste a couple of times to create tufts of hair. Press the circle cutter in at an angle to indent the smile, then dimple the two corners of each mini monster's mouth with a cocktail stick.

5 Cover the remaining pieces of cake in the same way. Make one more red mini monster, then two each in yellow, orange, green, blue and purple. With the remaining white sugarpaste, model flattened oval shapes for eyes. Colour 15g (½oz) black and roll tiny ball-shaped pupils. Attach the eyes and pupils with sugar glue.

6 To make the feet and hands, model teardrop shapes and flatten slightly. Make two cuts in the wider end and smooth to remove ridges. For the feet, pinch around the centre to indent and flatten under the toes. For hands, pinch to create a wrist. Model uneven ball-shaped noses. Secure all the eyes, noses, feet and hands in place with sugar glue.

7 Carefully position each cake on the cake board. So that each monster can be separated easily when serving, do not use sugar glue when assembling all the monsters on the board, unless the cake has to travel. Don't forget to save a piece for the birthday monster!

Sugarpaste shapes for each monster's hands and feet.

Trim the corners off each square of cake.

Indent a smile with the circle cutter.

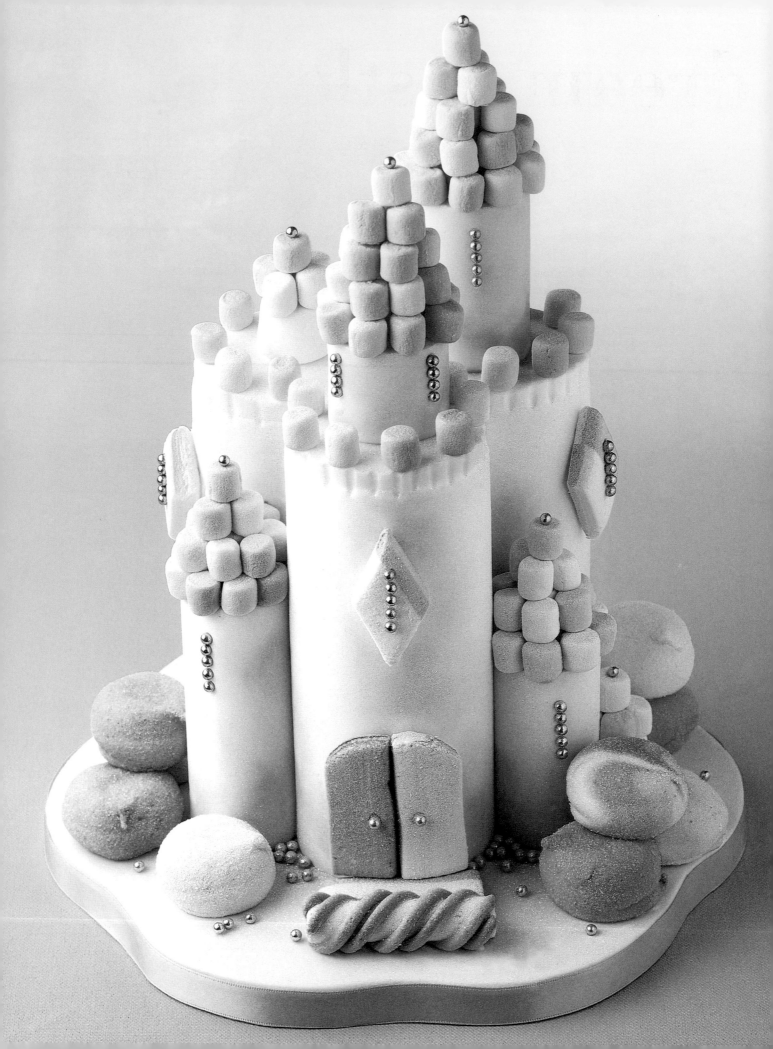

dream castle

A magical dream castle made from swiss rolls and turrets of marshmallows

MATERIALS

- 3 x 15cm (6in) swiss rolls/jelly rolls
- 5 mini swiss rolls/jelly rolls
- 25cm (10in) petal-shaped cake board
- 2kg (4lb) sugarpaste/ rolled fondant
- yellow food colouring paste
- icing/confectioners' sugar in a sugar shaker
- 375g (12oz/1½ cups) buttercream
- sugar glue
- 100g (3½oz/½ cup) royal icing
- mini marshmallows
- assorted marshmallow shapes
- silver dragees
- edible pink dusting powder/ petal dust/blossom tint
- edible sparkle powder/ petal dust/blossom tint

EQUIPMENT

- large rolling pin
- sharp knife
- piping bag/tip
- cake smoother (optional)
- medium paintbrush

1 Colour 315g (10oz) of sugarpaste yellow. Using icing sugar to prevent sticking, roll out the yellow sugarpaste and use to cover the cake board, trimming any excess sugarpaste from around the edge. Put the covered board to one side to dry.

2 To create the different sized mini towers, cut one third from a mini swiss roll and sandwich on to the end of another mini swiss roll with buttercream. Spread all the swiss rolls with buttercream to help the sugarpaste stick.

3 Thickly roll out 470g (15oz) of white sugarpaste. Don't be tempted to thinly cover the large swiss rolls to save sugarpaste, as the cakes need the support of a thick layer of sugarpaste. Position one large swiss roll down on to the piece of rolled-out sugarpaste. Cut to size by cutting a straight line in the sugarpaste at either end of the swiss roll.

4 Roll the sugarpaste around the cake, trimming at the join. Moisten the join with sugar glue and smooth closed. To achieve a totally smooth surface, roll the cake over the work surface using a cake smoother. Cover the remaining large swiss rolls in the same way.

5 Make sure that the three large, covered swiss rolls are exactly the same size and are level when upright. Put the royal icing into the piping bag and use it to stick the three large cakes in position on the cake board. Roll out the trimmings of white sugarpaste and cut a piece to fit the top of the three cakes. Place the piece of white sugarpaste on the top of the cakes and trim around the edge, then smooth the joins closed.

6 Press around the top edge of each tower with a sharp knife to indent. Stick mini marshmallows around the top edge of the towers to create the turrets.

7 Cover one end of each mini swiss roll with a piece of white sugarpaste, then roll out the remaining white sugarpaste and cover the sides of the swiss rolls, using the same method as before. Build up pyramids of mini marshmallows to shape roofs for the small towers, securing the marshmallows in place with sugar glue.

continued overleaf!

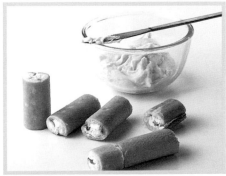
Sandwich swiss rolls together with buttercream.

Roll a layer of sugarpaste around each large swiss roll.

Place a piece of sugarpaste on top of the tower.

Secure the marshmallows with sugar glue.

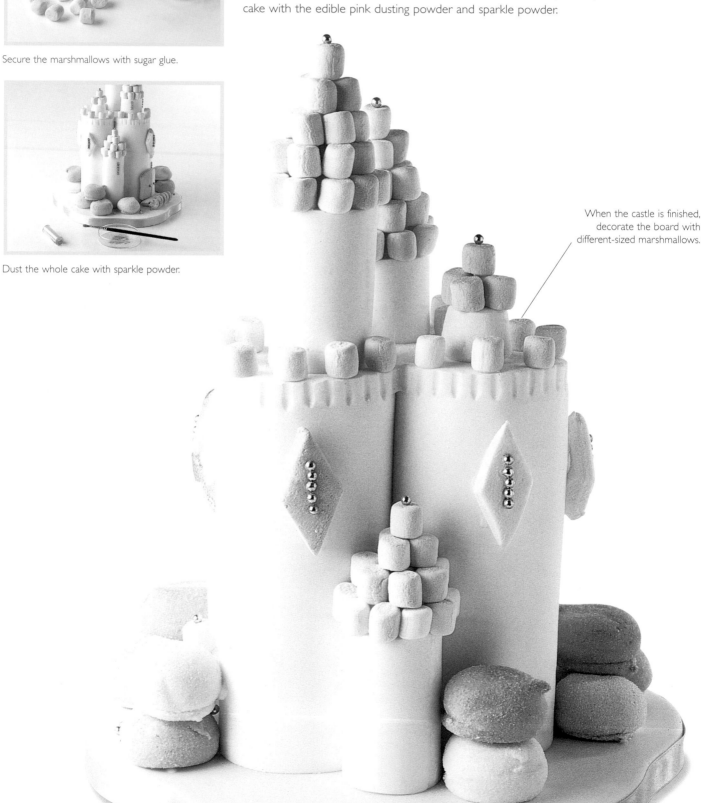

Dust the whole cake with sparkle powder.

8 Make smaller towers with piles of marshmallows to sit on top of the larger towers and at the base of the main cake. Secure all the towers in place on the cake board with royal icing. Place assorted marshmallow shapes around the towers to decorate.

9 Create the windows and door handles using silver dragees, pressing each one gently into the sugarpaste and marshmallow pieces. Stick a dragee on the top of each roof, then sprinkle some over the cake board. When the cake is dry, use a paintbrush to dust the cake with the edible pink dusting powder and sparkle powder.

When the castle is finished, decorate the board with different-sized marshmallows.

smiling sun

This smiley sun has got his hat on, and he is ready to come out to play

MATERIALS

- 2 x 1 litre (2 pint/5 cup) bowl-shaped cakes, see page 8
- 35cm (14in) round cake board
- 2kg (4lb) sugarpaste/rolled fondant
- blue, yellow & black food colouring pastes
- icing/confectioners' sugar in a sugar shaker
- 280g (9oz/1 generous cup) buttercream
- sugar glue

EQUIPMENT

- large rolling pin
- sharp knife
- cake smoother
- template, see page 108

1 Colour 500g (1lb) of sugarpaste pale blue. Using icing sugar to prevent sticking, roll out and cover the cake board completely, trimming excess from around edge. Trim the crust from each cake and slice the tops flat. Sandwich the two cakes together to make a ball, then spread buttercream over the surface to help the sugarpaste stick.

2 Colour 1kg (2lb) of sugarpaste yellow. Roll out and use to cover the cake completely, smoothing down around the shape and underneath. Cut away any excess pleats of sugarpaste and smooth the joins closed. Position the cake on the centre of the cake board and smooth the surface with a cake smoother.

3 To indent a wide grin, gently press in the rim of the ovenproof bowl that the cake was baked in, then smooth with your finger at each end for the corners of the mouth. Colour 45g (1½oz) of sugarpaste black. Roll out the black sugarpaste and cut out the sunglasses, using the template (see page 108). Stick in place with a little sugar glue.

4 For the handkerchief hat, thinly roll out 155g (5oz) of white sugarpaste and cut an oblong measuring 12 x 8cm (5 x 3in). Position on top of the sun, pleating the sides by pinching carefully. Make little curly teardrop shapes for the handkerchief corners, then roll small balls for each tie. To make the clouds, roll different sized balls of white sugarpaste, five for the front cloud and four for the back, then roll out the remaining white sugarpaste and cover the clouds completely, smoothing around the shape.

Using the template, cut out the sunglasses.

drummer boy

This cake is sure to create a big bang when presented at the party table

MATERIALS

- 2 x 15cm (6in) round cakes, see page 8
- 25cm (10in) round cake board
- 1.5kg (3lb) sugarpaste/ rolled fondant
- blue, black, red & cream food colouring pastes
- icing/confectioners' sugar in a sugar shaker
- 375g (12oz/1½ cups) buttercream
- sugar glue
- silver dragees

EQUIPMENT

- large rolling pin
- sharp knife
- cake smoother
- silver embroidery thread
- cocktail stick/ toothpick
- small circle cutter
- 2 lollipop sticks

Sugarpaste shapes for the soldier.

1 Colour 315g (10oz) of sugarpaste blue. Roll out and cover the cake board, then put aside to dry. Trim the crust from each cake and slice the tops flat. Sandwich the two cakes together with buttercream, then spread a layer over the surface of the cake.

2 Roll out 600g (1¼lb) of white sugarpaste and cut a strip to fit around the cake sides. Dust with icing sugar, then carefully roll up. Position the end against the cake sides, then unroll around the cake. Secure the join with sugar glue and rub gently to close. Roll out 250g (8oz) of white. Position the top of the cake down on to it and cut around. Turn the cake the other way up and position on the board. Rub gently with a cake smoother.

3 Colour 250g (8oz) of sugarpaste black. Roll out 100g (3½oz) and cut a strip to fit round the base of the cake. Roll up, then stick around the cake using sugar glue. Make a band for the top edge in the same way. To stick the silver thread in place, moisten the side of the black band where the thread is to be inserted. Push the thread into the sugarpaste with a cocktail stick. Press the thread into the band at the top and bottom, creating a zigzag pattern. Stick silver dragees at each point. Colour 75g (2½oz) red. Split 15g (½oz) in half and roll balls for the drum sticks. Using sugar glue, push the lollipop sticks into each and put aside to dry.

4 To make the soldier's shoes, split 7g (¼oz) of black sugarpaste in half and model two teardrop shapes, sticking the points together. For the trousers, model a teardrop shape using 30g (1oz), flatten slightly and cut the top and bottom straight. Mark a line down the front to separate the legs, then stick on to the shoes. To make the jacket, model a teardrop shape with 45g (1½oz) of red, flatten slightly and cut the top and bottom straight. Pinch around the base to hollow out so it sits neatly over the trousers and pinch at the waist to narrow. Stick in place on the trousers and against the cake. Make two sausage-shaped arms, then flatten a small ball, cutting a 'v' from one side to make a collar.

5 Colour some white trimmings cream to make the head, nose and hands, marking a smile with the circle cutter. Shape a black hat, hollowing out at the base to sit on his head. Cut thin strips using black, then stick everything in place with sugar glue. Decorate with two silver dragees. Position the drum sticks on the cake. Remove the thread before serving.

Unroll the strip of sugarpaste around the cake.

Place the cake on the sugarpaste and cut around.

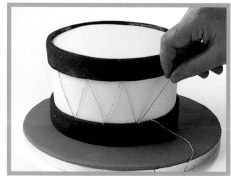

Push the silver thread in with a cocktail stick.

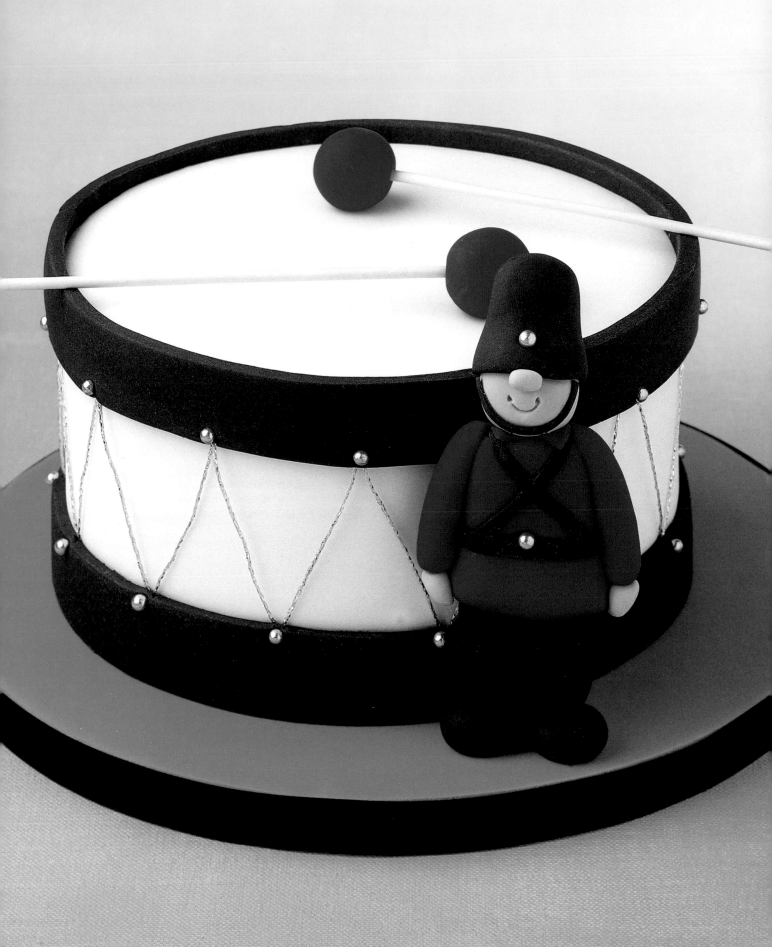

party bags

*Children will be thrilled to take
these bags home at the end of the party*

MATERIALS
- 20cm (8in) square cake,
 see page 8
- 30cm (12in) round cake board
- 2kg (4lb) sugarpaste/
 rolled fondant
- green, blue, red, golden brown & black
 food colouring pastes
- icing/confectioners' sugar
 in a sugar shaker
- 375g (12oz/1½ cups) buttercream
- sugar glue
- black food colouring pen
- lollipops
- sugar-coated chocolates

EQUIPMENT
- rolling pin
- sharp knife
- large petal cutter
- miniature circle cutter
- cocktail stick/toothpick

1 Colour 375g (12oz) of sugarpaste green. Using icing sugar to prevent sticking, roll out and cover the cake board, trimming the excess sugarpaste from around the edge. Put the covered board aside to dry. Trim the crust from the cake and slice the top flat. Cut the cake into nine equal sized squares, as in the photograph below. Spread each of the squares of cake with buttercream to help the sugarpaste stick.

2 Cover the top of one piece of cake by rolling out 15g (½oz) of white sugarpaste and placing the top of the square down on to it, then cutting around. Cover the top of all the other squares in the same way. To make a bag, roll out 155g (5oz) of white sugarpaste and cut a straight edge. Place the bottom edge of the square on this line. Cut the top of the sugarpaste in a straight line 2.5cm (1in) above the cake. Wrap the white sugarpaste around the cake, trimming any excess at the join. Stick the join together with sugar glue, then gently rub the join closed. Cover all the other squares in the same way.

3 Colour some sugarpaste trimmings red and blue. To decorate the bags, thinly roll out the pieces of green, red and blue sugarpaste and cut out balloon shapes with the petal cutter, sticking in them place on the sides of the bags with sugar glue.

4 Colour 410g (13oz) of sugarpaste golden brown. To make one teddy, roll 22g (¾oz) into a ball for a body. Roll 15g (½oz) into another ball for a head and stick on to the body with sugar glue. With 7g (¼oz), shape two oval-shaped feet, make a ball-shaped muzzle, two tiny ears and two sausage-shaped arms. Press a cocktail stick into each ear to indent. Mark a line on the muzzle using a knife. Press the miniature circle cutter in at an angle to indent the smile and dimple by pressing the tip of a cocktail stick into each corner.

5 Make eight more teddy bears in this way, turning their heads slightly to look in different directions. Colour some of the sugarpaste trimmings black and shape all the little triangular noses. Fill each bag with a teddy, a lollipop and a few sugar-coated chocolates. When the cakes are dry, draw in fine lines for the balloon strings on each bag with the black food colouring pen. Draw dots for eyes. Finally, position the cakes on the cake board, ensuring that the sides with the balloons are facing outwards.

Sugarpaste shapes for the teddy bears.

Cover the squares of cake with buttercream.

Wrap white sugarpaste around each piece of cake.

alien spaceship

Space buffs will certainly give this alien creation permission to land

MATERIALS

- 2 litre (4 pint/10 cup) bowl-shaped cake, see page 9
- 35cm (14in) round cake board
- 1kg (2lb) sugarpaste/ rolled fondant
- mauve, black & green food colouring pastes
- icing/confectioners' sugar in a sugar shaker
- 185g (6oz/¾ cup) buttercream
- 60g (2oz/¼ cup) royal icing
- strands of liquorice/licorice
- fruit-flavoured jelly sweets/candies

EQUIPMENT

- large rolling pin
- sharp knife
- cake smoother
- cocktail sticks/toothpicks
- small circle cutter
- piping bag

USEFUL TIP

A sprinkling of icing sugar when rolling out sugarpaste helps prevent it sticking to the work surface.

1 Colour 750g (1½lb) of sugarpaste mauve. Roll out 470g (15oz) and cover the cake board, then put aside to dry. Trim the crust from the cake and slice the top flat. Turn the cake upside down. Spread with a layer of buttercream to help the sugarpaste stick before positioning the cake on the centre of the cake board.

2 Roll out the remaining mauve sugarpaste and cover the top of the cake only. Trim away the excess sugarpaste, leaving a strip of uncovered cake around the base approximately 5cm (2in) wide. Smooth the surface with a cake smoother.

3 Colour 140g (4½oz) of sugarpaste black, roll it out thinly and cut a strip to fit the gap around the base of the cake. With the mauve sugarpaste trimmings, cut narrow strips to mark the windows and stick them in place with a little royal icing.

4 Colour the remaining sugarpaste green. To make each alien, roll a ball of sugarpaste, pulling down a neck and carefully pinching all the way round until long and thin. Put the alien on to the work surface, then push in the tip of a cocktail stick to mark two nostrils. Press in twice at the top to make two holes for the long antennae to slot into. Don't make the antennae until all the aliens are in position on the cake.

5 To mark the mouth, press in the circle cutter at an angle. Roll tiny balls of black sugarpaste for the eyes. Make all the other aliens, some larger than others, and secure them in position with royal icing.

6 Make the aliens' antennae by rolling a long, thin sausage of green sugarpaste and cutting it into short lengths. Slot the antennae into the holes. Stick a black ball on to the end of each of the antennae, securing everything in place with tiny dots of royal icing.

Mould a ball of green sugarpaste to create each alien's head, neck and ears.

7 Stick strips of liquorice and fruit-flavoured jelly sweets around the outside edge of the cake board using royal icing. Cut two small lengths of liquorice and push them into the top of the spaceship to create the aerial. Cut a small hole in two of the sweets and slot them carefully on to the ends of each of the liquorice strands. This spaceship and its alien occupants are now ready for take off!

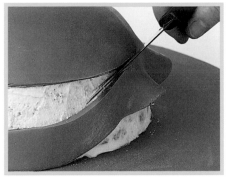

Trim a strip of sugarpaste from the base of the cake.

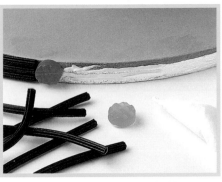

Decorate the edge of the cake board with sweets.

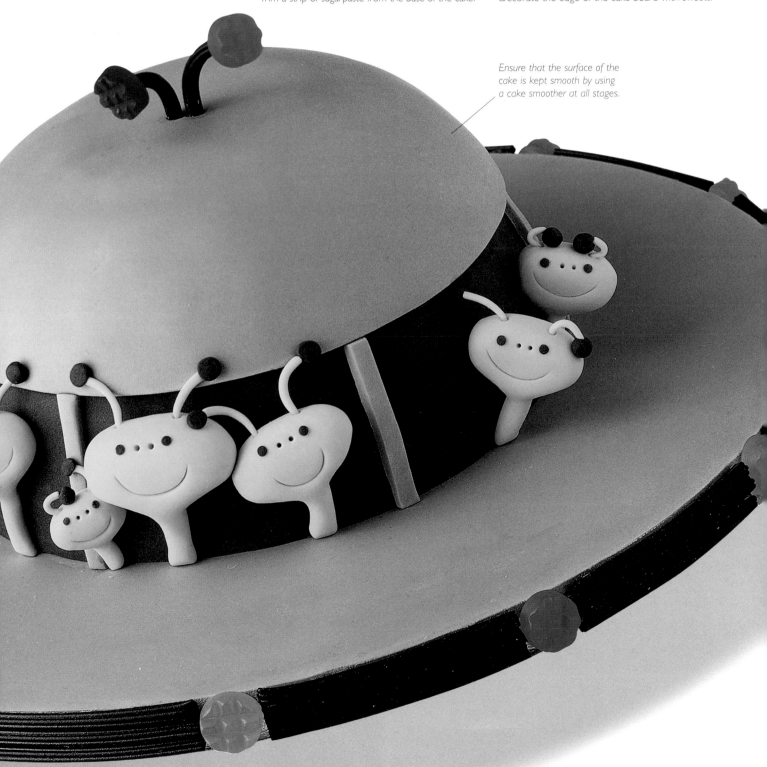

Ensure that the surface of the cake is kept smooth by using a cake smoother at all stages.

dog & bone

An unusual and very simple cake for any dog lover. No baking required!

MATERIALS
- 1 swiss roll/jelly roll
- 4 fairy cakes/cup cakes
- 30 x 25cm (12 x 10in) oblong cake board
- 1.5kg (3lb) sugarpaste/ rolled fondant
- black & red food colouring pastes
- icing/confectioners' sugar in a sugar shaker
- sugar glue
- 250g (8oz/1 cup) buttercream

EQUIPMENT
- large rolling pin
- sharp knife
- cocktail stick/toothpick

USEFUL TIP
Make sure that the covered cake board is completely dry before covering the cake with sugarpaste.

1 Colour 470g (15oz) of sugarpaste black. Roll out 440g (14oz) and cover the cake board, trimming any excess from around the edge. Thinly roll out 60g (2oz) of white sugarpaste and cut thin strips for the cake board, securing in place with sugar glue. Colour 75g (2½oz) of sugarpaste red. Thinly roll out and cut slightly wider strips than before to complete the checked pattern, then put aside to dry.

2 Position the swiss roll diagonally on the cake board, with two fairy cakes at either end, to form the dog's bone. Spread a thin layer of buttercream over the surface of the cakes to help the sugarpaste stick and to fill in the gaps between the cakes.

3 Roll out 625g (1¼lb) of white sugarpaste, using icing sugar to prevent the sugarpaste sticking to the work surface, and cover the cakes completely, smoothing around the shape of the bone. Trim carefully around the base, tucking the sugarpaste underneath.

4 To make the dog, first model a thick sausage using 140g (4½oz) of white sugarpaste. Following the stages in the photograph below, first make a cut at one end to separate the front legs, then smooth away the ridges and round off each front paw. Pinch the body all the way round to create a dip in the middle. Model one black and one white back leg, using 30g (1oz) of sugarpaste for each. Press the top of each leg flat, then stick in position using sugar glue. Press in with the side of a cocktail stick to mark the lines on each paw.

5 Using 15g (½oz) of red sugarpaste, model a flattened ball and stick on to the dog for his collar. Then roll a 90g (3oz) ball of white for the dog's head and pinch slightly to narrow the top. Model two flattened teardrop shapes for the dog's muzzle and two tiny flattened ovals for eyes. Mark holes in the muzzle using the tip of a cocktail stick.

6 Press on a black eye patch, spreading it out until completely flat, then stick on the two white eyes and black pupils. Shape a wide, triangular nose and two teardrop-shaped ears, then model a tongue with red sugarpaste. Stick these pieces on to the dog's head, then secure the head on the red collar with sugar glue. To finish, roll a sausage tapering to a point for a tail, and stick different sized black patches on the dog's body.

The dog's head, ears and collar. Model the sugarpaste to create the dog's body and legs.

Place the cakes on the board to form the bone.

make-up bag

If short of time, why not scatter the cake board with real girl's make-up?

MATERIALS

- 18cm (7in) round cake, see page 8
- 25cm (10in) round cake board
- 1.25kg (2½lb) sugarpaste/ rolled fondant
- pink & mauve food colouring pastes
- icing/confectioners' sugar in a sugar shaker
- 315g (10oz/1¼ cups) buttercream
- dark blue, dark purple, gold, dark pink, silver, pink, mauve & white edible sparkle powders/ petal dusts/blossom tints
- sugar glue

EQUIPMENT

- large rolling pin
- sharp knife
- small & large flower cutters
- 4.5cm (1¾in) circle cutter
- template, see page 109

Fill the tubs with different coloured sparkle powders.

1 Colour 315g (10oz) of sugarpaste pale pink. Roll out and cover the cake board. Trim excess from around the edge, then put aside to dry. Trim the crust from the cake and slice the top flat. Cut a 3.5cm (1½in) wedge from one edge of the cake to form the base of the make-up bag. Spread a layer of buttercream over the surface. Roll out 220g (7oz) of white sugarpaste. Place the back of the cake down on the sugarpaste and cut around. Cover the front in the same way. Colour 100g (3½oz) of sugarpaste mauve. Thinly roll out 30g (1oz) and cut a strip to cover the opening around the top of the cake.

2 Roll out 200g (6½oz) of white sugarpaste and cut two strips to cover the top of the cake, leaving the mauve inner strip showing. For the zip, press the tip of a knife along each side, then mark a line for the zip edge. Roll the white trimmings into two long thin sausages and use to hide the joins, then position the cake on the cake board. Thinly roll out 30g (1oz) of white sugarpaste and cut ten flowers with the large flower cutter, sticking in place with sugar glue. Using pink sugarpaste trimmings, model little flattened balls and use to fill each flower centre. Make another flower for the zip trim, using the small flower cutter.

3 To make the make-up, colour 45g (1½oz) of sugarpaste dark pink and 22g (¾oz) pale purple. For the mirror, thinly roll out dark pink and cut out a heart, using the template (see page 109), and a circle. Stick together with sugar glue, then stick on the board. With the remaining dark pink, roll a sausage for the base of the make-up tube and a tiny sausage for the applicator handle. Shape the eye shadow tub by pressing down into a ball of sugarpaste and smoothing around to create a dip. With the pale purple, shape another tub, the top of the lipstick, a small sausage for the applicator and the brush bristles, marking with a knife.

4 With mauve, make another eye shadow tub, the lipstick tube pieces and lid, the brush handle, a ball-shaped nail varnish bottle and a pencil tip. With white, make two more eye shadow tubs, the lid for the nail varnish tapering to a point, the sausage-shaped make-up tube lid and pencil, and all the applicator tips. Stick together with sugar glue. Rub patches of pink and mauve sparkle powder over the the cake, then brush with white sparkle powder. Fill the eye shadow tubs with sparkle powders and dip the applicator at either end. To finish, brush blue sparkle over the nail varnish bottle and silver over the mirror, lids and pencil.

Place a strip of mauve along the top of the cake.

Indent the zip with the tip of a sharp knife.

Brush silver sparkle powder on to the mirror.

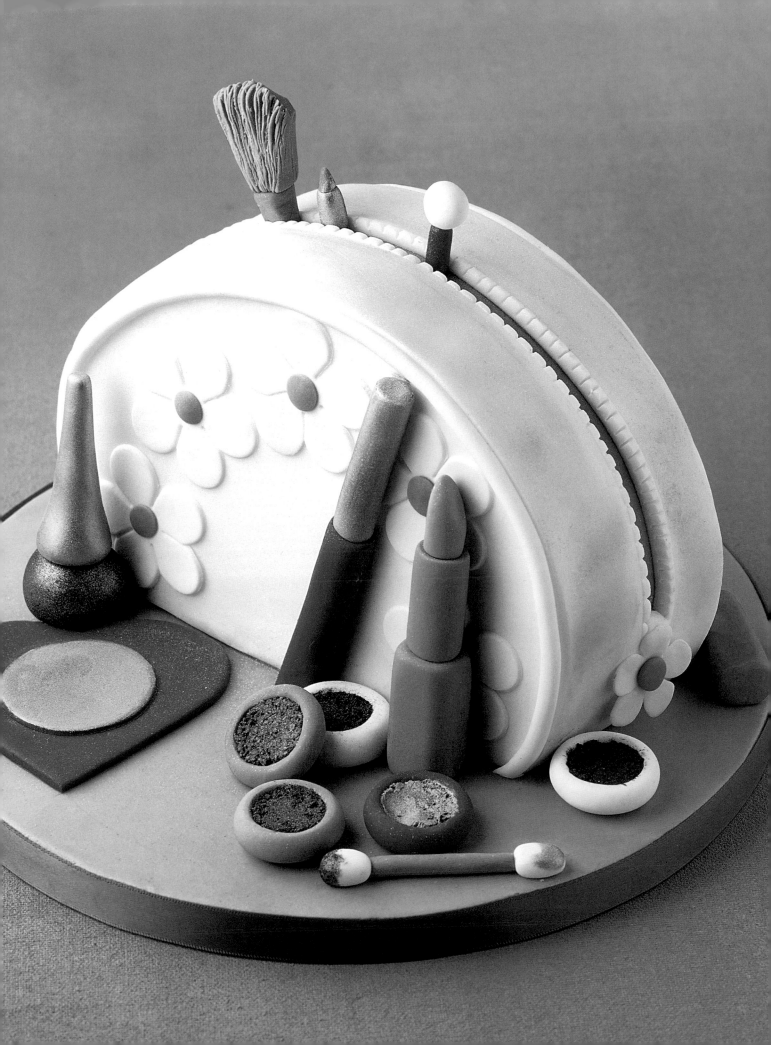

giant cup cake

A giant cake with the cutest teddy bear on top – a must for any small child

MATERIALS
- 22 x 9.5cm (8¾ x 3¾in) brioche-shaped cake, see page 8
- 25cm (10in) round cake board
- 1.5kg (3lb) sugarpaste/rolled fondant
- mauve, golden brown, red & green food colouring pastes
- icing/confectioners' sugar in a sugar shaker
- 220g (7oz/1 cup) buttercream
- sugar glue

EQUIPMENT
- large rolling pin
- sharp knife
- scissors
- bone tool
- small circle cutter
- cocktail stick/toothpick
- medium & large blossom cutters, see page 5

USEFUL TIP
Make sure that the buttercream is still soft on the sides of the cake before covering the cake with white sugarpaste, or the sugarpaste may start to come away from the cake sides when turned back over.

1 Colour 315g (10oz) of sugarpaste mauve. Roll out and cover the cake board, trimming excess from around the edge. Put the covered board aside to dry.

2 Turn the cake upside down and spread the bottom and sides with a layer of buttercream to help the sugarpaste stick. Roll out 750g (1½lb) of white sugarpaste and cover the cake completely, smoothing around the shape and into the grooves in the side of the cake. With scissors, cut a neat edge about 1cm (½in) longer than the cake edge. Carefully turn the cake back over and position on the centre of the cake board.

3 Roll out 185g (6oz) of white sugarpaste and use to cover the top of the cake, sticking in position with buttercream. Smooth the edge to round off and create a wavy effect.

4 To make the teddy bear, first colour 185g (6oz) of sugarpaste golden brown. Roll 60g (2oz) into a ball-shaped body. With 75g (2½oz), make a head and stick it in place using sugar glue. With the remaining piece, make two teardrop-shaped arms, flattened ovals for feet, an oval muzzle pressed flat and two ball-shaped ears.

5 Indent each ear using the small end of the bone tool. Indent the smile using the circle cutter pressed in at an angle and dimple the corners with a cocktail stick, then mark a line with the knife. Roll two white, oval-shaped eyes. Colour a tiny amount of sugarpaste black and make a nose and two pupils.

6 Model a cone from the white sugarpaste trimmings and stick it on top of the teddy's head. Colour the remaining sugarpaste red and green. Roll a small ball of red to make the cherry, pressing in the top with a cocktail stick to indent.

7 Thinly roll out the rest of the red sugarpaste and cut flowers using the blossom cutters. Stick the flowers around the edge of the cake board and over the white sugarpaste around the cake. With green sugarpaste, model the tiny teardrop-shaped leaves. Finally, roll out and cut red and green strips from the trimmings to decorate the hat.

Sugarpaste shapes for the teddy bear.

Trim the edges of the sugarpaste.

Cut flowers using a blossom cutter.

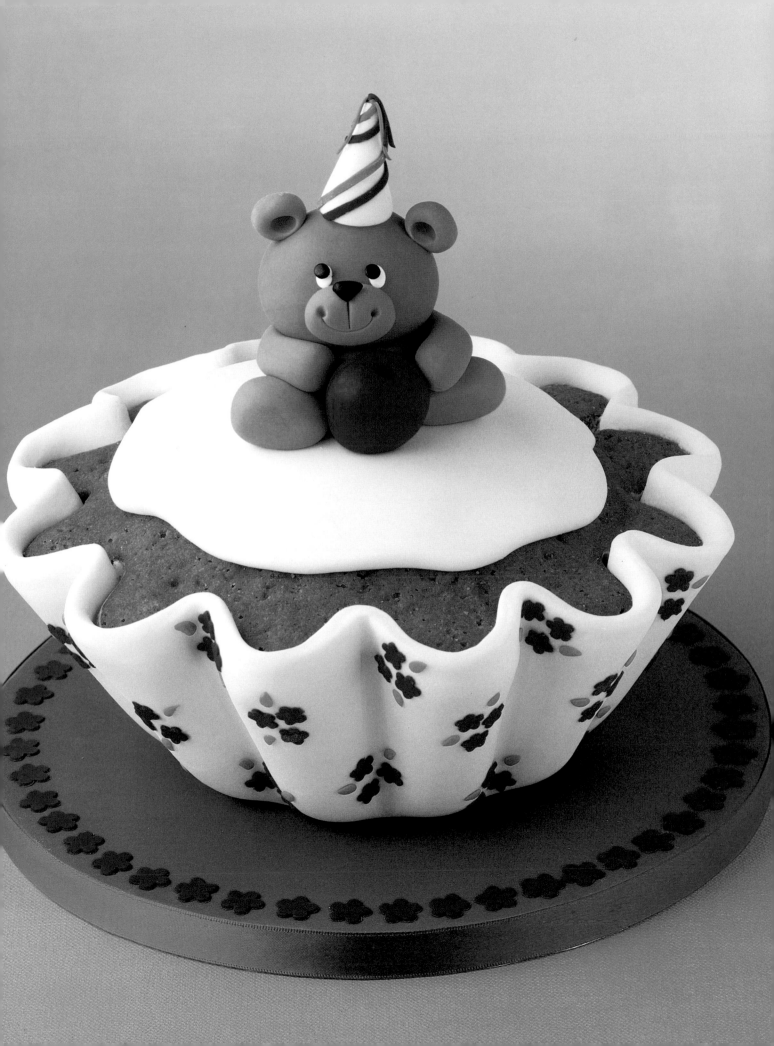

jewellery box

This pretty jewellery box will bring a gasp of delight from any little girl

MATERIALS

- 20cm (8in) square cake, see page 8
- 30cm (12in) petal-shaped cake board
- 1.4kg (2lb 13oz) sugarpaste/ rolled fondant
- blue & pink food colouring pastes
- icing/confectioners' sugar in a sugar shaker
- 410g (13oz/1⅔ cups) buttercream
- sugar glue
- mints, sweet/candy necklaces, mini sweets/candies & silver dragees
- edible pink sparkle powder/ petal dust/blossom tint

EQUIPMENT

- large rolling pin
- sharp knife
- cake smoother
- template, see page 110
- medium paintbrush

1 Colour 375g (12oz) of sugarpaste blue. Using icing sugar to prevent sticking, roll out the blue sugarpaste and cover the cake board. Trim any excess from around the edge, then put aside to dry. Trim the crust from the cake and slice the top flat.

2 Cut the cake in half, then sandwich one half on top of the other using buttercream. Spread a layer of buttercream over the surface of the cake to help the sugarpaste stick.

3 Roll out the remaining white sugarpaste. Position one side of the cake down on to the sugarpaste and cut around the shape with a sharp knife. Cover all sides of the cake in the same way, smoothing the joins closed. Cover the top in the same way, but cut the sugarpaste slightly wider than the actual cake to create a lip at the front.

4 Position the cake on the centre of the cake board and smooth the surface with a cake smoother. Using your finger, smooth slight dips around the lid to create a wavy effect.

5 Colour the sugarpaste trimmings pink. Roll out and cut two ballet shoes using the template (see page 110). Smooth around the edge of each shoe to round off, then press in the centre to create a dip and to outline the inside of each shoe. Thinly roll out the remaining pink sugarpaste and cut strips for the shoe ribbons. Stick the shoes and ribbons in position on the front of the cake with sugar glue.

6 Arrange all the different types of candy jewellery around the cake, securing them in position with sugar glue. Build up the mint necklace from the cake board up, so each mint is supported by the previous one. Stick with sugar glue, pressing firmly in place. Create a ring with a loop of white sugarpaste, and use a few silver dragees to create a sparkling jewel. When the cake is dry, use the paintbrush to dust with edible pink sparkle powder.

Sugarpaste shapes for the ballet shoes.

Cut the sugarpaste to fit the sides of the cake.

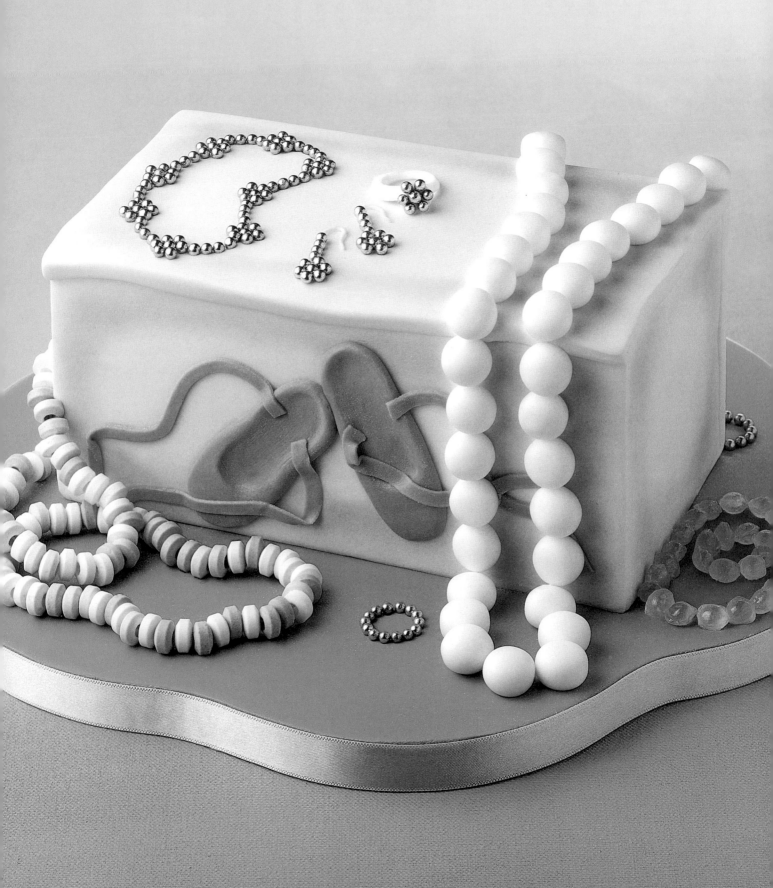

lovable ladybird

With its cheeky grin, this ladybird is sure to be a favourite birthday treat

MATERIALS

- 2 litre (4 pint/10 cup) bowl-shaped cake, see page 8
- 30cm (12in) round cake board
- 1.35kg (2¾lb) sugarpaste/ rolled fondant
- green, red, black & yellow food colouring pastes
- icing/confectioners' sugar in a sugar shaker
- 185g (6oz/¾ cup) buttercream
- sugar glue
- lengths of liquorice/licorice

EQUIPMENT

- sharp knife
- large rolling pin
- 4cm (1½in) circle cutter

USEFUL TIP

When sticking the ladybird's head to the body, do not use too much sugar glue as it could slide out of place.

1 Colour 375g (12oz) of sugarpaste green. Using icing sugar to prevent sticking, roll out the green sugarpaste and cover the cake board. Put the covered board aside to dry.

2 Trim the crust from the bowl-shaped cake and slice the top of the cake flat, using a sharp knife. Turn the cake upside down and then spread a layer of buttercream over the surface of the cake to help the sugarpaste stick.

3 Colour 625g (1¼lb) of sugarpaste red. Roll out and cover the cake, smoothing around the shape, then trim any excess from around the edge. Position the cake on the cake board. Using the back of a knife, mark a line down the centre of the ladybird's back.

4 Colour 155g (5oz) of sugarpaste black. Roll 125g (4oz) into a ball-shaped head. Stick in position using a little sugar glue then, with the circle cutter, press in at an angle to indent the smile. Dimple the corners of the smile using your finger.

5 Push two pieces of liquorice into the top of the ladybird's head and stick a small ball of black sugarpaste on the end of each antenna. Roll two tiny amounts of white sugarpaste into balls and press on to the face for the eyes.

6 With the remaining black sugarpaste, model two pupils, then roll out and cut six circles for the spots to decorate the ladybird's back. Secure on the cake with sugar glue.

7 Colour the remaining sugarpaste yellow. Model long, yellow teardrop shapes for petals, pressing each shape flat but still keeping them fairly thick. Stick the petals in position around the ladybird, making sure they do not hang over the cake board edge.

8 Make smaller and shorter yellow petals for a second layer, encouraging the petals to bend, as in the photograph opposite, then secure in place with sugar glue.

Sugarpaste shapes for the ladybird's head.

Model petals from pieces of yellow sugarpaste.

Mark a line down the centre of the cake.

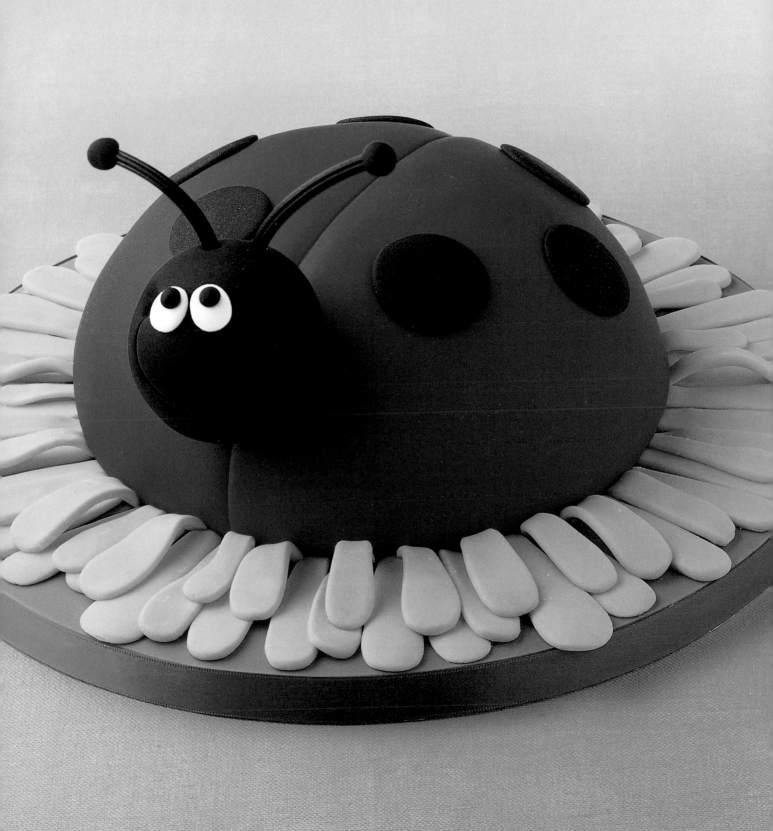

spooky tower

The perfect cake for any would-be ghostbuster who likes being spooked

MATERIALS
- 20cm (8in) square cake, see page 8
- 20cm (8in) round cake board
- 1.5kg (3lb) sugarpaste/rolled fondant
- dark blue, black & pink food colouring pastes
- icing/confectioners' sugar in a sugar shaker
- 375g (12oz/1½ cups) buttercream
- sugar glue
- edible sparkle powder/ petal dust/blossom tint

EQUIPMENT
- large rolling pin
- sharp knife
- cake smoother
- small square cutter
- fine paintbrush

Shape white sugarpaste to create the ghosts.

1 Colour 375g (12oz) of sugarpaste dark blue. Roll out 280g (9oz) and cover the cake board, then put aside to dry. Trim the crust from the cake and slice the top flat. Cut the cake into four equal sized squares. Trim each square to create four circles. Sandwich together with buttercream, then spread the surface of the cake with a layer of buttercream.

2 Colour 1kg (2lb) of sugarpaste pale blue-grey using a tiny amount of the blue and black food colourings. Position the cake down on to 875g (1¾lb) of rolled-out blue-grey sugarpaste. Roll it around the cake, trimming any excess from the join and at either end. Stick the join together with sugar glue, then rub gently with the cake smoother to close. Roll the cake carefully on the work surface to smooth out any wrinkles.

3 Position the cake on the board, sticking in place with sugar glue. Use a cake smoother to polish the surface. Roll out the remaining dark blue sugarpaste and cut a circle to fit the top of the tower. Remove pieces of sugarpaste to create the door and windows. Thinly roll out dark blue sugarpaste and cut inserts for the door and windows.

4 Roll out the remaining blue-grey sugarpaste and cut a 5cm (2in) deep strip. Using the square cutter, cut out the turrets. Moisten around the top edge of the cake with a small amount of sugar glue. Carefully roll up the turret and position it against the top of the cake, then unroll it all the way around. Glue the join and smooth closed.

5 Colour the grey sugarpaste trimmings slightly different shades by adding tiny amounts of blue, black and pink food colourings. Shape flattened balls of paste and stick over the tower and around the door and windows. Cut wedges for the window sills. Create the staircase by making the lowest stair the thickest, each further stair getting gradually thinner.

6 Model a long, tapering sausage of white sugarpaste for the ghostly tail and stick in position around the cake, twisting up to the top window. Make all the ghosts with white sugarpaste and stick in place with sugar glue, holding for a few seconds until secure. Model their eyes using flattened balls of white. Using the fine paintbrush, paint the eyes and mouths with the black food colouring. Brush the edible sparkle powder over the cake.

Cut the cake into four equal sized circles.

Roll the blue-grey sugarpaste around the cake.

Cut the turrets with the small square cutter.

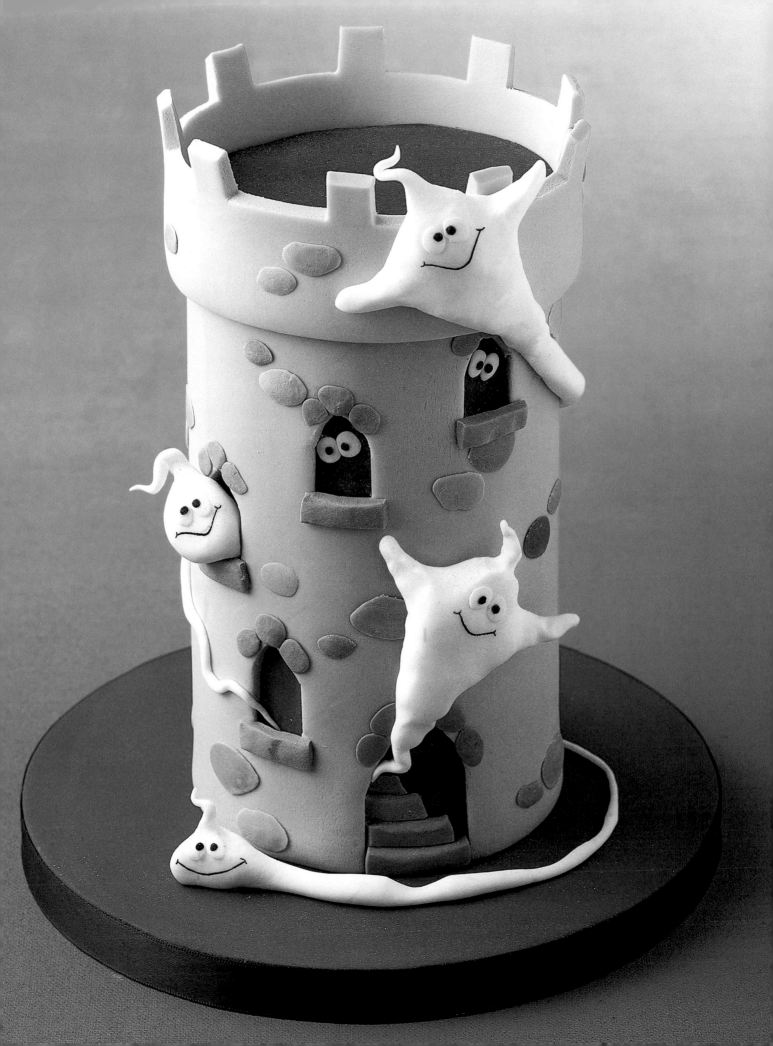

cute chick

A perfect cake for a small child's birthday or as a bright Easter treat

MATERIALS

- 1 x 2 litre (4 pint/10 cup) & 1 x 0.5 litre (1 pint/2½ cup) bowl-shaped cakes, see page 9
- 30cm (12in) round cake board
- 1.8kg (3lb 10oz) sugarpaste/ rolled fondant
- green, yellow, orange & black food colouring pastes
- icing/confectioners' sugar in a sugar shaker
- 440g (14oz/1¾ cups) buttercream
- sugar glue

EQUIPMENT

- large rolling pin
- sharp knife
- cake smoother

USEFUL TIP

When a large piece of sugarpaste is rolled out, lift by folding it over the rolling pin. This will make it easier to position the sugarpaste on the cake.

1 Colour 375g (12oz) of sugarpaste green. Using icing sugar to prevent sticking, roll out the green sugarpaste and cover the cake board, trimming the excess from around the edge. Set aside to dry. Trim the crust from the cake, keeping the rounded top on each where the cakes have risen. Cut two layers in the large cake and one layer in the smaller cake. Sandwich both cakes back together with buttercream.

2 Turn each cake upside down (the cakes are decorated this way up) and spread with a layer of buttercream to help the sugarpaste stick. Colour 1.25kg (2½lb) of sugarpaste yellow. Using 30g (1oz), pad the top of the smaller cake to heighten the top of the head.

3 Roll out 625g (1¼lb) of yellow sugarpaste and cover the larger cake completely, smoothing around the shape and tucking the sugarpaste underneath. Roll out 375g (12oz) of yellow sugarpaste and cover the smaller cake in the same way. Position the cakes on the board with the smaller cake on top, using sugar glue to secure them in place. Smooth the surface of both cakes with a cake smoother.

4 For the wings, roll six long teardrop shapes of yellow sugarpaste. Stick three on to each side of the chick's body, graduating down in size and curving up around the back. Model three smaller yellow teardrop shapes for the tail and three teardrop shapes for the hair tuft. Stick these pieces in place, curling up the points.

5 Colour a tiny amount of sugarpaste black, then colour the remaining piece of sugarpaste orange. Split the orange sugarpaste into three equal sized pieces. From two pieces, shape two ovals, pinching four times along the top of each to make webbed feet, as in the photograph below. Stick in position, pressing the centre of each to indent.

6 Roll a sausage with the remaining orange sugarpaste, then roll on either side of the centre to create dips to shape the beak. Stick on the chick's face, just below half-way. Finally, make the two oval-shaped eyes by rolling two small balls of black sugarpaste. Stick in place in the centre of the face, quite close together, securing with a little sugar glue.

Sugarpaste shapes for the chick's webbed feet.

Sandwich the cakes together with buttercream.

Cover both cakes with yellow sugarpaste.

templates

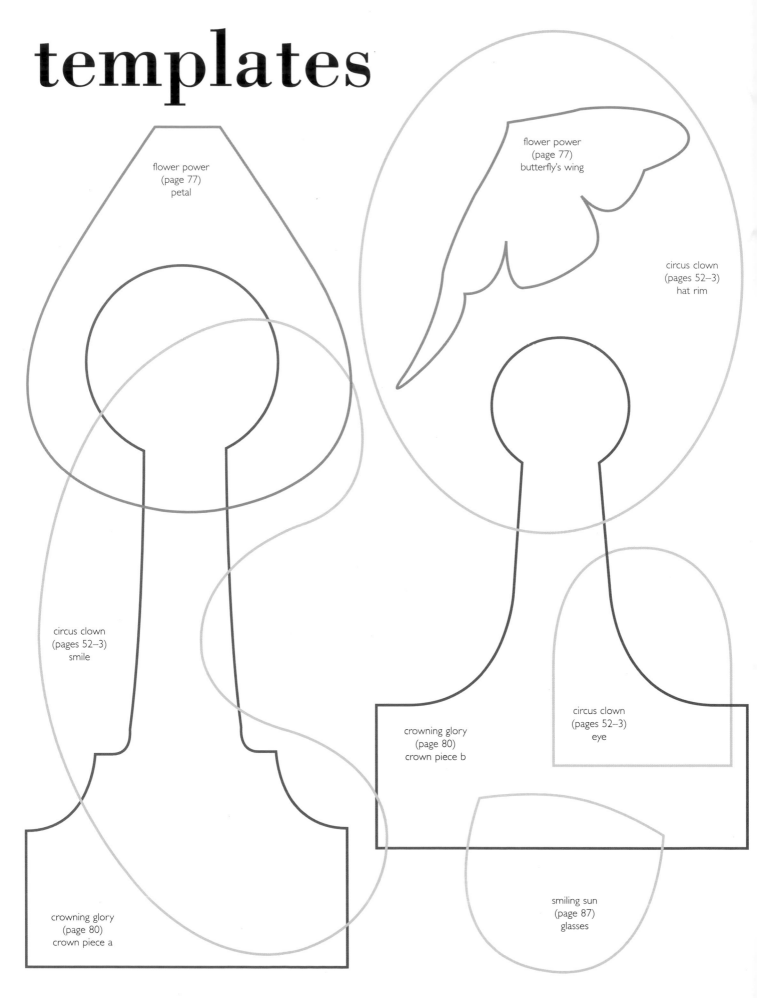

flower power
(page 77)
petal

flower power
(page 77)
butterfly's wing

circus clown
(pages 52–3)
hat rim

circus clown
(pages 52–3)
smile

crowning glory
(page 80)
crown piece b

circus clown
(pages 52–3)
eye

crowning glory
(page 80)
crown piece a

smiling sun
(page 87)
glasses

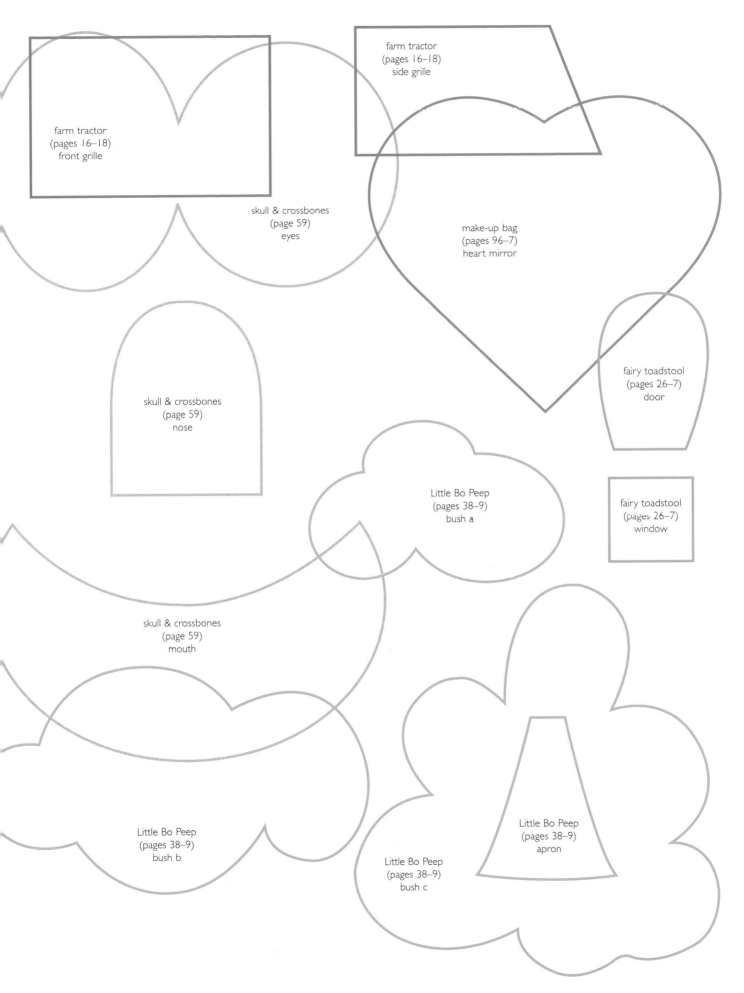

farm tractor
(pages 16–18)
front grille

farm tractor
(pages 16–18)
side grille

skull & crossbones
(page 59)
eyes

make-up bag
(pages 96–7)
heart mirror

skull & crossbones
(page 59)
nose

fairy toadstool
(pages 26–7)
door

Little Bo Peep
(pages 38–9)
bush a

fairy toadstool
(pages 26–7)
window

skull & crossbones
(page 59)
mouth

Little Bo Peep
(pages 38–9)
bush b

Little Bo Peep
(pages 38–9)
bush c

Little Bo Peep
(pages 38–9)
apron

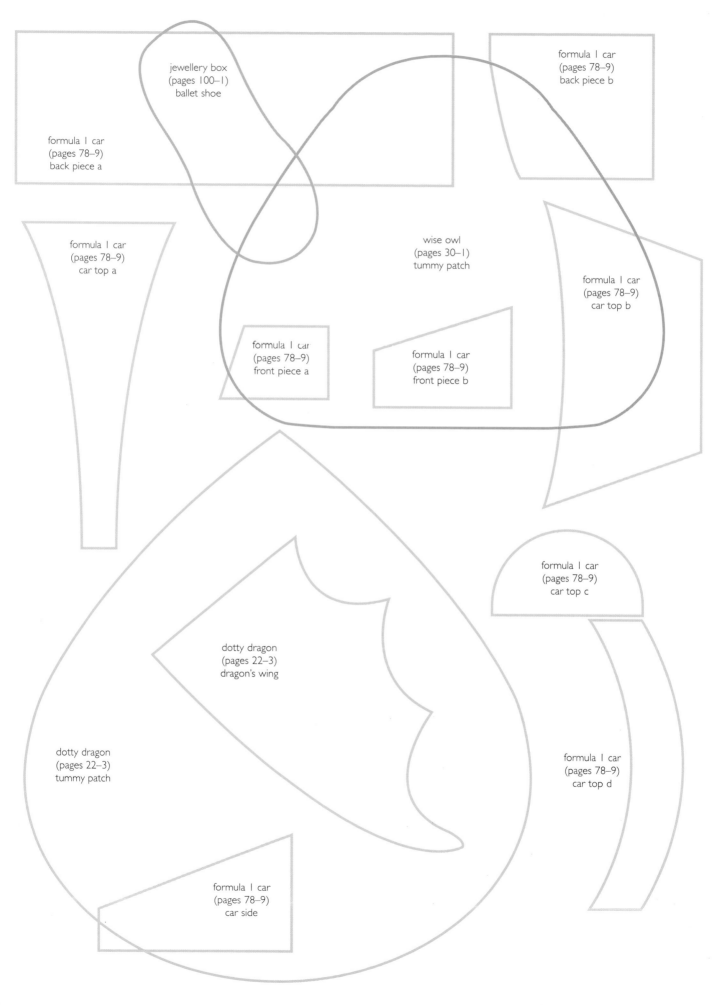

jewellery box
(pages 100–1)
ballet shoe

formula I car
(pages 78–9)
back piece a

formula I car
(pages 78–9)
back piece b

formula I car
(pages 78–9)
car top a

wise owl
(pages 30–1)
tummy patch

formula I car
(pages 78–9)
car top b

formula I car
(pages 78–9)
front piece a

formula I car
(pages 78–9)
front piece b

formula I car
(pages 78–9)
car top c

dotty dragon
(pages 22–3)
dragon's wing

dotty dragon
(pages 22–3)
tummy patch

formula I car
(pages 78–9)
car top d

formula I car
(pages 78–9)
car side

dedication

*For Lewis, Laura, Shaun, Daniel, Sarah,
Rhys, David and Craig*

acknowledgements

*The author and publishers would like
to thank the following suppliers:*

Culpitt Cake Art
Culpitt Ltd.
Jubilee Industrial Estate
Ashington
Northumberland, NE63 8UQ
tel: 01670 814 545

Guy, Paul and Co. Ltd.
Unit B4, Foundry Way
Little End Road
Eaton Socon
Cambs
PE19 3JH

Renshaw Scott Ltd.
Crown Street
Liverpool
L8 7RF
*The sugarpaste/rolled fondant used in
this book was Renshaw's Regalice.*

Squires Kitchen
Squires House
3 Waverley Lane
Farnham
Surrey, GU9 8BB
tel: 01252 711 749

Other distributors and retailers:

Confectionery Supplies
31 Lower Cathedral Road
Riverside
Cardiff
South Glamorgan
CF1 8LU
tel: 01222 372 161

**Beryl's Cake Decorating
& Pastry Supplies**
P.O. Box 1584
N. Springfield
VA22151-0584 USA
tel: 1 800 488 2749
fax: 1 703 750 3779

Cakes & Co.
25 Rock Hill
Blackrock Village
Co. Dublin
Ireland
tel: 353 1 283 6544

Cake Decorators' Supplies
Shop 1
770 George Street
Sydney 2001
Australia
tel: 61 2 9212 4050

First published 1999 by Merehurst Ltd.,
an imprint of Murdoch Books UK

Murdoch Books UK
Erico House, 6th Floor North,
93-99 Upper Richmond Road,
Putney, London SW15 2TG
Tel: +44 (0) 8785 5995
Fax: +44 (0) 8785 5985

Murdoch Books Australia Pty Limited
Pier 8/9, 23 Hickson Road
Millers Point NSW 2000
Tel: +61 (2) 8220 2000
Fax: +61 (2) 8220 2558

Copyright © Debra Brown 1999
Photography copyright © Murdoch Books UK

Debra Brown has asserted her right under the
Copyright, Designs and Patents Act, 1988.

ISBN 978-1-85391-855-1

Commissioning Editor:
Barbara Croxford
Project Editor:
Rowena Curtis
Design Concept & Art Direction:
Laura Jackson
Design:
Axis Design
Photography:
Clive Streeter

Publisher:
Kay Scarlett
CEO
Juliet Rogers

Distributed by

North America, South America & Canada
Tuttle Publishing
364 Innovation Drive, North Clarendon,
VT 05759-9436, USA
Tel: (802) 773 8930; Fax: (802) 773 6993
info@tuttlepublishing.com
www.tuttlepublishing.com

15 14 13 12 12 11 10
Printed in Singapore 1202CP

index